boink

College Sex
by the People Having It

EDITED BY

Christopher Anderson

Alecia Oleyourryk

Vanessa White

DESIGN BY Molly Mathis

ILLUSTRATIONS BY Paul Roustan

PHOTOGRAPHS BY Christopher Anderson and Simon Snellgrove

GRAND CENTRAL
PUBLISHING

NEW YORK BOSTON

To our parents, who may not always agree
with our choices but still love us **unconditionally.**

Grand Central Publishing
Hachette Book Group USA
237 Park Avenue
New York, NY 10017

Visit our Web site at www.HachetteBookGroupUSA.com

Printed in Canada

First Edition: February 2008
10 9 8 7 6 5 4 3 2 1

Grand Central Publishing is a division of Hachette Book Group USA, Inc. The Grand Central Publishing name and logo is a trademark of Hachette Book Group, USA, Inc.

ISBN-10: 0-446-69875-X; ISBN-13:978-0-446-69875-7; LCCN: 2007934250

Cover Photo: John Halpern

18 U.S.C. Section 2257 Compliance Notice

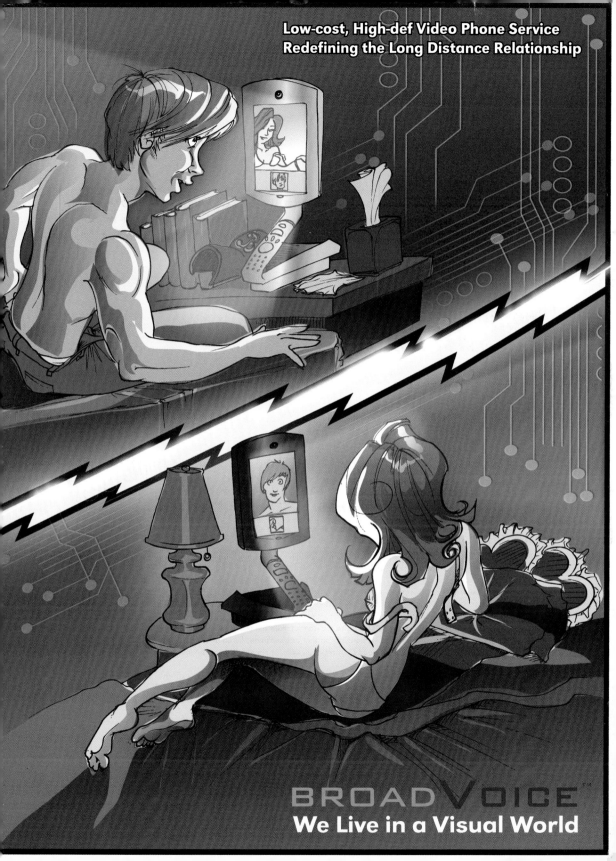

REED ::: JULIE

CAIT ::: NIC

RODERICK ::: TEAL

GELI ::: DEAN

boink
College Sex by the People Having It

acknowledgments

This is the place where we recognize all the amazing support that we've received to make this project happen. Without the generosity of the following people, we seriously would not have been able to do it.

First we want to thank Ben Greenberg, our editor at Grand Central, who really got what we were trying to do, championed our cause, and provided valuable support and feedback along the way.

We gratefully acknowledge the more than generous financial support of Frank Gangi and BroadVoice, without whom our spectacular photo shoots in the Caribbean could not have happened.

We sincerely appreciate the efforts of our literary agents, Daniel Greenberg and Lindsay Edgecome, who held our hands and guided us through the unfamiliar and sometimes daunting task of getting a book like this published.

Special thanks go to Molly Mathis and Paul Roustan. Molly's fresh and funky designs are responsible for the personality of this book while Paul's provocative illustrations bring the text to life in a way that is undeniably unique.

Finally we want to express our gratitude to all of our other contributors. We applaud our writers who had the courage to share a piece of themselves that most would have kept private. And we especially give props to our photogs and models (Cait, Dean, Geli, Julie, Nic, Reed, Roderick, and Teal), with whom we shared the experience of a lifetime in the Virgin Islands. We will never forget it.

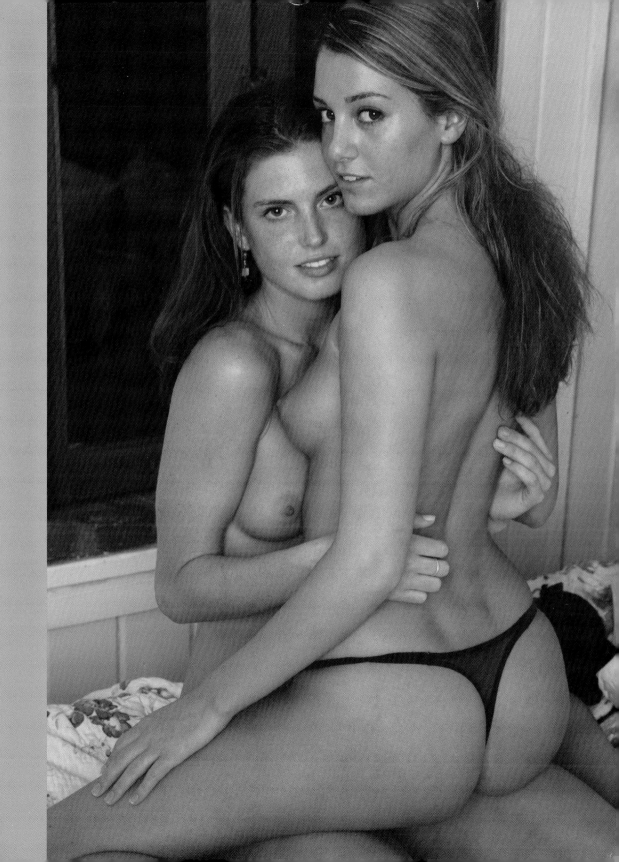

What is **boink**?

If you're like most people, you picked up this book because the title and or the picture on the cover caught your eye and aroused your curiosity. Then having flipped through the pages, you're probably asking yourself, "What the fuck is this?" That's perfectly understandable because *boink* is unique and not something that you're likely to have seen before, unless you happen to go to college in Boston.

It all began when a group of my fellow Boston University undergrads and I decided to publish a magazine dedicated to the primary interest of most college students, namely SEX. We wanted to create something different that would entertain and possibly inform other college kids like us. We were looking for a fresh approach to the subject from the perspective of people our age and wanted to provide more than just pictures of big-breasted girls, Photoshopped beyond the limits of fake perfection. We felt that it was important to keep it real and to provide something for everyone; guys and girls, straight, gay, and bi.

Of course, word quickly spread on campus about the project. We were soon inundated with requests from students who wanted to write and model for the magazine, which we decided to call *boink* to reflect the playfulness, openness, and above all fun with which we wanted to tackle sex. We worked throughout the semester to turn our vision into reality, facing more than a few challenges along the way. What kept us going through all the setbacks was the enthusiasm with which our contributors and other members of our potential audience embraced the concept. The end result was an eclectic mix of sexy fiction and provocative nonfiction, cool illustrations and naked pics of REAL college girls and guys.

Needless to say, we stirred up a shit storm. The BU administration immediately distanced itself with a public statement that "The University does not endorse, nor welcome, the prospective publication *Boink*." The story was picked up first by the local media and then by national and international news outlets. We were the subject of criticism and negative commentary from a variety of sources. Some parents and students complained that a sexually explicit magazine like *boink* would tarnish the University's reputation and had no place at an institution of higher learning. Social conservatives, religious advocates, self-righteous journalists and others who are generally uptight about sex publicly attacked us. The police even shut down our launch party at a local club, which was attended by 1,400 people.

Yet despite all of the opposition, there were also a significant number of people who supported our efforts, particularly among our fellow college students. And sales of the premier issue were impressive, especially given its limited distribution.

Since then we have continued to publish in the face of controversy and to expand the circulation of *boink* magazine. And now through our partnership with Grand Central Publishing, we are excited to be able to offer you this book and the opportunity to join the growing number of boinkers across the country and around the world.

Alecia Oleyourryk
Editor & Cofounder *boink* magazine

P.S. You may want to pick up two copies in case the pages of one get stuck together.

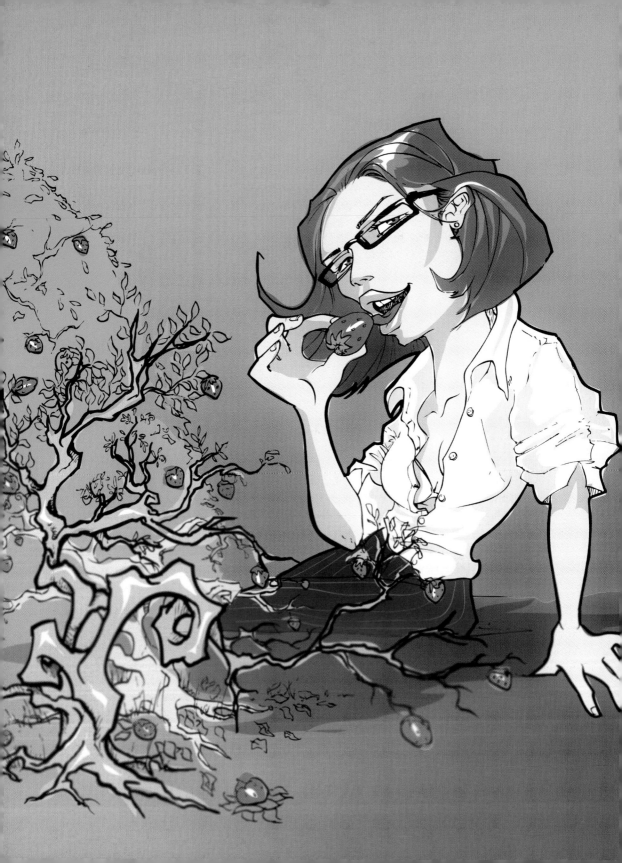

Her Strawberry Ghost

by **JUSTIN**
LARGE PRIVATE UNIVERSITY

AND HERE WE ALL ARE—fat strawberry sunburned people who get broken, pissed on, mended, and changed. We build fictions only to rewrite them, wad scraps of paper into balls to keep our fingers occupied, and then flick them away. We connect with people and then disconnect. We grow things. We let things die.

None of this ever mattered to Kat while we dated these past few years. Her main concern was having fun and having breakfast—or as I liked to call it, brunch. We would be together for a semester, drift apart for a bit, wind up back together again, and visit each other over summer and winter break. When she came to my house one June, the strawberry patch I had planted was spilling out onto the lawn, laden with bright red berries. During that week she was with me, we feasted. In the morning I'd roll out of the guest room where we slept and stumble down the hall, my bare feet squishing gently on the cool floorboards. She'd roll over a bit and grunt, not registering my exodus. That image of her burned into my brain, it was always the same when I'd glance back at her while walking out the door to pick strawberries in the dewy grass. Her naked shoulders, white and creamy, were poking out from under the sheets, with the sunlight shooting through the eastern window. And I'd be back an hour later with a white plastic colander my aunt gave me years ago. It'd be brimming with soft berries—fresh, tart, juicy, and smelling like something I've never understood.

We'd greet the day sitting in little pine chairs eating cereal and strawberries in mismatched bowls. Kat and I slurped while our spoons clinked with the loose rhythm of miniature jazz drums, playing at a Polly Pocket jazz bar on a Saturday morning. The air outside smelled like pine sawdust. We'd chat about random things that mattered to no one but us.

She's the kind of girl who for no apparent reason says the word Spain a lot. Says it with scrunched lips and precise diction, but then at the last second adds a twist that punctuates the kinetic aspect of "Spain." Neither of us has ever been, but one night

It was Kat, all pale and pretty. Not "hot" or "fuckable" or "sexy" or "bodacious."

Pretty.

She complained one day that nobody says that word anymore, and it's true. The language of passion derailed years ago, leaving us all with imprecise tools and prudish vocab. So I call her pretty, because that is what made her happiest to be.

When she straddled me and sank on top of my cock, she'd toss her hair back with a little whip-crack "I mean business" pose, sending our shadow puppets dancing on the painted tin ceiling of the old brownstone dorm where she lived.

after making love in her dorm room, we joked about going there. She got up naked, her pert ass sticking out as she leaned over to grab an old light-up globe she use to have on her nightstand, to settle some question of geography. She used to keep the globe next to the bed, along with a Big Ben windup clock, and a retarded-looking ceramic scarecrow with a magenta light bulb in it. When we had sex on the bed, she'd flip it on and it would cast spiky red shadows on the wall, our bodies adding new ghosts and contours to the dancing light. When she straddled me and sank on top of my cock, she'd toss her hair back with a little whip-crack "I mean business" pose, sending our shadow puppets dancing on the painted tin ceiling of the old brownstone dorm where she lived. She doesn't fuck halfheartedly. Her hair would catch the scarecrow light enough to make it look like a prehistoric shadow monster was straddling me—only it was not a monster, or a dinosaur.

And she is. It's the hair and the pale skin and the black glasses and a few weird birthmarks, one resembling China, that anchors to earth the spitfire lady that I spent the past few years with, discussing, cavorting, fucking, and being absurd. When we had sex it wasn't an activity, or a marathon, or a conquest—it was conversation. Our most vulnerable times, naked, sweating, a bit pink in the face, had a bebop lilt. Not the first time—that was awkward and we hadn't learned the humor of it—but later, we laughed so hard. Laughed at the desperate chase for orgasms. Laughed at the ridiculous mechanics of

putting certain pieces of body into alignment with others. Laughed at cum, which we thought would work better as a party gag than a means of procreation. Laughed at labia, which confuse silly men like me. And at each other and how happy we were.

I had my backpack with me when I came to visit her in Boston the last summer, and most of what was in it was more backpack. I brought a lime green face towel, because it's all you really need and I try to travel light. It was lime green because my uncle had a lime green truck years ago that he used to race on frozen lakes up north. The only girl who never laughed at that justification was Kat. Wrapped in newspaper, at the bottom of my pack, was a green carton of strawberries from the garden back home.

I unpacked the face towel and the rest of my bag. Her summer apartment smelled like Allston, and featured a dining room table surrounded by old wooden chairs, all partially broken. In her room, she had the nightlight and the globe and the clock just like it used to be in the dorm, and it was weird to see these little rooted things, which in my mind were glued to a different room and time and place, transplanted to an alien ecosystem. Allston noises and salt-and-pepper kittens scrambled in through the windows, but we kissed and ig-

nored all of that. I set the green carton of strawberries on her nightstand. She gave me a crinkled nose smile, and told me to take my goddamn clothes off, and who was I to argue? She wore this white collared shirt with rolled up sleeves, which came off easily. It always ruffled up a bit across her breasts, so you could see her bra underneath. She made fun of the fact that I was looking, and popped the rest of her buttons open for me. But I had to undo the bra myself. That was her condition. If I wasn't man enough to unlock a hook and eye clasp, then, well…

Kat giggled and unzipped my pants. My cock sprang free and she grabbed me. As my pants slipped off my legs, I felt the cool cotton sheets against my hot skin. She was a furnace. Her sarcastic mouth slowly covered my cock, the saliva of her lips clicking and popping as she took me into her throat. Fierce brown eyes, framed by her black rim glasses, stared at me with silent mirth. Warmth, like that from alcohol, shot up through the veins in my legs and curved up my ass to my spine and nape and lungs. I lifted her chin gently, feeling the smooth sweep of her jaw. I leapt up from the bed and out from under her, grabbing her hips. She wiggled as I tugged off her black pinstripe pants,

and slowly slipped my hand into her electric purple panties and slid them down her legs and off onto the worn wooden floor. She stuck her ass out at me, and I could smell her wetness, earthy and wild. She flipped onto her back as my fingers tickled her navel, and the curving lines of her stomach swept my eyes down to her flaring pussy lips, and to the

She gave me a crinkled nose smile, and told me to take my goddamn clothes off, and who was I to argue?

tuft of hair she kept, trimmed, but not pretentiously so, waiting to tangle my tongue.

I lowered myself over her, kissing the side of her eyebrow and the tip of her nose, running my hand along the bit of fat under her chin that, when lying down, reminded me of William Shatner. I stuck my tongue out at her and she grabbed it with her teeth and pulled me closer, hard. I loved the taste buds on her tongue, as they explored my teeth and tongue and cheeks. She always tasted like black cherry soda, the kind made with sugar cane in glass bottles. I broke away from her as my fingers twirled her pubic hair, walking around her pussy lips, teasing as much as possible. I slid down between her legs and ran my tongue from her navel to the edge of her triangle, then around the outside and in just to graze her clit. She gasped as my tongue rippled over her. I licked my finger and slowly slid it into her body, while my lips latched onto her clit gently and my tongue caressed her little button. My finger rubbed against the top of her vagina, and I felt the muscles inside her contract, and the subtle soft ridges, deep inside of her, as they brushed against my pumping fingertips. Her pussy hair poked into my nostrils and scratched my face. The deep smell of her wetness filled my nose. She smelled

determined, but not bad. And Kat tasted salty, with a pink ginger tang. I pushed her closer to climax, slipping another finger into her. Kat wrapped her legs around my neck and her hands clawed at the bedspread, tense, shaking slightly.

"Faster," she panted, and I sped up. Her pelvis shifted and she forced my fingers deeper and higher up into her. Kat bit her lip and yelped. Then she let out a deep alpine sigh, and her body relaxed. A warm red glow burned into her pale skin, and I looked up at her, smiling. I wiped my lips, now a bit tired, and watched as her sparkling juices mixed with the sweat from her leg. It formed a big drop, growing and swelling until the surface tension broke and it darted down her thigh, around the lips of her pussy and past the pink rosebud of her asshole. It faded into the blue cotton sheets, leaving only a damp silhouette of its presence.

I scooted back up to her, cradling her tightly, feeling the sweat on her arms and back, and the little dewdrops on the soft hair on her neck. She kissed me, her tongue exploring her own salty taste. She straightened her glasses, sat up a bit, and she burped.

"Your face looks weird when you go down on me," she said. I smiled.

"That's 'cause your vagina attacked my face."

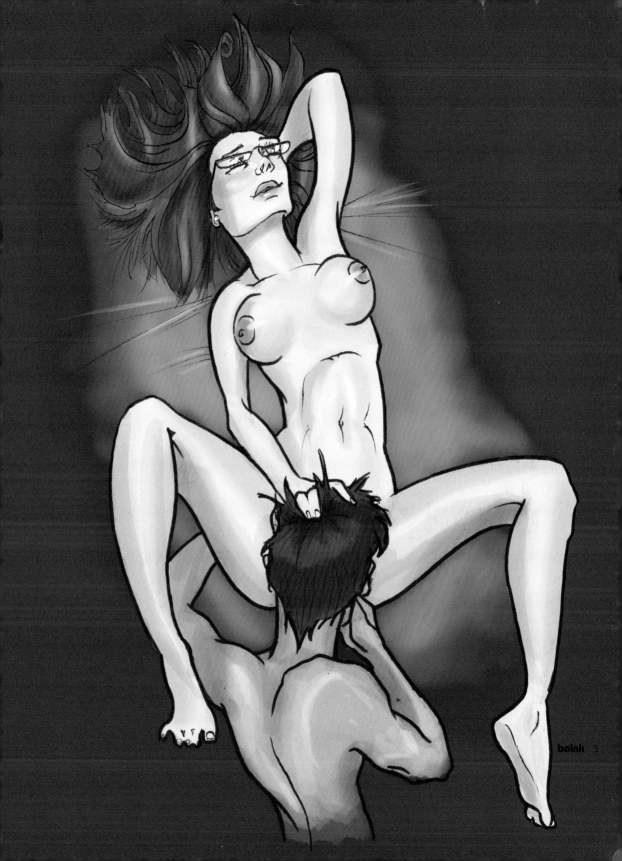

"Ugh, don't call it that."

"Your vagina wanted to give me a makeover." She rolled her eyes and fluffed out her bangs, which were scattered across her forehead.

"Okay, Dr. Gynecology. Way to ruin the mood."

Kat squirmed in my arms and I squirmed back. She grabbed my cock in her hand, running her fingers down the tense chiseled head and along the thick shaft. She parted her legs and guided me into her. Her warmth engulfed my cock. I felt her muscles rippling inside her, squeezing me. I sank deeper and just held her for a moment, silently.

"So, we're gonna go to Spain, right?" she blurted. We both cracked up. I pulled out of her, laughing, and then pushed back in. Kat and I struck up a rhythm that advanced and receded. We broke into solos and twisted with each other. We improvised, made mistakes, got out of synch, and corrected our occasional awkwardness.

"Faster," she panted, and I sped up. Her pelvis shifted and she forced my fingers deeper and higher up into her. Kat bit her lip and yelped. Then she let out a deep alpine sigh, and her body relaxed.

The two of us screwed for an hour. Our leg muscles burned from thrusting, and my left knee felt sore, so we stopped and cuddled, spent. We whispered to each other about mundane things, until we both tired of talking in low, throaty bed voices, and fell quiet. She reached over to the nightstand and grabbed a strawberry and shoved it at my mouth. I bit a chunk, and juice rolled down my chin. She licked it off, and before I could bite the rest of the berry, she had eaten it. Her stained fingertips dangled the strawberry leaf in front of me.

"Bet they won't have these in San Diego."

They don't.

The rest of the weekend passed like any other mash-up of summer, when you realize that it's almost done and that you wasted most of your time doing nothing. She seemed okay about me moving to San Diego for grad school, and that surprised me. I thought she would get all weepy and emotional, but instead I was the one fighting back tears when we had lunch at the diner, a few minutes before I had to catch my train back home. We ate sandwiches, paid, and left. As we walked around the corner she suddenly pushed me against the dirty brick and grabbed my face. We kissed, lewdly, for a minute. Then Kat let me go.

"That's gotta last me a while." She sighed, slapped my ass, and sent

me off toward the wheezing Amtrak engine. I didn't have the courage to ask her how long.

Back home, I packed my bags and bought my plane ticket to California. The strawberry patch turned brown at the end of August, so I plowed it under and covered the fresh dark earth with hay. Little plants like that survive for a few good years and produce fantastic fruit, and don't let anyone tell you it's hard. Growing strawberries is the easiest thing in the world as long as you don't live in Alaska or Guam. They can be grown hydroponically, or in greenhouses, or on factory farms with black plastic fields. But they only last so long before you need to replant. They thrive on rich soil, water, room to spread, and not being stepped on. Strawberries do not need grand conceptions, or excuses, or phone bills. They last as long as they can.

Leaving Kat gave me that sinking feeling that everyone says is in the heart or stomach, but is really in your pancreas. It's the same gravitational certainty like when you're lying on a couch at an angle and it's really slippery, and you start sliding off because you're wearing silk pajamas. Kat never wore silk pajamas, and I never slid off the couch, but we could have. We could have been many things.

Right now, I'm a caffeinated fraction of an airport security guard's day, dying a slow boredom death at the Cleveland airport. Outside the terminal, a hazmat crew removes a dirty diaper from the toilet of my connecting flight. In five and a half million hours I will be in San Diego, the victim of ultraviolet onslaughts and Chevron gas prices.

Five months ago I ate strawberries and cereal with Kat, who burps when she orgasms and never notices when milk from her Corn Flakes splashes onto her Buddy Holly glasses. Kat, whose brilliant mind tackles everything sideways. Kat, who I didn't break up with or get dumped by, who faded from my life along with the strawberries I used to grow and pick in the morning when we woke up. We didn't fight or love each other. We just faded away in the geography, while the sinking feeling and the fragrant memory of her strawberry ghost kills me every night and morning that they are gone from me.

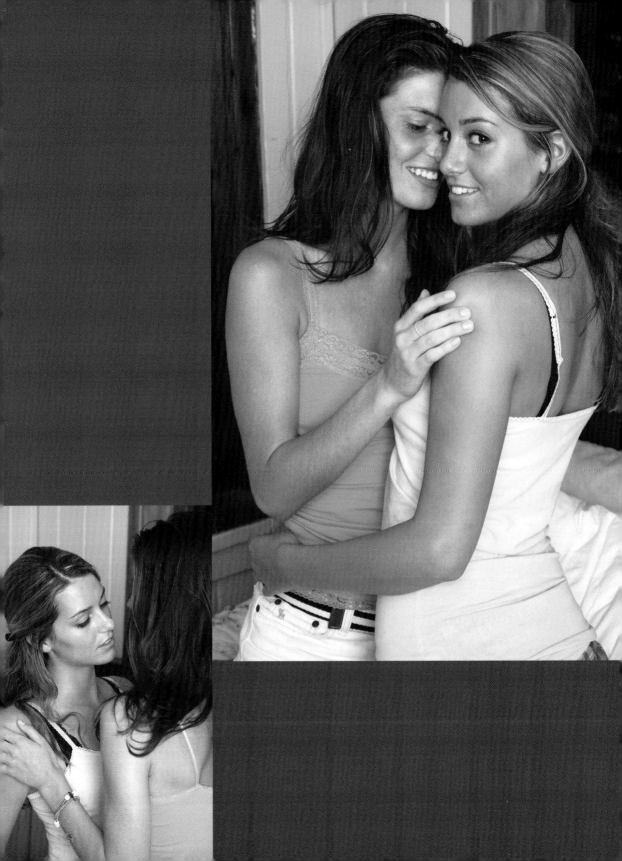

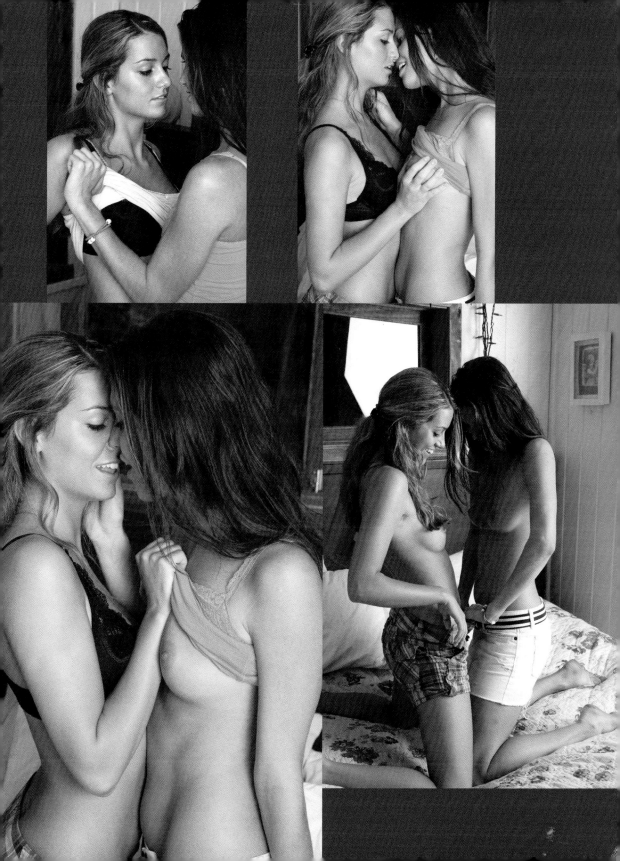

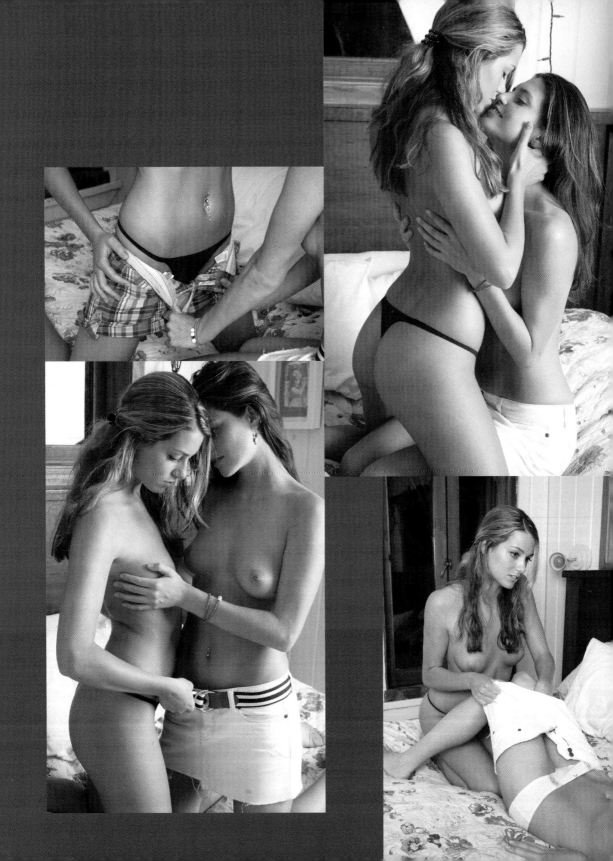

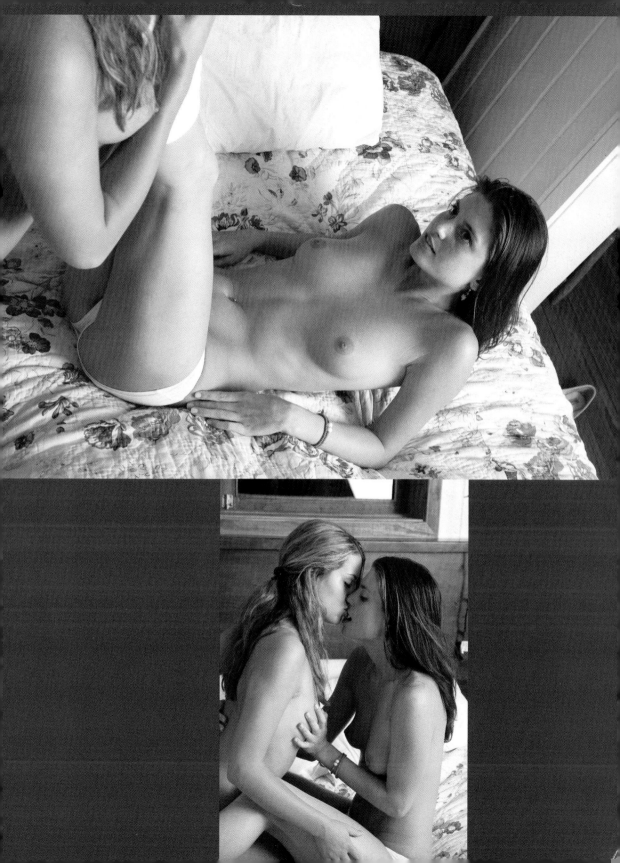

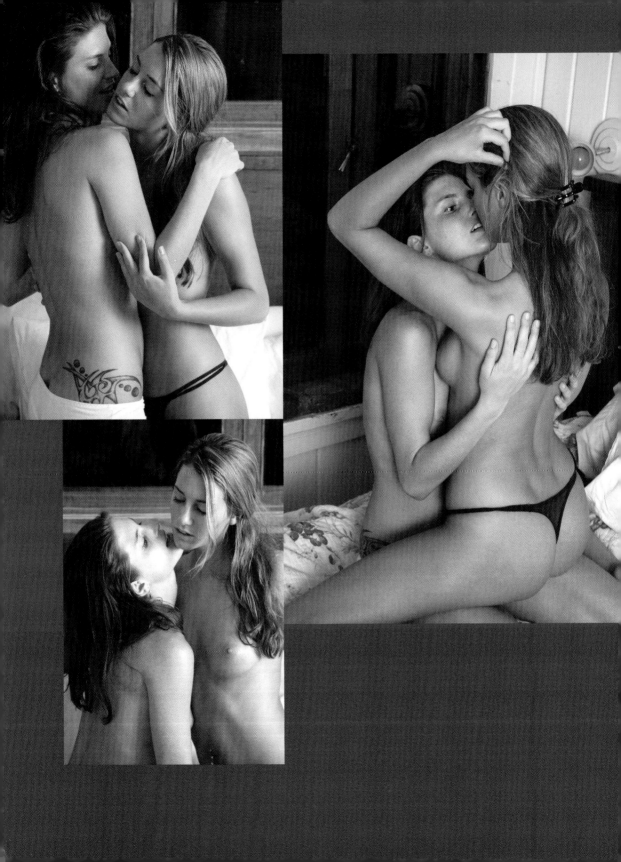

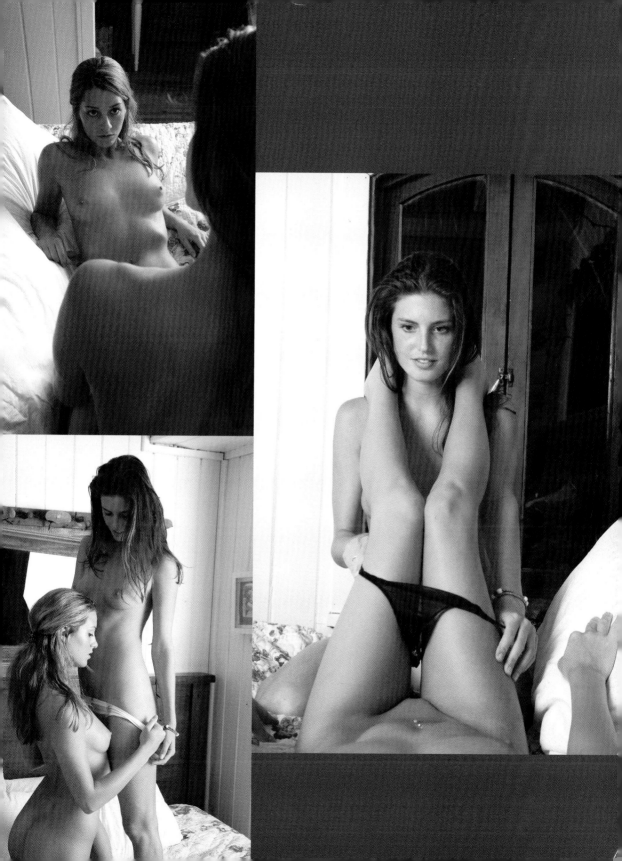

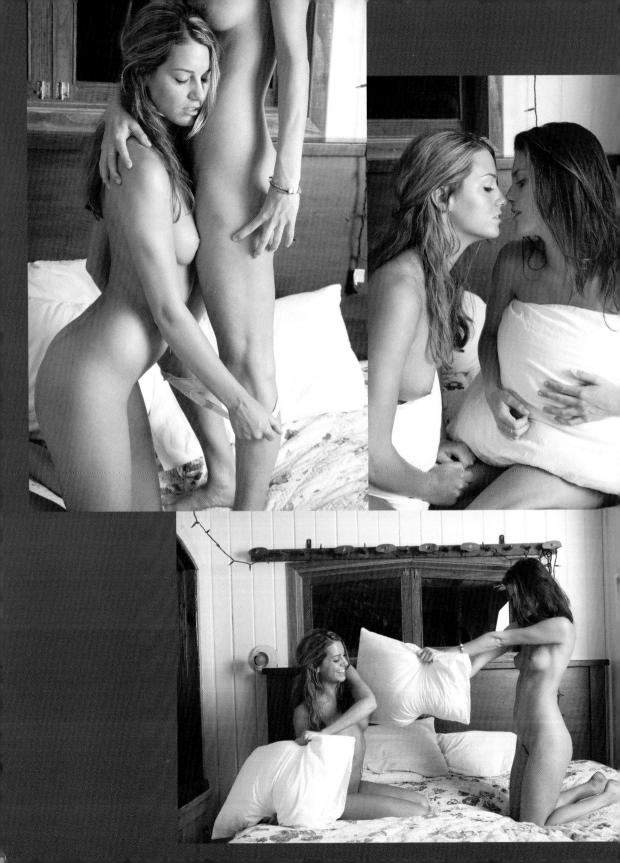

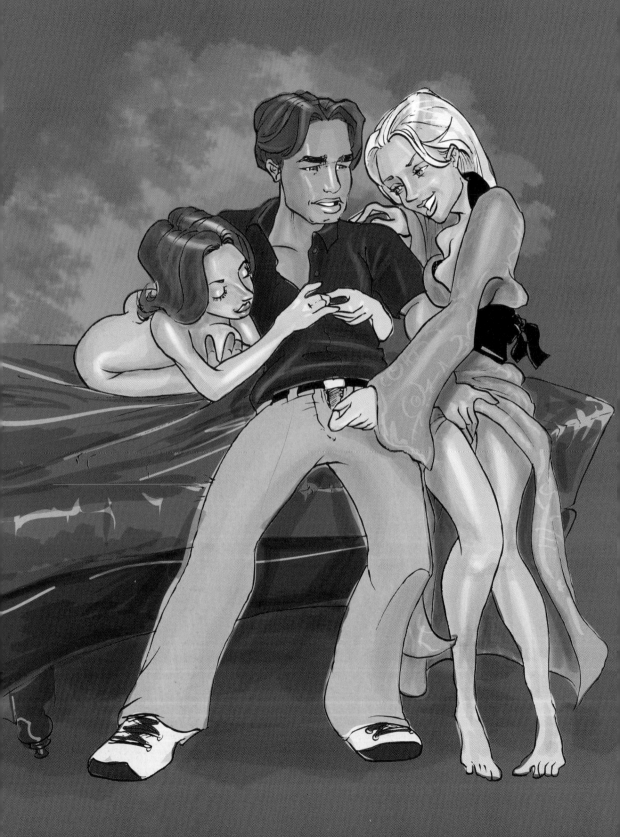

The Wager

by **EVA**
LARGE PRIVATE UNIVERSITY

I'VE JUST STARTED TO GO down on her when there's a knock on the door. Resting my head on Amy's thigh, I look up into her face and we exchange mischievous glances. "Shall I get it?" I ask her. She nods, tugging a sheet around her body in a way that accentuates her nakedness more than it hides it. I grab my crumpled cotton kimono from the floor of our less than tidy apartment in the student ghetto of Boston, don it, and hurriedly tie the sash for the benefit of any watching neighbors—not that I don't have an exhibitionist streak in me, but I prefer to flash people deliberately, not by accident.

Before I can decide whether I should appear eager or seductive I'm pulling the door open and grinning into his face. Hmmm. Suppose eager it is. Grabbing Kyle's arm, I drag him inside and push the door shut with my hip. I kiss him on the mouth, knowing he'll be able to taste Amy on my lips. He looks amused as we pull apart again, our eyes dancing over each others bodies. "You were late, so we started without you," I tell him. He laughs.

I take his hand and lead him to the bedroom where Amy's waiting. He sits on the edge of the bed to kiss her hello. The warmth grows between my thighs as I watch his hands slide over her plump hips, her long auburn hair spilling down her back as she caresses his clean-shaven cheek. They were lovers, once, before I knew them; now they're both mine. I'm quivering with anticipation at the thought of being with them simultaneously, not sure who I'm more excited to share.

As soon as their lips part, I sit next to Kyle and tug on his jacket. "He's wearing far too

many clothes, don't you think?" I raise an eyebrow at Amy.

"Hmm, yes, I agree," she replies with mock seriousness. He lets us have the jacket. Then Amy goes to work on his shirt, while I'm undoing his fly. He's playfully distracting us, fondling Amy's breast, sliding his hand up my thigh, under my robe. We make feminine tsk tsk tsk sounds and giggle. Amy bites his shoulder, and I slide off the bed to pull off his shoes.

> ## His fingers slide between my legs, one bends up to gently penetrate me. I gasp. Amy gasps too; I realize he's done the same to her.

Kyle pretends to struggle as we strip off everything but his underwear, and the beauty of his well-toned muscles distracts me momentarily from the tussle. We're all laughing now as we wrestle, and Kyle is deliberately losing. "I'm being manhandled!" More giggles, and then I climb back on the bed. We sandwich him between us. He puts an arm around each of us and we snuggle close. Amy reaches across him to

tug open the knot holding my sash in place, letting my robe fall open, revealing my breast for Kyle to eye appreciatively. She winks; he grins.

"We want to play a game," Amy tells him, tweaking his nipple. Kyle's fingers pull back my robe, revealing my hip and side.

"Oh, a game," he says. "And how is it played? Something like this?" His fingers slide between my legs, one bends up to gently penetrate me. I gasp. Amy gasps too; I realize he's done the same to her. I tweak his other nipple a bit harder and he yelps.

Amy and I smile at each other. "This game involves a blindfold," I tell him, producing a long, opaque silk scarf from under a pillow and dropping it onto his chest with a flourish. We rub the silk temptingly over his skin, caressing his cheeks, neck, and chest. Our hands run lightly over his hips, still covered by his boxers. I feel the heat as my hand nears his loins. "So do you want to play?" I ask, smiling sweetly.

"How could I say 'no'?" he replies with a curious look in his brown eyes. Amy gives his balls a little encouraging squeeze.

He sits up, and Amy holds the blindfold in place while I tie it. Kyle's hands continue to move over our bodies, and I see his nostrils flare as the scent of our juices reaches his nose. He licks his fingers one at a time, like a little boy surreptitiously eating honey. "So do I get to pin a tail on something? Or maybe just pin some tail?" We laugh and shove him back down on the bed, pinning him by the shoulders instead. After exchanging a knowing look, we simultaneously stick our tongues in his ears. Kyle shudders.

I let my robe slide off and we remove his boxers without further ceremony. Amy and I start to work him over lightly with our mouths and hands, stopping occasionally to caress each other, or to kiss, knowing he'll be able to feel and hear but not see us. My tongue is running over Kyle's skin but I'm focusing on Amy, enjoying our combined power over him, wondering how hard we're going to make him come.

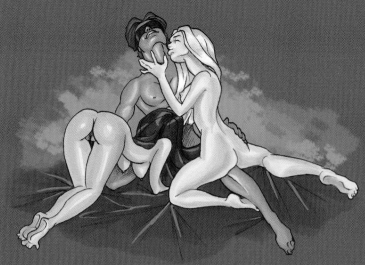

My tongue is running over Kyle's skin but I'm focusing on Amy, enjoying our combined power over him, wondering how hard we're going to make him come.

We migrate down to his thighs and are nibbling at his most delicate parts, licking the soft skin of his cock, tugging at his scrotum, our hands caressing him and also each other. He's grasping, unable to keep his hands to himself, lifting himself off the pillow to reach for our breasts and between our legs. We stop momentarily and I give Amy a wink. Then she bends to barely take the head of his cock in her mouth, and I push him firmly back down onto the pillow. Lowering my mouth to his ear, I tell him softly, "We have a little wager going," and bite his earlobe for emphasis. Behind my back, I hear Amy move, causing Kyle to moan. "We have a bet about whether or not you'll let us tie you up." Amy moves again, and he writhes, momentarily unable to answer. "And if you don't let us," I say a little louder for her benefit, "there's always the old-fashioned way." As I finish my sentence, I straddle him, grab his wrists, and pin them to the bed beneath my legs. I bite his shoulder, neck, and jaw, and then kiss him, thrusting my tongue possessively into his mouth as I feel him lifting his hips.

When I pull back, Kyle says a little breathlessly, "Okay."

I pinch one of his nipples. "Okay what?" I tease.

"You can tie me up," he says.

Lovingly, Amy removes her mouth from his cock and begins to dig in the bag next to the bed. She emerges with a pair of black leather cuffs; lengths of chain with fasteners are already attached to the metal loops. Amy and I kiss as she hands one to me. The cold links drag across his chest, making him shiver. It's short work for the two of us to attach the Velcro, firmly buckle the straps around his wrists, then secure the chains to the legs of the bed. There's an inch or two of slack, and we watch him tug at his bonds, feeling the constricted range of movement.

I enjoy the spectacle of my athletic lover chained to the bed, a faint sheen of sweat beading on his upper lip. Kyle could probably break free if he panicked, but for our purposes he's well and thoroughly caught. Chuckling softly in his ears, Amy and

I let him know he is our prisoner. We each kiss him passionately, and our hands begin moving indiscriminately over exposed skin.

The level of play intensifies as we cover Kyle with tiny bites, pinching him, scratching down his sides, running our hands over his tightening muscles with firm strokes. Soon we're both massaging his stiff cock, moving the foreskin over his swelled head and playing with his balls. I flick my tongue over his head, open my mouth and abruptly thrust him down my throat, then withdraw again using circular motions with my tongue. Amy smiles at me, and I stop to kiss her, taking a moment to tuck her flowing dark hair out of her eyes and behind her ear. It's her

> Soon we're both massaging his stiff cock, moving the foreskin over his swelled head and playing with his balls. I flick my tongue over his head, open my mouth and abruptly thrust him down my throat, then withdraw again using circular motions with my tongue.

turn again. This time I watch intently, not wanting to miss a second of it. Her eyes close; soft lips redden as they close around him. Kyle thrashes repeatedly and tries to thrust, but I am straddling one of his legs and have it lightly pinned down. He moans steadily now.

With both my hands momentarily free, I reach over to the bedside table for the lubricant and coat the middle fingers of my right hand. My knee has already forced his thighs apart, and my fingers slide between them to find the tender bud of his anus. With circular motions, mirroring the movement

of Amy's mouth on his cock, I begin to coax it open, teasing the muscles to relax and let me in. With my free hand, I reach up to rub his chest. "Doing all right, sweetheart?" I ask him. He manages an affirmative grunt just before Amy engulfs his cock again, causing him to cry out in surprise and pleasure. His muscles are relaxing, and I slide my finger in slowly, timing the little pulses of pressure to syncopate with the movement of Amy's hands and mouth. I stroke her hair back from her face again, running my nails lightly over her back. Her eyes open dreamily and smile at me before drifting shut again. Inside him, my fingertip brushes the hard walnut I'm looking for and he moans deeply, pulling at the restraints.

From Kyle's breathing I can tell he's getting close, so I stroke Amy's back and ask her (more for his benefit than for hers), "Should we let him come yet, my dear?" Her mouth releases him for a moment and the rhythm of her hand slows slightly.

"Oh no, I don't think he sounds nearly desperate enough," she says. I raise an eyebrow, as I apply a little more gentle pressure inside him, and he whimpers. Amy and I laugh and then kiss.

"Well, what do you suppose would make him more desperate?" I ask, playing along. Amy's blue eyes are bright with suppressed laughter. She touches

my face, and then runs her hand down my body to tease my vulva. Finding me wet, she leans forward, sliding a finger inside. "Oh, you are so clever," I tell her, and reach across his body and between her legs to reciprocate, one hand now inside her, one inside him.

This proves to be very tricky. We find it difficult to keep a steady rhythm up on him and simultaneously on each other. Soon we're both moaning enthusiastically, while Kyle encourages us, his body jerking. With determined smiles on our faces, she and I compete to see who can go the longest without breaking rhythm. We each try to render the other unable to continue through our mutual manipulation. Until finally, as if on a cue, we both shut our eyes tightly and begin to tremble.

Free from that pleasant distraction, we both turn our attention fully back to Kyle, who is obviously very desperate now. But Amy and I continue to take our time. I take his head in my mouth and tease the shaft with my fingernails. I can sense that Kyle is about ready to crawl out of his skin.

"I think he's ready." I say to Amy, inviting her to do the honors with a gesture. We both smile and exchange one more kiss before she goes down on him again and I slide up toward his face.

When I run my Amy-wet fingers over his lips he sucks on them greedily. I take them away and undo the loose knot of the blindfold, patting the beads of sweat on his forehead dry and pushing back his damp hair. Kyle opens his eyes, the pupils hugely dilated, with a wild look in them. His breath is hot and labored. Ah, beautiful. He's right on the edge of climax. I tilt his head to center his gaze on me. "Feel that?" I ask him. "She wants you to come. Come for us, darling."

He nods and then his face changes and he's gone, his eyes rolling up and squeezing shut, his mouth moving in a cry that's half a whimper as his cum begins to dribble down Amy's chin. I stroke his face and when his convulsions subside, he looks into my eyes again. Very slowly, I withdraw my hand from him and find one of Amy's, squeezing it tightly. As our eyes meet we exchange a look of deep satisfaction.

We snuggle together in the warm bed, recuperating in anticipation of another round. I am beginning to drift off, when I hear Kyle drowsily ask, "So what about that bet? Who won?"

The Mating Rituals of Choches & Sorostitutes

An Anthropological Essay

by **JULIANNA**
STATE UNIVERSITY

THE CHOCH IS A CURIOUS creature, living life one drink special at a time, stalking from bar to club, in search of his prey.

In preparation, he stands before his mirror and contemplates his image while going over a checklist designed to maximize his chances of "scoring":

- Do I smell like Axe body spray?
- Are the ends of my hair still frosted, or do I have to wear a smugly tipped white trucker hat tonight?
- Do I have my pooka shell necklace on?
- Do I feel like wearing a Livestrong bracelet to show that I am trendy, or should I put on the pink breast cancer one to show that I care about women's issues?
- Is my collar popped?

He takes equal care to ensure that when he does score his chances of procreation are negligible. He always carries a condom in his wallet, and sometimes two.

When the Choch has determined he is suitably groomed and accessorized, he will then "blow up the celly(ies)" of his boy(s). Choches are not lone predators. They hunt in packs. At least one pack mate is essential when taking shots, or when there are two or more "hot bitches" in the same bar.

Choches are relatively loyal to their pack mates. Once a Choch-Pack has formed, it can be difficult to separate them unless one member starts getting a noticeably disproportionate amount of female attention. Then, the other Choches will ostracize him, telling themselves and everyone else that he is a "faggot," so they can relieve themselves of the embarrassment and/or self-loathing associated with not being the group's alpha male when it comes to getting laid.

At eleven o'clock, the Hunt typically begins.

The Choch and his mates arrive at the chosen venue. Depending on pack size, they may choose to commandeer a table or go directly to the bar. Either way, a Choch will instinctively order a Vodka and Red Bull. If the pack gets a later start than usual, they may also decide to do a round of "Jägerbombs" (Redbull with a shot of Jägermeister)—guaranteed to "fuck their shit up."

Choches tip according to their income and their server's appearance (ladies) or manliness (dudes). Income level varies from Choch to Choch, depending on employment. Some work their way through school, while others live off parental allowances. Many work at stores typically found in malls, such as Hollister or American Eagle, where they will stare longingly across the way at the Virgin Records, wishing they were Justin Timberlake (who, while a "faggot," probably gets a lot of ass). Other Choches work for their respective fathers. Choches almost never work in the food service industry, and while they will occasionally wear shirts that say "porn star," they never are. This is due in part to the paranoia that shaving their testicles will make them a "faggot."

> Once he is upon her, the Choch will attempt to perform a mating ritual in which he rubs his clothed genitals against the female's clothed buttocks, either in or out of sync with the music.

A Choch with a decent income will tip an attractive female server well, based on the false hope that she will be so impressed with the two dollars he has given her that she will want to engage in sexual relations with him when her shift is over. He will tip a male bartender well if he thinks that it will increase the likelihood of stronger drinks, or even free drinks, should the bartender take a liking to him. The Choch rarely gets what he wants out of a generous tip, aside from the self-gratification that he has done something "sweet."

Once a Choch has been supplied with liquor, he holds it in his left hand, leaving his right hand free to touch the posterior of any female he should pass while relocating from one area of the bar to another. He may also madly gesticulate while speaking to attract attention to himself, or repeatedly shake hands with anyone he has just met.

In any case, the Choch is now ready to pursue potential conquests. The method of pursuit varies according to what the female is doing.

If the female is dancing, it is best to approach her from behind. The Choch is a stealthy predator (unless he is truly intoxicated) and will usually use the "shuffle" method to get near her. By keeping her unaware, he prevents her from spooking and leaving. Once he is upon her, the Choch will attempt to perform a mating ritual in which he rubs his clothed genitals against the female's clothed buttocks, either in or out of sync with the music. If the female responds hesitantly, he may try holding her firmly by the hips to prevent her escape or by offering to purchase her a drink, to prevent her from thinking clearly.

If the female is sitting at a table, the Choch will tell her she is pretty, inquire as to what her name is, and then offer to buy her a drink. If the female says no, the Choch will assume she doesn't drink. If the female says yes, he will consider it an invite to her table where he will try to use a combination of flattery and bragging to win her favor. Common phrases heard from Choches include, "You're the hottest girl in the whole bar," "The only reason you don't like sex is because you haven't had it with me yet," "My dad just bought me a Hummer," and "I'm so totally wasted."

If after three hours of hunting the Choch cannot find a suitable female at the bar to bed, he will take to the streets. Drunk or not, he will attempt to convince random women to go home with him. Looks become unimportant. The Choch will take any woman he can get at this point.

If no female will submit to his desire, he has only a few options:

1. Try the nearest street vendor. Buy a hotdog and pretend it is what he truly wanted all along.
2. Cruise the streets for a hooker that takes debit.
3. Return to his den, attempt to masturbate, pass out instead.

The next day, the Choch will claim to have been "so drunk" he "can't even remember" what happened the night prior, though deep in what passes for his soul, he will know that he is a failure.

An uninformed reader might assume that the Choch never gets what he wants, and that he is in a constant state of disappointment. This is not true. The Choch has a natural mate: the Sorostitute.

The Sorostitute is equally diligent to ensure that she is fully prepared for the evening ritual. She must inspect her fake tan for fading and streaks. She must try on several different outfits which usually consist of some combination of the following items: sequined tank or tube tops paired with short, cloth pleated skirts, tight-fitting white pants, or low-rise jeans. Once the Sorostitute has selected the clothing ensemble that will best accentuate her figure, she will then adorn herself with dangling earrings and jewelry marked with her name (this conveniently serves as a nametag for any Choch who may be too intoxicated to remember it). Sorostitutes usually wear heels too high to comfortably walk in, giving the Choch an advantage. After two to four Appletinis, the Choch can pretend to be a gentleman by helping her remain upright while in public. Before leaving her habitat, a Sorostitute will insert cash into her brassiere, though she has no real intention of using it.

Like the Choch, the Sorostitute is not an independent creature. From pre-game to last call, the Sorostitute moves with a herd of "sisters". A Sorostitute can take comfort in the compliments her sister will pay her, and also in the knowledge that a given sister is fatter or has smaller breasts than her. The herd's membership is constantly shifting as Sorostitutes generally change their preferred sister at least bi-weekly. Two Sorostitutes who have decided they value each other over all others are called Best Friends Forever, often abbreviated BFF. But because Sorostitutes are fickle creatures and prone to change their minds as often as they do their outfits just before to going out to the club, the term "forever" in Sorostitute-vernacular means about fifteen days.

Sorostitute herds often arrive at the club later than Choch packs; Sorostitutes, after all, are weary

from a full day of grazing at the mall and need more time to rest and recuperate. But once they are in the house, the mating game begins in earnest.

While Choches and Sorostitutes may have similar goals, the later has an expanded agenda. She is not only looking for someone with whom to engage in the ritual act of "making out"; she is also looking for someone to purchase all of the drinks for her (and perhaps for her sisters too). To aid in this pursuit, Sorostitutes have learned from reality TV the power of being a Fake Lesbian.

Fake Lesbians are not to be confused with Real Lesbians. They will only engage in kissing, light breast fondling, and gratuitous dry humping with other women in public and then only in the company of men whom they would like to manipulate. Fake Lesbians understand that their actions will make them appear edgy and sexually adventurous to men. A Fake Lesbian in Training (FLIT) will enter a single-facility restroom with a sister and giggle loudly to give the impression of erotic behavior behind closed doors, when in actuality the two will be fixing their hair and situating their breasts into a more ostensible position. A Fake Lesbian will never engage in girl-on-girl play in private, but will be prepared with stories that suggest the opposite.

After only a few cocktails or a couple shots, the Sorostitute becomes "totally wasted" and begins acting in a conspicuous and boisterous manner. She will sing along to the songs on the jukebox and demand that everyone in the bar "pour some sugar" on her. She will drop her purse and cell phone, and while she basks in the attention everyone is giving her, she will ask for another drink. This is a trick. Sorostitutes will always act more inebriated than they truly are to give the Choch the impression that they are not usually that easy.

Once the Sorostitute has sipped her fill, she will likely try to lure a partner onto the dance floor. A Sorostitute has within her arsenal a series of moves that Choches are unlikely to be able to resist, assuming that they would ever want to. These moves include, but are not limited to, the following:

1. Moving her posterior in a swaying motion, either solo or against another female.
2. Cupping her breasts with her hands.
3. Simulating masturbation or using her hands to otherwise draw attention towards her vagina.
4. Tussling her hair with her hands as though she were in the shower.
5. Bending her knees and sashaying her hips, moving as low to the floor as possible, then with one hand on the dance floor for balance and the other extended skyward, repeatedly thrusting her pelvic region into the air.

At this point, a Choch may safely use the aforementioned "shuffle" and the game will advance. As the Choch rubs his clothed genitals against the Sorostitute's buttocks, the stimulation will cause him to become aroused. The Sorostitute's carefully chosen, thin and tight outfit will enable her to feel his growing erection. The sexual tension builds as the Choch and Sorostitute move beyond the capture and focus on the actual mating. Their ultimate ability to actually copulate is usually determined by last call.

If one party is so drunk as to vomit or pass out, their ultimate success is unlikely but not impossible.

If the Sorostitute's sisters become jealous, they may intervene with a common practice referred to as "cockblocking." Similarly if the Sorostitute believes that the Choch has flirted with any of her sisters (or anyone else for that matter) over the course of the evening, she may get jealous and decide to withhold the goods to punish the Choch for his disloyalty. Barring these unfortunate circumstances, odds are good that they will "fuck."

Once the lights are on, the alcohol stops flowing, and the music ends, the rest seems anticlimactic. Wherever the final step of the ritual occurs—the backseat of the Choch's car, in a dorm room, in an apartment, or in the alleyway outside the club—the actual act of intercourse always proceeds more or less in the same fashion. Following penetration, the liquor in both parties will render them unable to truly appreciate the act and will prevent the Choch from Human Beings, which leads to an evolutionary dead end. Additionally, Choches and Sorostitutes are inherently dissatisfied, and have a biological imperative to

> If the Sorostitute's sisters become jealous, they may intervene with a common practice referred to as "cockblocking."

holding out long enough for mutual satisfaction. Once the Choch has ejaculated into the condom, the night is over. But this inevitability doesn't bother the Sorostitute too much. She secretly knows that she can only orgasm after masturbating for at least forty-five minutes, anyway. Not to mention the fact that she prides herself on her ability to convincingly fake it. In any case, the two may exchange phone numbers with the intent to contact one another for future interludes, but the likelihood of a reconnect is low.

It is evident that Choches and Sorostitutes are indeed genetically well suited for each other. But that does not necessarily ensure the survival of the respective species. While the two are compatible, they are not always immediately recognizable to each other and will occasionally make the mistake of attempting to mate with continually pursue anyone who is more attractive, richer, or simply different from their current mate. The lack of emotional connection involved with their physical interaction further hinders their abilities to stay with any one partner. The paradox seems to be that even when their mating ritual successfully meets their expectations, it is still a failure.

But before you write them off for extinction, don't forget that all creatures have the ability to evolve and adapt. After all, cockroaches have survived for millions of years and there's always next Thirsty Thursday.

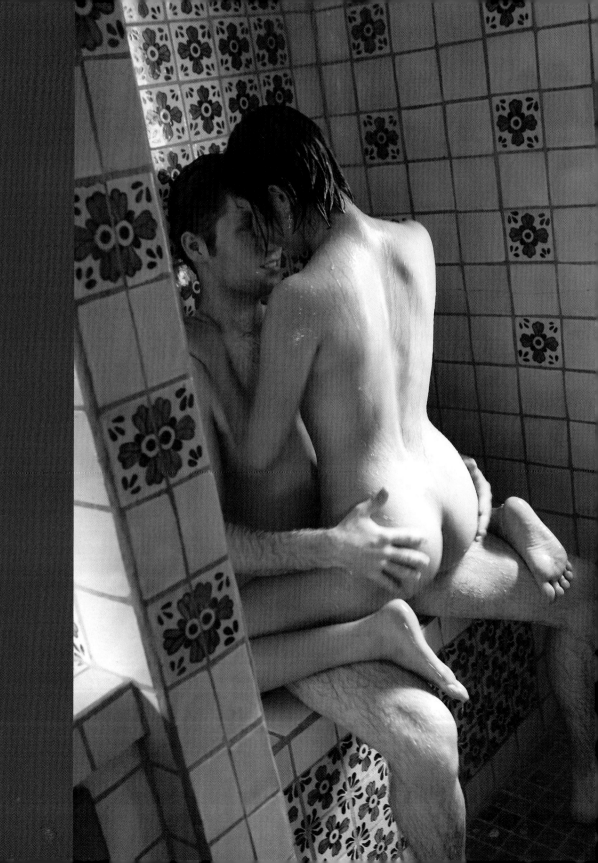

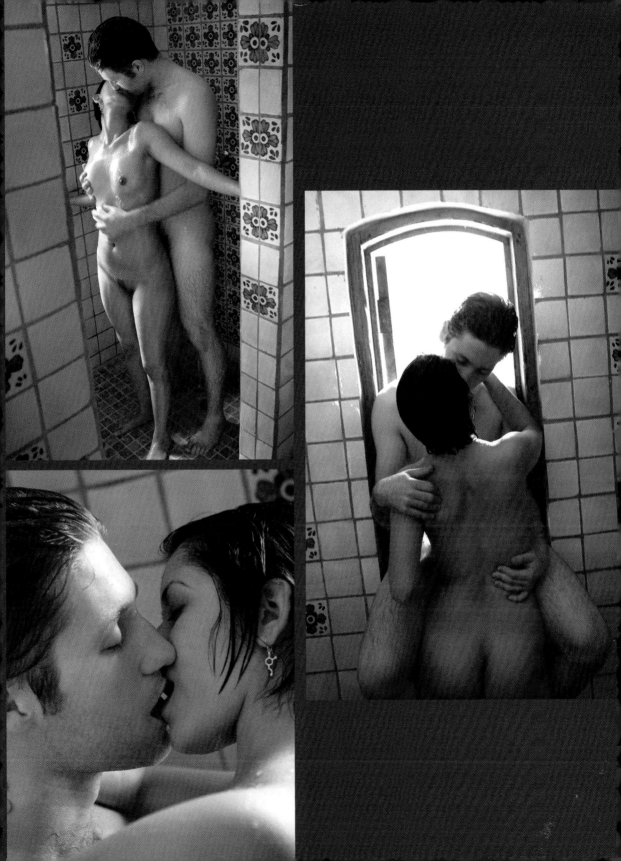

Virginity, or Lack Thereof

by **CHRIS**
LARGE PRIVATE UNIVERSITY

OKAY, I ADMIT IT—I'M A VIRGIN. I've been this way for nineteen years, and you know what? I've finally acclimated to the status. I'm actually okay with it. It all started one sunny spring day back in March, 1987.

I was born a healthy, plump, little virgin. Fast-forward nine years to 1996—hey, look, still a virgin! Everyone around me is too! This is great. Girls have cooties and boys rule. Fast-forward another nine years—virginity still in full bloom but my hormones are raging. I'm a college freshman and all of a sudden, my virgin status is some kind of a big deal. It came up casually enough, freshman roommates getting to know each other.

"Got a girlfriend?" I asked.

"Yeah, actually she's coming up this weekend, so you'll be able to meet her then. Oh, it would be great if you could make yourself scarce after you meet her."

"What for?" I asked naïvely.

He smiled. "Why? So I can fuck the shit out of her, of course." Fuck the shit out of her. I remember those words well—they would stick with me throughout the year. He actually talked like that and was serious.

"You've had sex?" I inquired.

"Of course. You mean you haven't?" He started laughing at that point. "Oh, I'm sorry man, that's cool, dude," he managed to choke out.

I've hated him ever since. I was hoping that he was an exception, one of the few guys around who had actually gotten laid. I started asking other guys in my hall as casually as I could if they had done the deed.

My growing obsession with sex reached beyond my consciousness—even my dreams were becoming more and more perverse. As the days went on, sex literally consumed my mind.

To my surprise and disappointment, they all had or (intelligently) lied about it. Even the geekiest of geeks said he had sex once with some chick he met at a sci-fi convention. She was probably a hooker, I thought, but still couldn't get over the fact that even he had sex.

It's not that I'm a freak show, a caveman, or even Sideshow Bob (though we happen to share the hairstyle). I'm just a normal guy, someone you might call "good-looking" or "cute," but certainly not "handsome" or "gorgeous." My roommate and I came from different worlds. Him: New Jersey or something. Me: a Boston suburb. He grew up playing football and drinking beer, I grew up playing Frisbee and watching movies. He grew up doing whatever and whomever he pleased, I grew up awkwardly. It's not that I haven't even kissed a girl before, far from it. It's just that I was never able to coax them into going all the way. High school chicks from my town were prudes, not many guys were able to get lucky. By that time, girls didn't have cooties anymore, but they sure as hell weren't putting out. They were always full of excuses:

"Is that all you want from me?"

"I'm way too worried about getting pregnant."

"I thought our love was greater than that."

And the inevitable, "I want to wait until marriage."

College was a whole different ballgame. I became the minority and began hating myself because of it. I started to doubt all my past actions, or lack thereof. I thought that maybe if I had egged so-and-so on a little bit more, she would have eventually opened wide. Maybe if I had gone to more parties, ended some of those longer pointless relationships, hung out with a different crowd, then I could have gotten laid. These thoughts consumed me throughout that entire year.

That weekend I met my roommate's girlfriend. She was beautiful. I had been falling in love with every girl I met that week; they were like candy to a diabetic: delicious but terrifying. The campus was full of hot girls still dressed in summer apparel. I

walked around with a perpetual boner. But I was always too shy or scared of rejection to go talk to them (this was a recurring theme). Anyway, I quickly picked up on my roommate's signal that it was time to leave. The question was, what was I to do on a lackluster Tuesday night? As I walked down to the lobby, I resolved to spend every waking moment outside of class dedicated to losing my virginity.

My growing obsession with sex reached beyond my consciousness—even my dreams were becoming more and more perverse. As the days went on, sex literally consumed my mind. I couldn't concentrate in class, couldn't do my homework. I became so desperate that I quickly began to lower my standards. If any girl had made the smallest advance, I would have been all over it.

As it turned out, I was to be sexiled from my dorm room on a regular basis, and not just because he was with his girlfriend either. He was banging all sorts of attractive girls (of course, I fell in love with them all). The situations did have some perks though—there were always girls in our room, some of whom he was just friends with. Being surrounded by women casually makes it easier to get to know them and to flirt. I got to know one girl particularly well, a redhead named Catherine. She wasn't exactly beautiful, but I found her attractive enough. At first she seemed relatively smart and a lot more interesting than most of the other girls my roommate hung around. Part of me felt I could do better but, well, you know.

Unfortunately it didn't work out. The more we talked, the more I realized that she wasn't that interesting after all. In fact, I decided she was particularly vapid, which is probably why she was hanging around my roommate in the first place. More to the point, she didn't want to put out. At least, not for me. She admitted that she wasn't a virgin (no surprise there), but didn't want to fuck the first college guy she met who was just looking for some ass. I never told her I was a virgin. I lied and

told her how much she meant to me, how I loved her, how much it would mean to me. She said she wanted to wait until she felt ready, which was probably never. I kept on nagging and eventually it became clear to her that all I wanted out of her was sex. She broke it off after a tepid three months and I was eager to move on and to find someone more willing.

I decided to move further down the food chain and IQ scale. I picked one who I thought would be the most likely to give it up: her name was Laura. I always thought that name sounded particularly slutty. How wrong I was. I didn't exactly have much experience with one-night stands or sluts in general, but apparently, they aren't as plentiful in real life as

they are in movies. Maybe I was unlucky, or she just didn't want to have sex with me for some reason, but once again my hopes of losing my virginity were crushed. Things started off with promise: we managed to do more in one night than I'd done with Catherine in three months. But when I felt it was the right time and grabbed a condom, she shot me an icy look and shook her head no, saying "I don't think so." We sat in the dark for a while, listless and naked. Eventually she put on her clothes and slipped away. I still had the condom in my hand.

Eventually spring rolled around, and things still weren't exactly going my way. I wasn't getting any closer to my goal, so I decided I needed to step up my game. I started drinking heavily. It wasn't that I particularly enjoyed

the taste of alcohol, but the benefits of being drunk outweighed the drawbacks. I found myself much looser and eagerly flirting with all sorts of girls who I had been too shy to approach. They miraculously became much more interesting and fun, not to mention more attractive.

One particular night I was wasted and found myself in bed with (what I thought was) a hot little blonde. The alcohol was fueling my sexual desires and I was rabid to lose my virginity by this point. There was only one problem—I wasn't hard. I couldn't get it up no matter what I did. Ordinarily I would have to think of wrinkly old men and cold showers just to keep myself from coming, but this time was different. Something was wrong; my penis was smaller than ever. I had to keep my underwear on out of sheer embarrassment. That's when I learned one of the major pitfalls of drinking, as keenly observed in the song "Too Drunk to Fuck" by the Dead Kennedys. I'm surprised I even remember the night at all. The girl's name was Hailey, and by the time I had sobered up in the morning, her appearance had radically changed (the only thing I'd gotten right was the hair color). However, she was one of the sluts at school that would have put out for me. How fucking ironic—the one time the gates opened, I was too blind drunk to get through them. I had hoped that the more I drank the easier it would be. Instead I spent many nights hugging a toilet instead of a girl.

I finally smartened up. I started drinking much less and encouraging the girls to drink more. It was nearing the end of my freshman year and I still hadn't gotten laid. I was getting more and more desperate by the day. Most of the girls I hit on sensed my desperation and stayed away from me—except for one. Her name was Katie. She kept introducing herself to me and I kept forgetting her name. This may sound harsh, but she was the epitome of unattractive. She was a chubby brunette whose personal hygiene left a lot to be desired. I really wasn't attracted to her; but I decided I'd had enough of this bullshit.

One particular night I was wasted and found myself in bed with (what I thought was) a hot little blonde. The alcohol was fueling my sexual desires and I was rabid to lose my virginity by this point. There was only one problem—I wasn't hard. I couldn't get it up no matter what I did.

I didn't even have to get her drunk. I didn't have to take her out to dinner or to the movies. Truth be told, I didn't want to be seen with her at all in public. She claimed she was "in love" with me and "would do anything" to prove her love. I was far from in love with her, but I lied. It was a warm Thursday night, my roommate was out drinking. I was a little drunk myself—I had to be if I was going to go through with this. She arrived early and, to my surprise, it seemed she had showered. I got right down to business. She squealed like a pig when I got out a condom. Then she smiled and whispered to me, "It's my first time." Of course, I didn't admit it was mine too. I got the condom on with a bit of a struggle and tried to put my dick in her, but it didn't want to go in. The thought of failing at this with Katie nearly made my head explode. I kept trying and she soon piped in with "Maybe we're not ready." At that point, I was absolutely determined to lose my virginity then and there. I blocked out all thoughts from my mind except that of my penis in her vagina. I tried again and again, each time getting a little deeper. Eventually it just slid all the way in, and I sighed with triumphant relief. A few thrusts were all it took before I came. I had done it! I had lost my virginity—I was pumped. I got up feeling all proud then I looked down at her face. She was crying.

I began to feel bad. I figured losing my virginity would unlock something deep down inside of me; that it would immediately change me for the better. But I hadn't changed at all, except for a horrible regret that was building up inside of me. I shouldn't have used Katie like that. I felt absolutely terrible for trying to take advantage of her and all those women. I was sure that they all said I was an asshole. And to be honest with myself, I was an asshole—nobody deserves to be treated like that.

Remember earlier when I said I was a virgin? I lied—I only wish I still were.

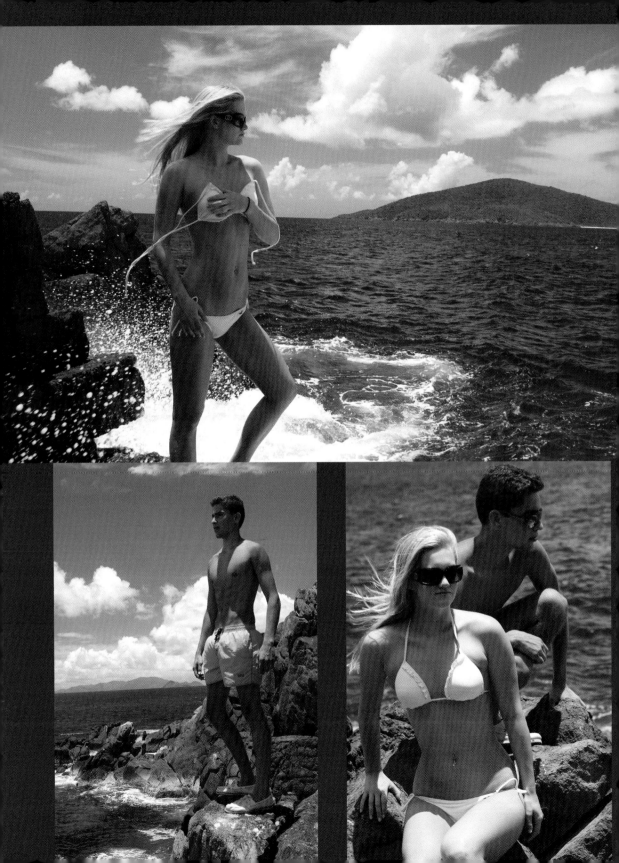

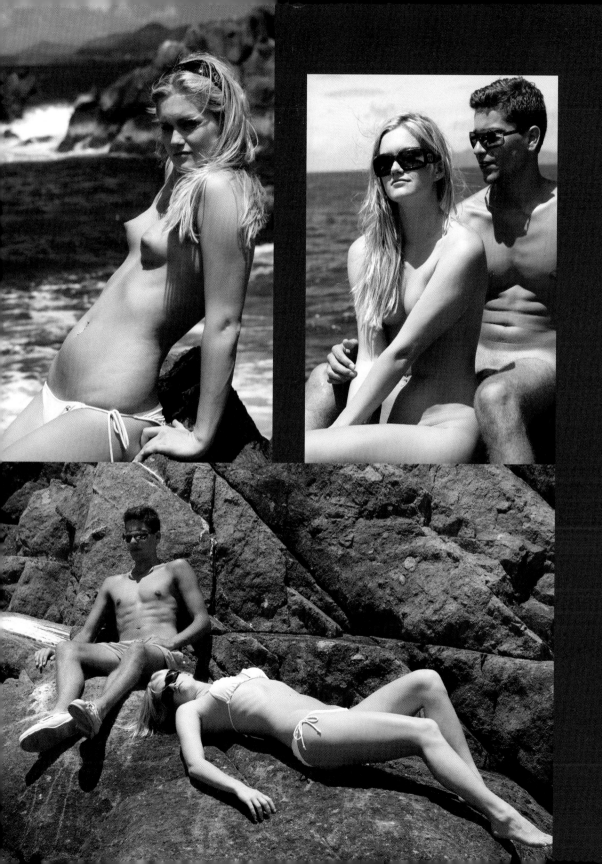

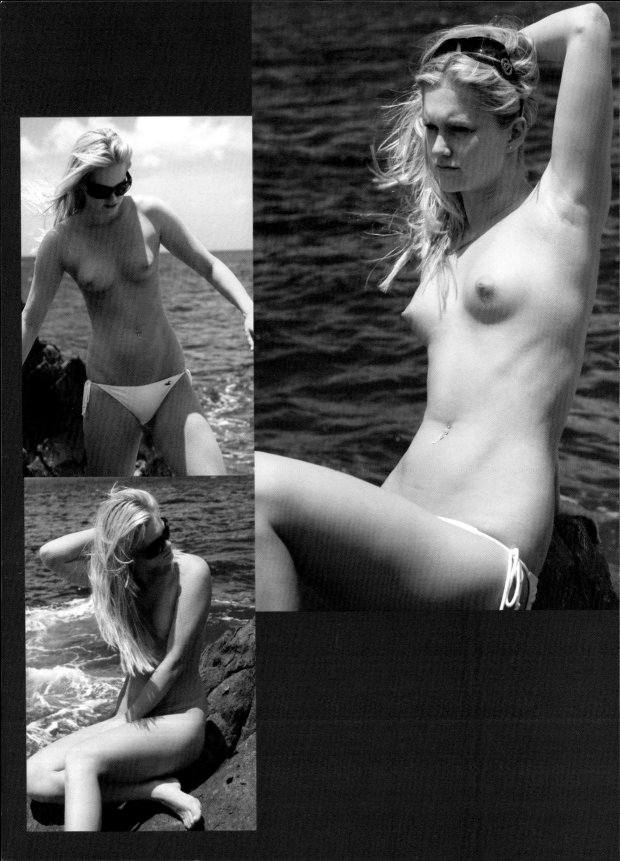

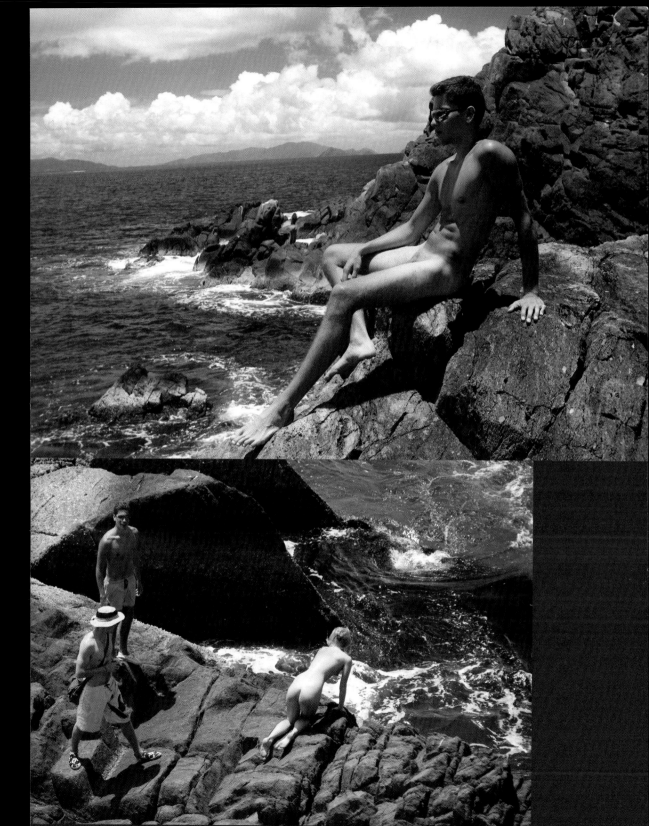

Two Drinks Away

by **ELIZABETH**
STATE COLLEGE

JULIE WAS HAVING an affair with a forty-two-year-old married man.

David was Julie's boss at NyaFocus, the downtown production company where she was serving her fall internship.

He was forty-two years old.

He was successful.

He was blessed with three children, two maids and a mansion in the suburbs of Boston.

And, he was married.

Julie was an aspiring filmmaker in her sophomore year.

She loved sex.

She loved drugs.

She loved the fact that she was having an affair with a married man.

"He started hitting on me my first day there," Julie told her lover Allison. "He was saying shit like 'I want to take you into the bathroom'".

"What did you do?" Allison asked.

"I said, well, can you buy me alcohol? Alright then."

"Cool."

"It worked out well," Julie said. "He bought me alcohol and I fucked him."

Julie and David had sex in his office, in his Mercedes, in the aforementioned bathroom, in the Boston Common (once, when very drunk), in hotel suites, and in her dorm room.

"The sex is OK," Julie said, while rolling a spliff. "But the sexual circumstances are fabulous."

"What do you mean?" Allison asked.

> She loved sex.
> She loved drugs.
> She loved the fact that she was having an affair with a married man.

What Julie meant was that the physical pleasure derived from the sex act with David was average. Maybe even below average. That he was married was what really got her wet.

"I like to think about his wife while he's inside me," she said.

> Julie was known to get ridiculously drunk at parties, pull the nearest guy into the bathroom and subject him to expert fellatio.

"He has a picture of her in his office. It's so hot to think about her making his dinner while he's fucking my cunt."

"You are an evil bitch," Allison sighed.

Allison was a lesbian.

I'm talking field hockey coach lesbian.

I'm talking activist lesbian.

I'm talking, "It's cool, I live in Massachusetts, I can get married" lesbian.

She was also an aspiring filmmaker in her junior year.

She loved sex.

She loved drugs.

She loved the fact that she was sleeping with a girl all the boys wanted to sleep with.

Julie, of course, was not a lesbian. She was "just playing" and "doing the college thing." She enjoyed the scandalous aura that sex with girls added to her already illustrious reputation.

Julie was known to get ridiculously drunk at parties, pull the nearest guy into the bathroom and subject him to expert fellatio. She was known to pick up guys on the subway, bring them back to her dorm and fuck them senseless. Essentially, she was known as a slut.

Julie was also known for lusting after the female form, from images in films and magazines to the real thing at bars and clubs. She had an impressive collection of pornography. She thought nothing of dropping hundreds of David's dollars on lap dances. She would flip through romance novels looking for lurid descriptions of a woman's sex.

"At any given time," Julie was fond of saying, "Every girl here is two drinks away from girl on girl action."

Allison realized she had a serious problem.

She was falling in love with Julie.

"I always fall for the bad girls," she told her therapist.

"Why do you think that is?" her therapist had asked her.

"I don't know, I guess...they just draw me in," she said. "I'm falling pretty hard for this little slut. I'd better find something to break my fall before she breaks my heart."

Allison hated going to campus parties.

She always felt like everyone was staring at her and thinking...DYKE. Allison "looked straight" but she couldn't shake this insecurity. She only went to these parties so she could seduce Julie. She preferred taking Julie to gay clubs or, even better, just hanging out with Julie at her apartment. But, when in Rome and all. If Allison wanted to sleep with Julie, and Julie wanted to go to a party, then party it was.

"I really want him to fuck me in his house," Julie told Allison while they knocked back shots of vodka at a party.

"David?"

"Yes," Julie said. "I want him to take me in his bed while that fat bitch wife of his is taking his children to the aquarium, or whatever the fuck it is she does."

"You don't feel bad for her?"

"Survey says....um...no."

"Even though she's a fellow woman... or whatever?"

"Hey, if she was taking care of business, I'd be out of business."

"You are an evil bitch."

At some point Allison lost track of Julie. Probably going down on some guy in the bathroom, she thought. Then she took another shot of vodka.

Julie was indeed going down on some guy in the bathroom. She had identified him as an "adorable cutie" and moved in to chat him up. Next thing the guy knew she was pulling him into the bathroom and rendering him unable to speak (metaphorically) while rendering herself unable to speak (literally).

Julie stumbled out of the bathroom in need of a chaser. She grabbed a bottle of rum and took a long and refreshing drag from it. Then she went in search of another adorable cutie. What she found was a "real fucking dork." This guy was short and fat. He had narrow eyes and a long, crooked nose. His teeth were crowded and his voice was "real fucking gay."

No worries. Julie got off on turning guys on, no matter how much their appearance turned her off. There were limits to how "fucked up" a guy could look and still get some play, but the bar was set pretty low.

Julie dragged the guy into an upstairs bedroom. She laid herself on an accommodating bed and spread her legs. It should come as no surprise, she wasn't wearing any panties.

What happened next wasn't subtle. The dork got down on his knees and got licking. He was nervous and his technique wasn't the best but it did the job. Julie climaxed, snapped her legs shut, stood up and waltzed out of the room.

"I'll let anyone give me head," she was fond of saying.

Allison eventually found Julie in the bathroom, on her knees, but this time vomiting into the toilet.

"Oh baby," Allison sighed, holding Julie's abundant blond hair back while she spewed raw vodka/rum/stomach acid into the porcelain bowl.

One thing Julie liked about Allison was that Allison always took care of her when she got too drunk, which was a pretty frequent thing. There were plenty of guys that were willing to take care of her but they were also a little too inclined to "take care of her" once they got her home.

"I hate waking up all hungover and then realizing I've been fucked in the ass," Julie had told Allison.

Allison walked Julie home and helped her drink a glass of water. Then she brought her into her dorm room and helped her sit on her bed. Allison unlaced Julie's knee-high boots and pulled them off. She pulled Julie's socks and

Julie said. "I want him to take me in his bed while that fat bitch wife of his is taking his children to the aquarium, or whatever the fuck it is she does."

skirt off, frowning at the lack of panties.

Allison helped Julie slip on some pajama pants. Then she unbuttoned Julie's shirt and pulled it off. She pulled off the skimpy t-shirt underneath and unsnapped Julie's bra.

Julie's voluptuous breasts weren't the only things exposed.

A folded up piece of paper fell on the bed.

Allison unfolded it.

It was a note with a phone number and the message: *Call me, David.*

"Motherfucker," Allison said as she tore it up.

She munched two Vicodins, cuddled up with Julie and passed out.

A week later Allison was at another party, knocking back more shots of vodka with Julie and hoping she would get a chance to get in Julie's pants. And then Nikki walked into the kitchen and poured herself a shot of vodka.

Nikki was also an aspiring filmmaker in her freshman year.

She loved sex.

She loved drugs.

She loved the fact that she was young, single and drunk.

"I love your skirt," Julie told Nikki. "And that total cleavage shirt. You have the same problem I do."

"This is my special shirt," Nikki smiled. "I wear it when I want to meet new friends. It draws them to me."

"I do feel drawn in," Allison said.

"Me too," Julie laughed. "But I don't know if it's the skirt or what's beneath it."

"Matching panties?" Allison laughed.

"How do you know I'm even wearing panties?" Nikki asked her.

"I never do," Julie said, tilting her head and knocking back another shot of vodka.

"I know," Allison sighed, waves of jealously crashing down on her.

"Are you two…together?" Nikki asked.

"Well, we are standing next to each other," Julie smiled.

Julie waltzed off in search of an adorable cutie.

Allison got over her jealousy and continued to chat up Nikki.

"You should hang out with us sometime," she said at the end of the conversation. "We are very fun girls."

"You seem pretty fun."

"I want her all to myself," Julie told Allison the following afternoon as they ate breakfast and recovered from vicious hangovers. "I don't want to share."

"Well, I got her number," Allison smiled. "So it would be me that shares with you."

"Fine," Julie said, rubbing her temples. "Set that up. My fucking head is killing me."

Allison passed her a Vicodin and she munched it up.

Allison called Nikki a few days later and set up a date for Saturday night.

"Don't go verbal," Allison told Julie as they lay in bed Saturday afternoon, fondling each other and discussing the impending seduction of Nikki.

"What the fuck does that mean?" Julie asked her.

What Allison meant by "going verbal" was what a drunk frat boy does when he goes to put his hand down a girl's pants and she grabs his wrist and pulls him away. He starts arguing with her about why she should let him sleep with her. Completely and utterly pathetic. Barbaric. Low class.

You never go verbal. If a girl blocks your march into her pants you move your hand back to her breasts (which you had better have freed before making a move on her pants), make out with her for another 10 minutes and then try again.

You don't miss a beat.

You don't go verbal.

"Don't worry about me," Julie said as she brought Allison to a shuddering climax. "I know what I'm doing."

Julie, it turned out, did not know what she was doing.

That night, as the three underage girls sipped mixed drinks at the bar (courtesy of Julie having slept with the bouncer), Julie ran her hand up Nikki's back and began giving her a sensual neck rub. Allison watched the discomfort manifest on Nikki's face.

Goddamn it, Julie, she thought.

Nikki excused herself and went to the bathroom.

"You're going to scare her off," Allison said. "Stop touching her."

"Whatever," Julie huffed.

Allison walked after Nikki.

"I'm sorry Julie is so touchy tonight," she told her as they stood in line for the bathroom.

"What are your two...intentions for me?" Nikki asked.

"We just want to get you back to my apartment and play with you," Allison told her.

"That's cool," Nikki said. "My most important rule is that no one dies. And I don't want to have sex tonight."

"Of course not, sweetie," Allison told her. "Whatever you want."

Allison knew women. She understood that a woman is capable of changing her mind hundreds of times in one evening. Guys never understood that. If Nikki told some guy she didn't

feel like having sex it would probably put him in a bad mood. The guy might even go verbal. Allison knew all she had to do was play it cool and to wait for Nikki to change her mind.

Nikki loosened up after a few more drinks and on the subway ride to Allison's apartment started kissing Julie. Allison felt electric jealousy surge through her body and hoped she wouldn't get kicked out of the mix.

Thank God we're going to my apartment, she thought.

At the apartment Allison poured them all a gin & tonic while Julie rolled a spliff. As they took seats on the leather couch in Allison's living room Nikki accepted the drink but declined the spliff.

"I was a total stoner back in high school," she said. "It was like, everywhere you went someone was handing you a joint. I actually came to Boston to get away from marijuana."

"That's ridiculous," Julie told her. "Boston is like…one of the best weed cities in the…world."

"I know," Nikki sighed. "Anyway, I don't really like spliffs."

"The spliff is great," Julie said. "You get the THC and the nicotine all at once. Then you smoke a cigarette and get more nicotine. Then you finish your drink."

"Nikki, I can't believe you were corrupting Julie on the subway," Allison said.

"Yes, I do feel very corrupted," Julie agreed. "I think maybe you should corrupt me some more."

"I'm not as innocent as I look," Nikki said.

"No, you're not, are you?" Julie laughed. "You're wicked. Very, very wicked."

"Pills, anyone?" Allison offered, opening her purse and taking out bottles.

"Vicodin," Julie told her, pausing to toke in on the spliff. "My knees hurt."

"Vicodin it is," Allison said, handing her one.

"I'm all set," Nikki declined. "I've never been into prescription drugs. I've been all about cocaine lately for some reason."

"Cocaine is a fun time," Julie said after she munched up the Vicodin, chased it down with gin & tonic and inhaled on the spliff. "But Vicodin really chills you out. I was never into it or whatever and then one day I wake up all hungover after this party and my ass is killing me. This fucking guy went and fucked me in the ass, totally took advantage. Rape, basically. Allison came through with her little bag of pills."

"Fucking men," Allison hissed. "Do you realize one in five women will experience rape during college?"

"Savages, I know," Julie laughed. "I still fucking love them."

Allison sighed and waited for the underwater peace of the Vicodin to kick in. All she wanted to do was climb into bed with Julie and hold her.

She wanted to gently kiss Julie's mouth and run her hands over Julie's smooth skin.

She wanted to take a long, hot, stoner bath with Julie and wash her long, blond hair.

She wanted to paint Julie's finger nails purple and her toe nails pink.

She wanted to work her hand between Julie's legs and feel her heat.

She wanted to tell Julie all about how fat she was when she was fourteen, how her parents took her to medical specialists who proceeded to weigh her on a scale normally reserved for animals, the look of disgust her mother had on her face when she watched her own daughter eat, about binging in her room, forcing herself to vomit, her fingers fucking her throat, like giving a blowjob, yeah, she used to do that.

She wanted to tell Julie about the hospital stays, the feeding tubes, the family therapy session where her father looked down at the ground and said, "What do you do when you feel like you don't love your daughter anymore?" the treatment facility where she finally got herself back on track, the first girl she slept with…

For the first time all evening Allison began to feel turned on. She grasped onto Nikki's breasts like she was grasping for a lifeboat while tossing about on a deep and dark ocean night. Nikki unbuttoned Allison's jeans, unzipped them and shoved her hand down into her feminine chaos.

She wanted a hug.

She wanted to tell Julie she loved her and discover that Julie had been secretly in love with her all this time, just too afraid to say so.

She wanted to live happily ever fucking after.

I love you, Allison thought as tears streamed down her face.

"Let me kiss you more," Julie said to Nikki as she leaned into her.

Julie and Nikki began making out. Allison watched them as the Vicodin gripped her and she slumped back into the couch.

"I need to...facilitate," Julie laughed, standing up and walking into the bathroom.

Now is the time to make my move, Allison thought. I only set this threesome up because I want Julie all to myself and I can't have her. This is the next best thing, sharing a girl together. I can't flake out now.

Allison wiped the tears from her face.

"You look very beautiful tonight," she said, sliding closer to Nikki.

"You're trying to liquor me up," Nikki protested, holding her head.

"Perish the thought, sweetie," Allison said, running her hand through Nikki's dark hair.

Allison leaned in and the girls began kissing.

Julie came back in the room and tried to take Nikki's shirt off.

Nikki protested.

"I have issues about my body," she said.

"Oh, sweetie," Julie told her. "Don't be insecure. I'm insecure too. About my body. Ask Allison, she'll tell you. All girls are insecure. Don't be like that with us."

"I'm sorry," Nikki sighed.

"Don't be sorry," Allison said. "We just want you to be comfortable."

"Here," Julie suggested. "I'll go first."

Julie pulled off her shirt and unsnapped her bra.

Allison and Nikki took turns kissing her luscious breasts.

Things quickly moved to Allison's bedroom.

Allison lit candles to set the mood.

Nikki lay between Julie and Allison on the bed. They passed her back and forth, kissing and fondling her. Julie tried to take Nikki's shirt off again and was once again rebuffed.

Allison could tell from the look in Nikki's eyes that she was far more into her than Julie. This was

confirmed when Nikki put up no resistance as Allison pulled off her shirt and even assisted while Allison pulled off her bra.

"Do you want to play with me at all?" Julie snapped. She slid off the bed and stormed out of the room.

Allison watched as Julie stomped about in the kitchen and poured herself another drink. Then Nikki cupped her hand around Allison's face and pulled her back in.

For the first time all evening Allison began to feel turned on. She grasped onto Nikki's breasts like she was grasping for a lifeboat while tossing about on a deep and dark ocean night. Nikki unbuttoned Allison's jeans, unzipped them and shoved her hand down into her feminine chaos.

"Fuck," Allison said as Nikki began working her.

"I want to make you come," Nikki hissed at her, kissing her hard on the mouth and gently biting her lower lip.

Then Julie leapt on the bed and tried to take Nikki's skirt off. Nikki's legs snapped shut and she rolled in closer to Allison. Allison slapped Julie's groping hands away.

"You two are a couple of real sluts," Julie said.

Then she passed out.

"Someone had too much to drink," Allison sighed.

"I want to go home now," Nikki told her.

Allison and Nikki got dressed and Allison called a cab.

They walked outside to wait for it.

"Sorry you didn't get to have your threesome," Nikki told her.

"I didn't really want to have a threesome," she said.

"Yeah, me neither," Nikki said. "I was just..."

"Playing?"

"Yeah, or whatever."

"I guess I was just playing too."

"Every girl here is two drinks away..." Nikki laughed.

"Yeah, so they say."

"Are you in love with Julie?" Nikki asked her.

"I thought I was," Allison sighed. "I don't know anymore."

"I think you're kind of cute."

"Thanks..."

The cab rolled up and Nikki walked up to it.

"Call me sometime," she said as she got in.

Allison watched the cab drive off. Then she started walking. She didn't feel like going back into her apartment. She felt like another drink.

David was drunk.

He called Julie on her cell phone, waking her up.

"Where did those two sluts go?" she huffed, pulling out her phone. "Hello."

"Hey, it's me, what are you doing?"

"Being drunk."

"Nice. Me too."

"What do you want?"

"Let's get lunch today."

"You want to fuck?"

"Well, I mean...yeah," he said. "Can't we get lunch and then go back to your place or get a hotel room and you know, see what happens?"

"I'm all set."

"Come on, it was my birthday last week. I had to do the whole family thing. Now I want to actually celebrate it. Have lunch with me. I'll buy you some alcohol."

"Alright," she said. "Call me later."

Julie was having an affair with a forty-two-year-old married man.

Confused

by **JULIET**
LARGE PRIVATE UNIVERSITY

LIKE THE MERMAIDS, legendary half-women, half-fish who enticed ancient mariners, the modern-day bisexual remains an elusive and alluringly vague creature. After all, what is a bisexual? He or she may appear to be one thing, whose true nature is hidden, shimmering beneath the ripples of the undefined.

There are those who have made nets to catch them, like Kinsey and his famous number game. But few people apply his categorical standards when defining themselves, or they play a see-saw game between *Desperate Housewives* and *L Word* extremes.

Let's take score: one girl has slept with more women than I have but calls herself straight, another is only using the bisexual label to acclimate herself to the fact that she is a lesbian, a "straight" boy continually makes homoerotic jokes that have some serious longing behind them, and another boy believes in the concept of bisexuality but can't find

Being bisexual makes you seem complex and interesting at a cocktail party

men attractive. Where do they fit on the scale? They don't, which is all the more reason to throw away the categories altogether.

But instead, labeling is encouraged not only by observers but by many bisexuals themselves, because then we have a community. It would be unusual to see a straight couple in a matching pair of "We enjoy role-playing!" shirts or a car sporting a bumper sticker that said "I'm a foot fetishist." Yet for non-heterosexuals there is sexuality bearing, Gay-Lesbian-Bi-Transexual-themed street wear

but every non-straight Angie fan knows her as the Bisexual Actress, or as Gia (and owns a copy of *Foxfire* even though it's a horrible film). Being bisexual makes you seem complex and interesting at a cocktail party; it's like having a pet python instead of a puppy. And the giddy excitement of donning such exotic labels keeps my t-shirt drawer brimming with sassy slogans.

But what is left is a glitzy term that seems to be drained of any emotional significance, if it ever had any in the first place. And I recognize the contradiction; I feel a need to justify my sexuality, to say that dismissing potential loves based on gender is just as bizarre to me as writing off all brunettes. But if I truly believe that this view is so logical, then why do I keep explaining to everyone that for me, two plus two equals four? Why would I ever mention my sexuality to anyone who wasn't my partner, let alone put it on Facebook, especially if I consider it a pitifully obvious truth about love?

Part of it is the thrill. There is something undeniably delicious about discussing sex, and this is a seemingly benign way of broaching the topic (any veteran of this situation can hardly plead innocence; a confession of bisexuality is almost always followed by a "so... you...?" and a sly grin).

Part of it is social justice. Being out means that one serves

> I feel a need to justify my sexuality, to say that dismissing potential loves based on gender is just as bizarre to me as writing off all brunettes.

and signage everywhere you look. For a group who despises the fact that its members are often pressured to divulge more information about their sexuality than straight people are, this over-exposure seems contradictory, and any real message is lost in a sea of gimmicky iron-ons. If I wear an "I like girls who like girls!" shirt while holding hands with my boyfriend, aren't I doing more harm than good to a group who is ultimately looking for a good dose of societal anonymity (that magical "So what if she's queer? Who cares?" moment)?

Rainbow iconography is by definition more representative of one's solidarity with gaykind rather than with humankind, so what keeps it from being labeled as anti-straight propaganda? Isn't it?

Straight is ordinary. Straight is mundane. For instance, the moment the big-lipped, bisexual beauty named Angelina Jolie sauntered down the middle of the sexual spectrum in Hollywood she was thought of as interesting, edgy, and fresh. Granted her heterosexual relationships have been far enough in left field to create a stir on their own,

as a resource for friends and family to dispel rumors and inaccuracies about The Gays. But this ambassador position in the affirmative action stage of alternative sexuality is a taxing one; a single slip-up allows one's constituents to quickly conclude that all bisexuals are sluts, are show-offs, or are secretly looking for a heterosexual relationship—as if love weren't tricky enough. This position also tends to be mandated by members of the GLBT community, which means having to accept a socially unjust pressure in the name of social justice.

Another part is the honesty it requires. While in most relationships discussions involving exes and current crushes are dogmatically avoided, bisexuality drags these issues into the open. Being forced to defend and maintain my sexuality allows me to be comfortable and clear about what I've learned and what I feel. And if my boyfriend and I are checking out the same girl at a party, there's no need to keep it a secret; we can be honest with each other on a deeper level and categorize that wanderlust as innocent eyeing, reducing it to a natural and insubstantial phenomenon.

It's easy enough to talk about the strategies for tackling this dilemma, and to dissect the pros and cons of discussing your bedroom habits with everyone within earshot, but it's impossible to extrapolate which strategy will really lead to sexual equality and to acceptance on a larger scale. In a perfect world, no one would talk about sexuality, but everyone would talk about sex. This isn't a perfect world; while there are those who consider sex as something whose rules, definitions, and practices should be worked out freely and individually, there are still the Puritan pigeon-holers and the hyper-sexual reactionaries whose ideological battles leave slews of emotional casualties in their wake. We're living in a sexual milieu that makes it difficult to know whether it's better to make love or to make war. So here I am, writing a piece about my sexuality while simultaneously wishing I will never have to mention it again. No wonder they call us "confused."

PURITAN

ANGELINA

SEX

LESBIAN

Bi

STRAIGHT

BUTCH

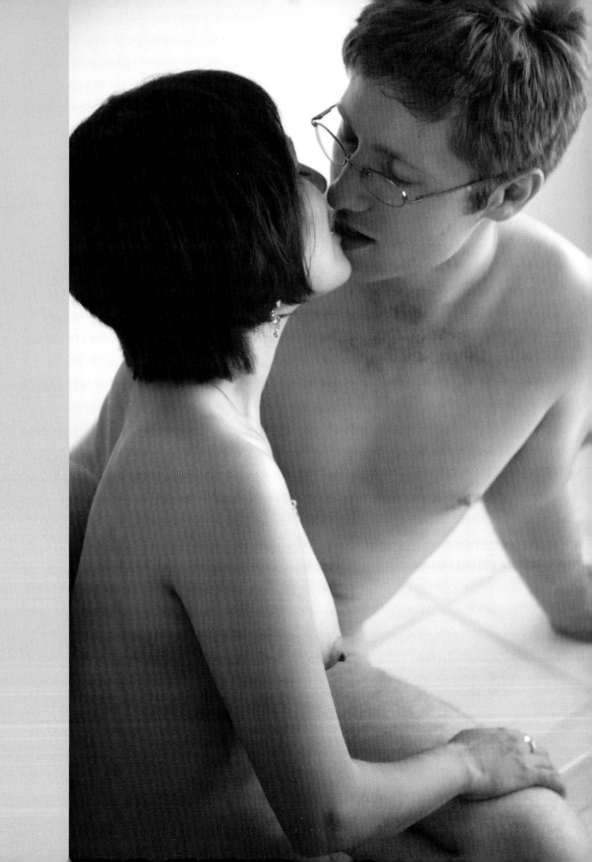

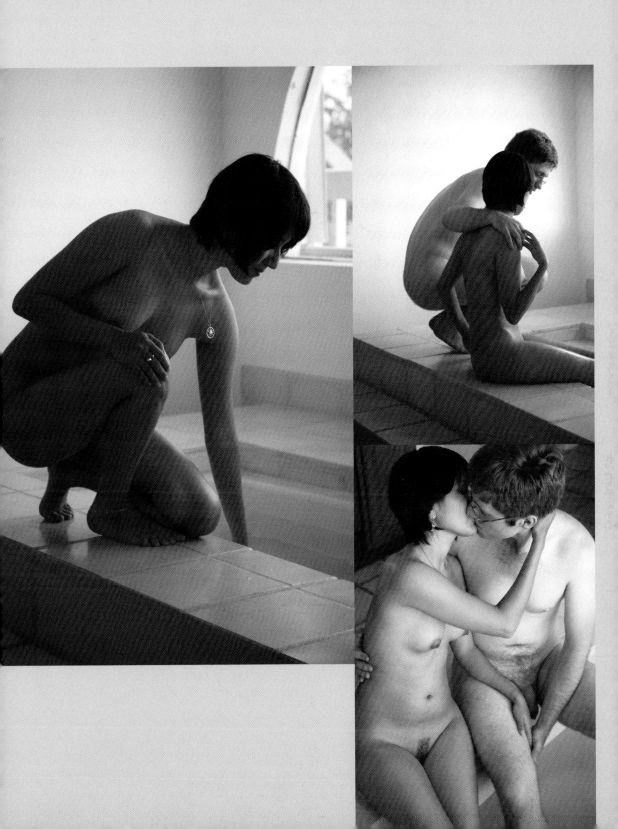

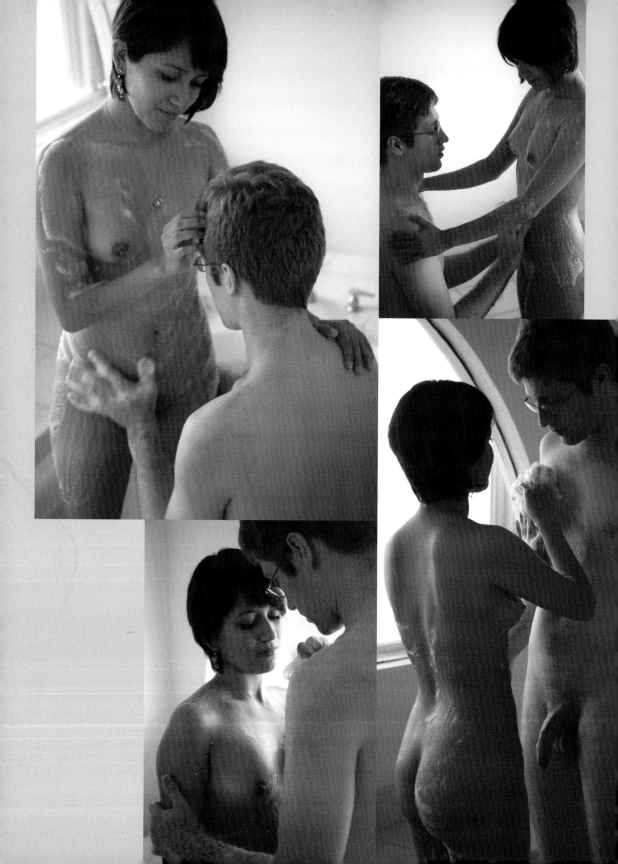

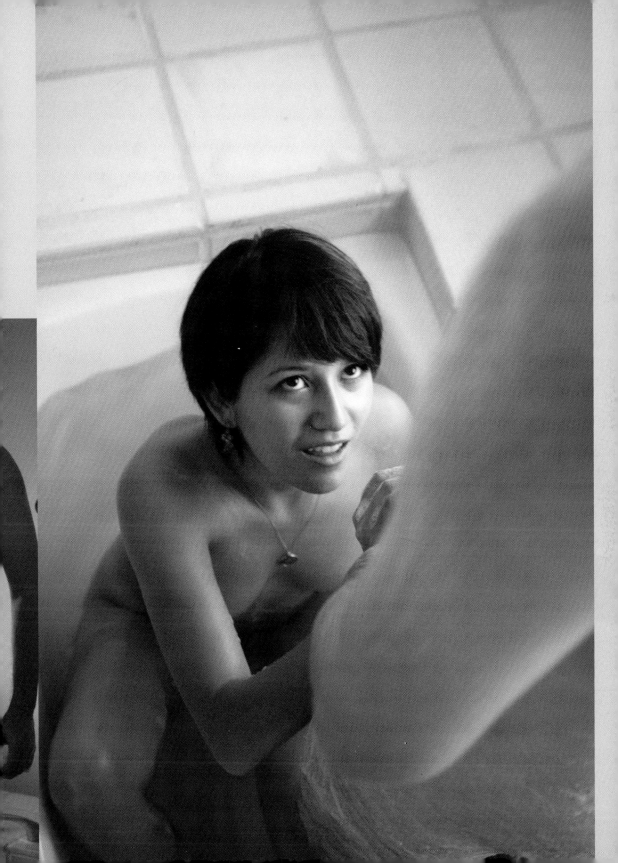

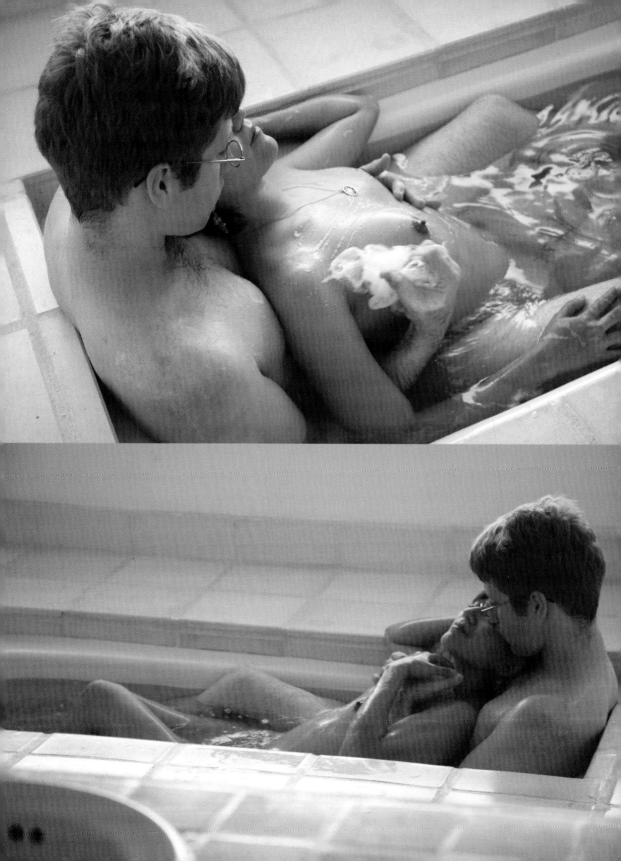

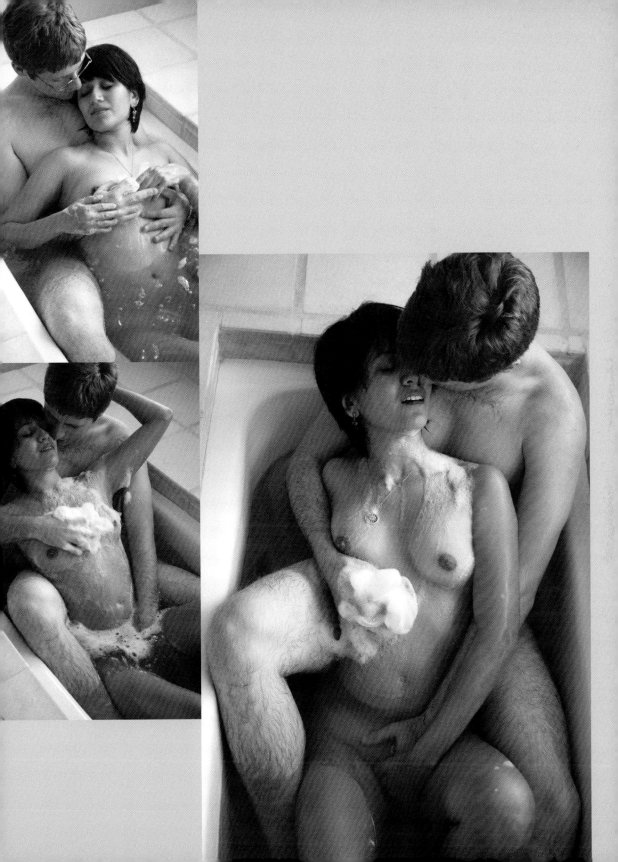

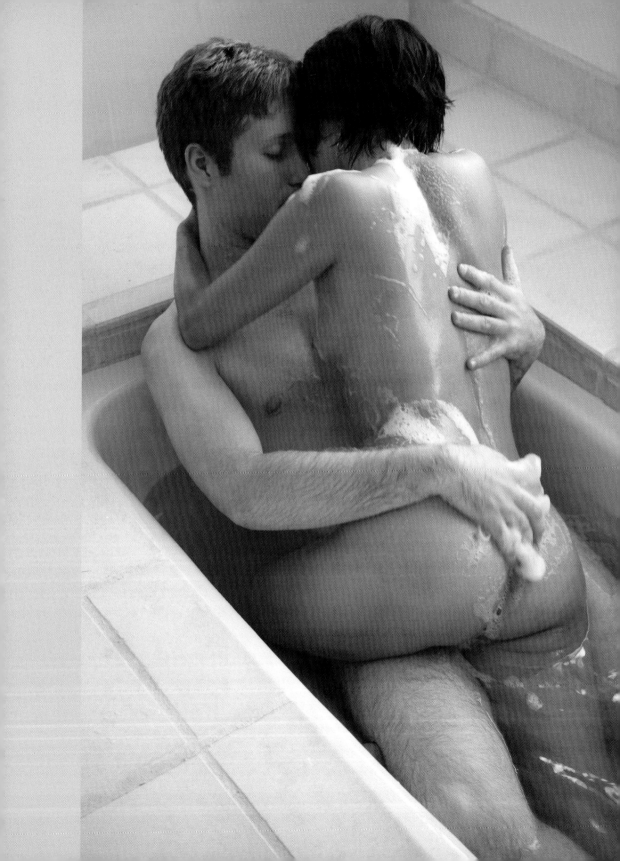

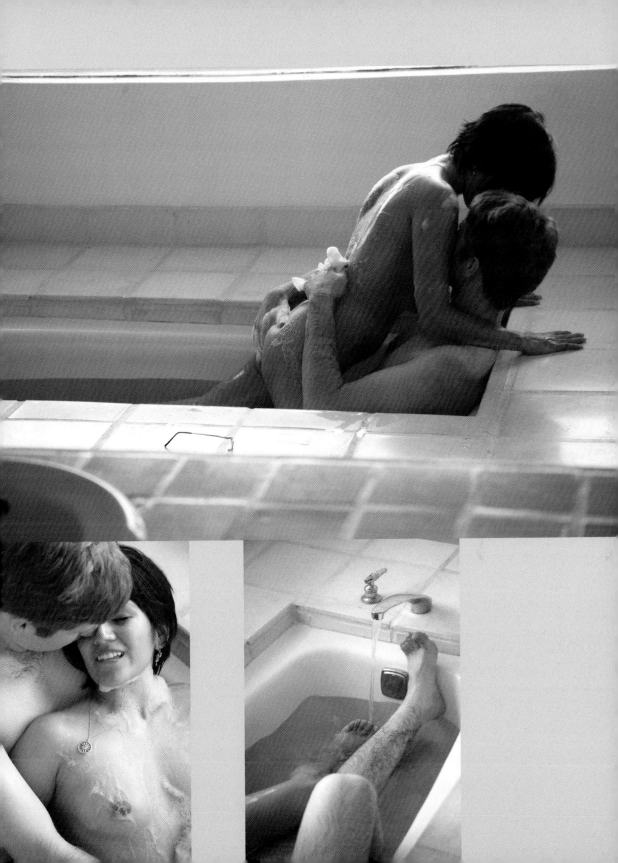

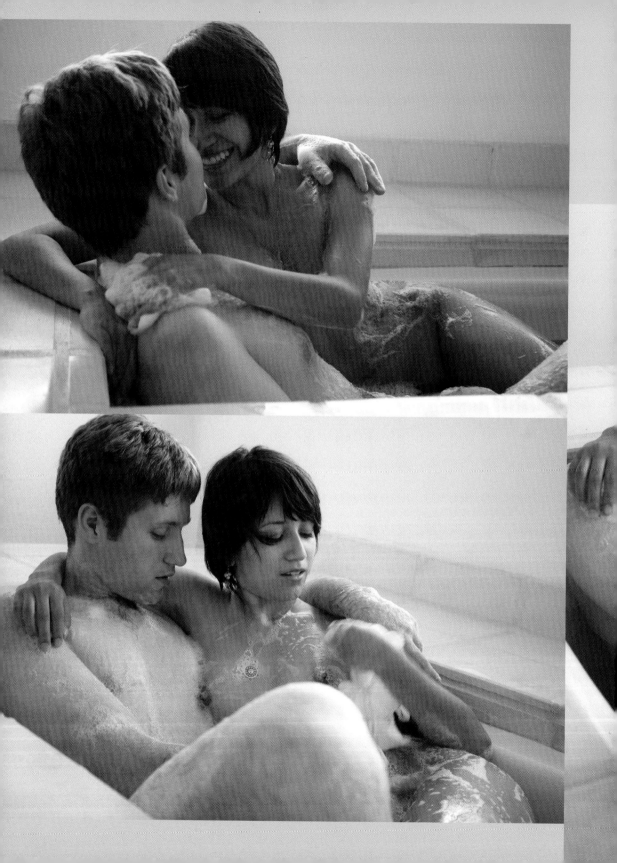

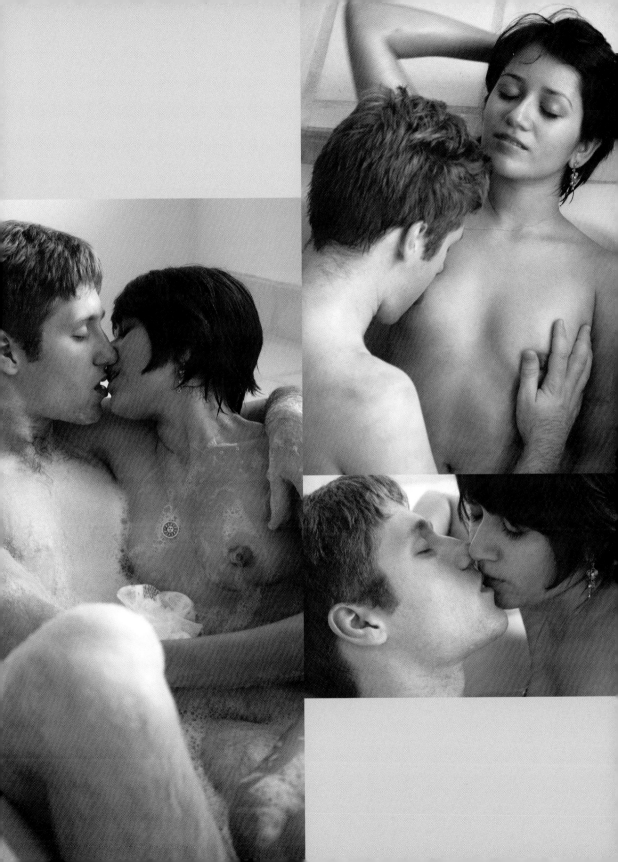

Prayer

by **STEPHANIE NICOLE**
IVY LEAGUE COLLEGE

I mistake affection for redemption
For sins I have yet to confess,
And every kiss on my lips
And touch of my breasts
Sounds to me like a hundred Hail Mary's,
And yes,
I have been a bad, bad girl.
Our sex is like mass
And you kneel down in the doorway of my chapel
And whisper prayers of devotion before entering
And all I can think of is blessing you with my holy water.
I preside over this private service meant for two,
A surrogate for your god of choice,
Meant to take away the sins of your world.
What a fucked up world it is.
You serenade me with hymns of praise
Letting the words glide off your tongue
Reverberating off of gilded walls;
How delicate your praise can make me feel.
My gospels sound like oohs and ahhs,
Closed eyes and clenched fists giving thanks to the nameless god.
Oh god.
We celebrate communion,
And you enter my tabernacle,
Slowly
Gently
Silently
Reaching for my host
So that it may be prepared for an offering
Body becoming bread
Meant to be devoured on altars
Of cotton sheets
And kitchen tables
And hardwood floors.
Meant to give you nourishment.
Meant to be an offering of me
To you.

Lost in the Valley
and Hoping for Snow

by **ALEX**
PRIVATE UNIVERSITY

"SO I HAVE THIS FRIEND…who has a problem with this guy…"

"You have a problem with a guy…" He raised his eyebrows to prompt me.

"Yeah. Okay…um…basically, it's a matter of lack of communication, I think." I wrung my hands, trying to think of how to proceed. I pushed a stray lock of hair behind my right ear. (My bangs constantly get in my way). And I clasped and unclasped my hands. Twice. "Okay. So you know I just got out of this relationship. I mean, come on…you know the story, yeah? In the end, it was a six-month-long battle of the wills. This wasn't even a break-up. It was a divorce! It was ridiculous! And the last thing I want is another bout of insane seriousness. I was engaged for fuck's sake!"

"I know. And you've come through it. You've gotten through it."

"I got the blender."

"You've moved on, though, right? This isn't about him."

"Right," I said. "I'm totally over it. He's totally forgotten. It's…this new guy just doesn't get it. I think he thinks that I want a relationship. That I want flowers and dinners and constant attention."

"You don't."

"No! I had that! For three fucking years!" I slumped back on the couch. "Look how well that turned out…"

I opened the driver's side door and braced my ass for the pain it was going to feel in three, two, one, shit that's hot.

"So what is it that you want then?"

"I don't know...nothing. Sex. Good sex." I sat up again, quickly. "Why can't someone just use me for sex?"

He was surprised. I knew him. He covered it quickly by clearing his throat. "Use you? You wouldn't be able to handle that. I know you."

"Well," I said haughtily as I crossed my legs. "I guess you don't. Because that's what I want. No strings attached. Threads." I stood up and began to pace in front of the couch, something I did when my thoughts couldn't vocally articulate themselves. "I mean, I do have feelings for him, obviously, or this wouldn't be an issue. But I don't want anything more." I looked pointedly at him, stopping midstride, and then resumed my march.

"So why don't you talk to him about it?"

"Ah, there's the rub: I *have* talked to him about it! We've talked." As I paced, my bangs fell into my eyes again. I pushed them back. "I told him point blank: I don't want a boyfriend. And he said, 'I don't want a girlfriend.' So there it was. But this was a couple of weeks ago. And then, the other night...I don't know, I just freaked out."

"Why?" He prompted again.

"Because!" I plopped back onto the couch.

"Okay, we were talking. Not like a serious talk, you know, just hanging out. And I said something and he contradicted me, proving me wrong. I don't even remember what the conversation was about, but I must've made a face or had some weird expression, I mean, you know how I have a very expressive face, and he said something like, 'That's what you get for dating me,' and it just resonated in me. You know, BAM! And I thought, 'Dating? Are we dating? I thought we were just fucking!' And it totally freaked me out."

"Well...are you dating?"

"No!" I stood. "That's the whole thing. We totally aren't. He's never taken me out to dinner or a movie or anything...and we've been sleeping together for a month! So, to me, if we were 'dating' that would be at least three dinners or lunches and a movie or two, you know?"

"So he hasn't taken you out at all?" I knew he was trying to clarify.

"Well, I mean, we've gone out to breakfast a couple times and he paid, but it was like, 'hey, I'm hungry, let's get some food.' And of course, I'm wearing the same thing I wore the night before, which is totally inappropriate. I mean, my night clothes are totally different

from my day clothes. Who wears stilettos to brunch? It's embarrassing! That doesn't count as a date!" By this time I was standing by the window, playing with the blinds, flipping them up and down, enjoying the clanging sound they made as they reverberated.

"Maybe he thinks that counts as a date," he suggested.

"It doesn't." I looked at him. "A date is me getting nervous while I'm getting dressed in something totally hot and he picks me up like a gentleman and opens the door for me and we go out and do something. I mean, I've been going over there in jeans and tee shirts recently! I even stopped thinking about what underwear to wear! Ugh!" I was frustrated. So I flopped dramatically back onto the couch, lying on my back, my feet hanging over the armrest, staring at the ceiling. A couple seconds ticked by. I raised my head to look at him. I dropped it down again. "We aren't dating." I said. I sighed. "But that's not even the whole story."

"There's more." He wasn't surprised. It wasn't a question.

"His ex-girlfriend lives across the hall."

"Okay. And is that a problem for you? Are you worried he'll get back together with her?"

I sat up, my elbows propping me. "Ugh, no. She's crazy. I only found out that she existed because at 4 a.m. one night she, like, overdosed or something, called the fire department and they had to break into the building, obviously waking everyone up. The walls are thin."

"She overdosed?"

"Yeah. I'm, like, half-asleep and I hear this pounding and a voice yells out 'Fire department, open up!' and he gets out of bed and goes outside to see what's happening and when he comes back, he tells me about his crazy ex who's a diagnosed schizophrenic who likes to OD for attention. And I'm like, 'are you fucking kidding me with this shit.'"

"And she lives across the hall?"

"Yeah, I guess that's how they met."

"Why can't someone just use me for sex?"

I could tell his interest was piqued. "How long had they been together?"

"I think he said it was about a year and a half-ish." I swung my legs around so my feet were flat on the ground and sat normally on the couch. "He apologized pro-fusely. I could tell he was embar-rassed that this whole thing was happening."

"What did you think?"

"I thought, 'good god, this is going to be a serious problem.' I mean, I have my baggage too. Everyone does. But mine doesn't live across the hall, right?"

This was the paradox of Los Angeles. Everyone had a shrink because they didn't have real friends. However, no one was ever willing to open themselves up to real friendships because they'd been screwed over too many times.

"Right. So has it been a serious problem since?"

"Yes! She's done all sorts of crazy shit! The woman's a total nutjob! She actually asked him to not have sex when she was in the building. And then she had her dad call him...it's ridiculous."

"And how are you handling this?"

"Like a lady." I folded my hands on my lap.

He laughed. "Seriously. Have you done anything?"

"Well, I want to go punch her in the face, but I actually like him and I think that would probably make the situation worse, so no, I've been a perfect angel. I haven't even said anything bad about her."

"Really?"

"Not to him..."

He smiled. "Ok, we're out of time. Next week?"

I stood. I picked my handbag up off the floor and pushed it onto my shoulder. "Yup. Next week." I walked toward the door.

"The check's in the mail," I said over my shoulder as I crossed the threshold into the waiting room, the door shutting behind me.

It was sunny outside, as usual. The courtyard, like all courtyards of nondescript office buildings, was overflowing with palm trees and artificial fountains. My shoes click-clacked on the pavement. Heels do that. The sound of women in heels had always comforted me.

I saw my car, baking in the parking lot. Summer was not a good time to park outside in Southern California, for obvious reasons. I drove an SUV. It was a Dodge Durango with an ass that wouldn't quit. I couldn't park it anywhere.

Feeling the way I felt that day, frustrated and hot, was my least favorite feeling and the sole reason I couldn't wait to move out of the Valley. Everything about this sprawling metropolis was depressing to me. Hence being in therapy since I was ten.

My car was one of my favorite places in the world. I opened the driver's side door and braced my ass for the pain it was going to

feel in three, two, one, shit that's hot. Leather seats. Not my idea. Of course, the fabric seats always smell weird. I put the key in the ignition and clicked it to the right twice. The speakers immediately popped to life, blasting whatever Top 40 station I had been listening to on the way to the office. The window rolled down, my finger already poised to press the button.

I fiddled with my sunglasses with my left hand, sticking myself in the eye as I put them on, and dug in my purse, which sat on the passenger seat, with my right. I grasped the little rectangle, finally able to differentiate between it and my wallet. Marlboro lights. Fire. Ah.

I slumped back in the seat, the hot leather burning my back through my shirt. Enough people had told me I was beautiful that I had started to believe them a couple years ago. Knowing that you're attractive is both an extremely positive and negative thing. I was always skeptical of men who were interested in me, never knowing if it was because I was interesting and engaging or simply because I was attractive.

My thoughts began to wander as I sat there, sweating, smoking. I thought about him. Blue eyes and light brown hair. His haircut was too short. But I still liked it. I wanted to see him. Actually, I wanted him to want to see me. But I knew I couldn't just wait around in my shrink's parking lot all day.

I started the car. Put it in reverse. Pulled out of my spot and rolled slowly into the street, not knowing where I wanted to go. I was on Ventura Boulevard. Should I go right towards Calabasas, home? Or should I go left toward Studio City, him.

I went left. Maybe he was home, bored. Maybe he wasn't there at all. It didn't matter. I just wanted to drive.

The San Fernando Valley is set up like a piece of graph paper. It's a bunch of long, straight streets, some going horizontally across the city, some going vertically from the beach to the mountains. I liked just driving for hours down a straight road, mindlessly stopping for traffic lights and

other cars, not really caring where I was going.

My cell phone rang. Although my window was still open and the radio was still on, I could still hear the insufferable Nokia ring. It was annoying. I let the call go to my voicemail. I didn't feel like talking to anyone.

For some reason, I always found myself more depressed than comforted after spilling my guts in therapy. It always dawned on me about fifteen minutes after I left the office that I wouldn't be there talking to some random guy about my problems if I had any real friends that cared about my problems. This was the paradox of Los Angeles. Everyone had a shrink because they didn't have real friends. However, no one was ever willing to open themselves up to real friendships because they'd been screwed over too many times.

My cell phone rang again. I decided it was probably the same person, trying to tell me something important. My left hand held cigarette and steering wheel. My right hand dug, shifting everything in my purse once more, trying to find the source of the noise and vibration. Got it. Flip it open.

"Hello?"

"Hello! What are you doing?"

The matriarch. Of course. "Driving. What are you doing?"

"Working. I have all this paper all over my desk and I have a meeting in, like, twenty minutes. Then we're going out for lunch. I think we're going to go to Sagebrush. Maybe I'll have a tostada. I need some good salad. Did you go to your appointment?"

"Yes."

"Are you going home?"

"No."

"Where are you going?"

"I don't—"

"Hold on. Hold on. What? No, I don't think so. Check with Susan. Wait, no, I'll be there in a minute. Okay."

"Hello?"

"I have to go. I'll call you later, okay?"

"Okay."

"Bye." She hung up.

"Bye."

My mother was a workaholic. That was one of the reasons she divorced my father. Because he was a workaholic too. Recently, she had gotten engaged again to some guy she met on Yahoo personals. This was the third engagement in five years.

The fiancé was an engineer of some sort. I didn't know him well, having been away at school for the past couple years, but my mother seemed to like him. He was younger, only about forty to her forty-seven. The week I got home for the summer, about a month ago, they got engaged. I still didn't know how I felt about it.

My cell phone rang again. It was in the cup holder in the center console. Vibrating. Ringing. God, it was annoying!

"Hello?"

"Hey," he said. "What are you up to?"

I got suddenly nervous. My stomach began cramping. "Nothing, just driving around."

"Where are you?"

"Somewhere near Reseda. Where are you?" Please be home. Ask me to come over. I couldn't control my thoughts.

"I'm at home."

"Oh yeah? What are you doing?" Ask me to come over. Ask me to come over.

"Just cleaning up some stuff."

"Hmm." Why wasn't he asking me? He obviously doesn't want me to go over. Was it because it was the afternoon? What would we do? Should I go to Blockbuster or something and get a movie? Fuck this, I'll ask him. "Wanna hang out?" I said it too fast.

"Um, yeah." He exhaled. I could tell he was smoking. "Do you want to come over here?"

"Yes." Oh, shit. I sound desperate. Fix it. Fix it. "But, um, I think I'm going to get a smoothie or something." God. A smoothie? I sound so LA. Jesus.

"How about you get your smoothie and then come over," he said. "I want to see you."

Okay, he wants to see me. That's good. Say something. "Okay. I'll be there in, like, twenty minutes?"

"Cool. See you then."

"Okay. Talk to you later."

"Talk to you later."

I was nervous. The truth was, I liked him more than I wanted to admit to myself. The last serious relationship I had been in had ended with the discovery that I hadn't been the only girlfriend in that bastard's life. Our completely naive "true love" ended when his sister related to me the seriousness of his infidelities. It was that simple. I was holding back because I really didn't want or need to go through another ridiculous break-up followed by six months of nausea.

Honestly, the shrink had it right. I wasn't a casual dating person, as much as I wanted to be. At the end of the day all I wanted was an arm around me and a shoulder to cuddle into, and not to be taken advantage of. But I had decided to take this "casual" thing one day at a time.

Studio City was on the other end of the Valley from me, but I found myself in that neighborhood quite often and not just for the good shopping. That part of the city had a real "city" atmosphere, a quality that the rest of Los Angeles seemed to lack.

He had moved to Studio City from the Northeast, hoping

> Oh no. Here it is.
> He's breaking up with
> me already. Shit.

to pursue a writing career, like so many other people who came to LA. He wanted to be a reporter or a screenwriter. I just wanted to leave. People who didn't grow up in southern California never understood why half the people who were raised there left for something better. I could never offer a decent explanation, no matter how many times I had attempted it.

I met him at an open house at the Museum of Contemporary Art. He was sipping a beer, me a cosmopolitan, the cocktail of choice for young women who lived through the Carrie Bradshaw era. He asked me for a light. And then he asked for my phone number.

The gate of his apartment building parking lot was rusty. I never parked in those lots, always choosing to park on the street in case I had to make a quick escape.

He lived in a ground level one-bedroom. I had been in those before. I used to want to live in one when I fantasized about moving away from my parents during high school. This was before I had the sense to fantasize about living in a studio in Geneva or Budapest.

I buzzed.

The door buzzed back. I pushed it open, the air conditioning enveloping me as I walked into the lobby. I heard his door unlatch, waiting for me to come in. My stomach flipped. I pushed his door open.

"Hey," he said, grabbing me around the waist and kissing me.

I didn't close my eyes. My brain took notice of this. Why could I never close my eyes anymore? "Hey," I returned when he let go. I put my handbag on the couch. "How are you?" I sat down on the armchair.

"I'm fine. I was just cleaning."

I looked around. The place did seem a little bit tidier since the last time I had been there. Still, there were papers everywhere, the essence of unfinished manuscripts, as well as books and DVDs, scattered around. At least the underwear was off the floor. "It looks clean."

"Yeah." He was looking at me. Smiling. "Hi."

"Hi."

He leaned over and kissed me again. "You look really good," he said, checking out my outfit. "I like your style."

"Thanks," I said. I didn't know what I wanted to talk about.

He knew what I needed though. "You want a beer?"

The clock on the wall said 4:30. "Yeah. Thanks."

I heard him walk behind the chair, open the refrigerator and take out two beers. They clanked against each other. He came back around, sat on the couch and handed me one. I watched as he twisted the top of his off and take a swig. I held mine out to him.

He knew what I wanted. "It's a twist off."

"But it hurts my hand."

He sighed, smiling, took another sip of his and took mine. He opened it easily and handed it back. I took a sip. It felt so good going down. Cold beer on a summer afternoon in California. Nothing better.

"So…" he started. I looked at him expectantly. He continued, "I have to talk to you about something."

Oh no. Here it is. He's breaking up with me already. Shit.

"What's up?"

"Well, you know about… her?" He pointed to the front door, obviously speaking about his ex across the hall.

"What about her?" Okay, good, its not about me. Wait. Oh god, what if they're getting back together?

"She came over here yesterday and…" he lowered his voice as if she were listening, "asked me to have sex with her."

WHAT?? My head began to spin. "Okay…"

He saw my nervousness. "I didn't," he said quickly. "I told her, you know, I'm seeing you now and that's it."

Okay, he didn't. Good. So, are we together now? What's he trying to say? What's going on? "Okay." I couldn't think of anything else to say.

He looked at me curiously. "I guess…I just want to see you." He looked down for a second. I stared at him. He looked up and met my eyes. "Is that okay?"

"You're not seeing anyone else?"

"No. I don't want to. I haven't been remotely interested in anyone else since I met you." He shifted his eyes, but looked at me again when he spoke. "Why? Are you seeing anyone else?"

"No…" I said, without much conviction. I didn't mean it to come out like that. "So are we, like, dating exclusively now?" I felt like I sounded unsure of the situation. Maybe I was. I didn't know.

"Yeah, if you're okay with that…"

"Yeah." I let it sink in for a second. "I'm okay with that."

"Okay. Good." He grabbed my hand that was resting on my knee. "I don't really like the whole 'boyfriend/girlfriend' title, you know? It just seems so…fifties."

"Yeah…me either." I looked around the room. I looked back at him. "You wanna give me your pin?" I smiled at him. "Letter sweater?"

He laughed. Then leaned over and kissed me again.

When he pulled back, he was smiling. I think I was too. "Do you want to go out to dinner tonight?"

I reached out for his collar, pulled him towards me and kissed him. Eyes shut.

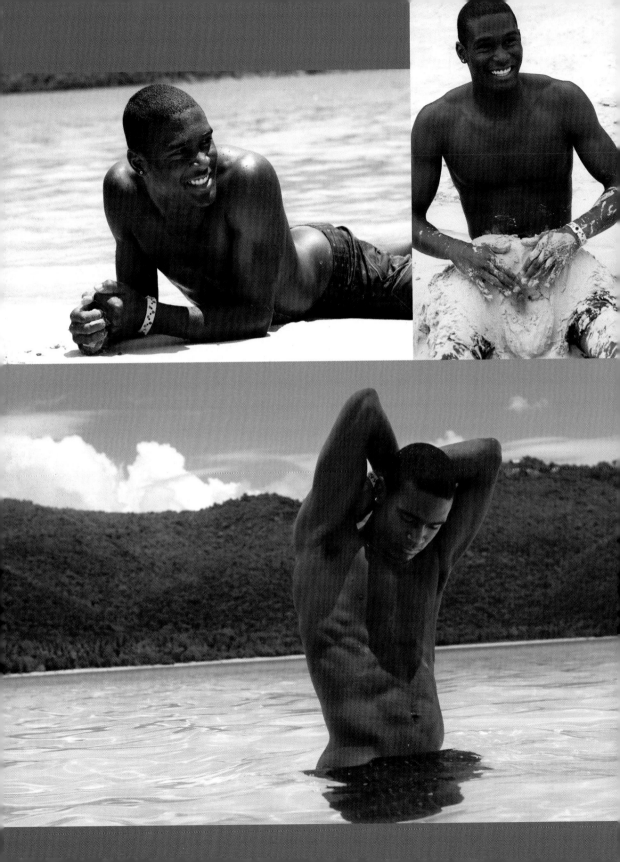

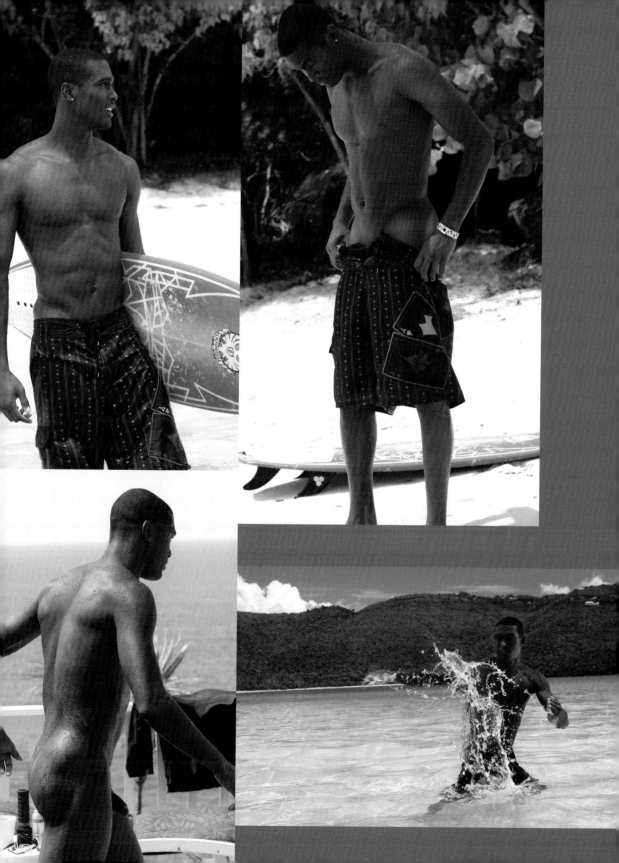

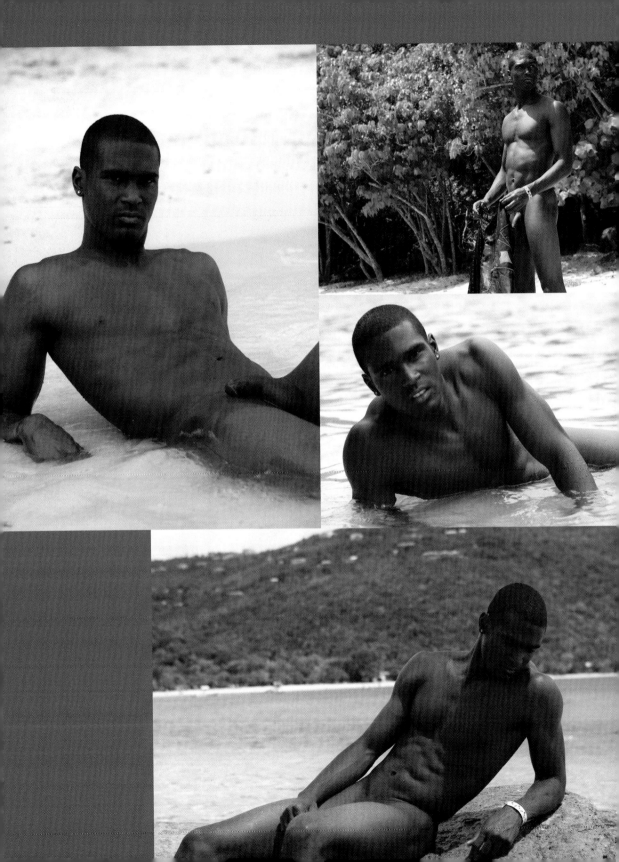

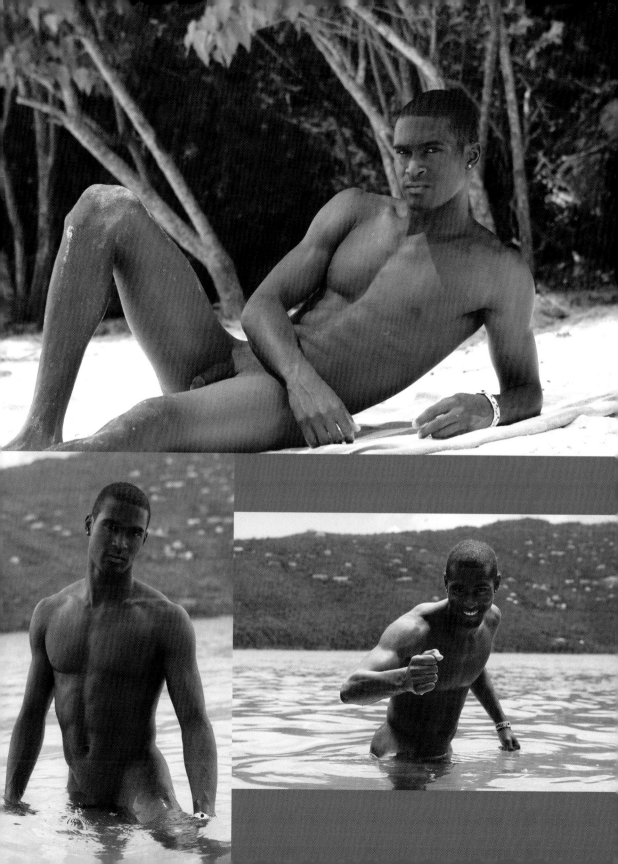

She Was a Hot Truck

by **JASON**
PRIVATE COLLEGE

THE NIGHT BEGINS INNOCENTLY ENOUGH. Me and two close friends from high school going to visit another old buddy at Marlborough College on a Friday night. One is a white Armenian we can call Armo, the other is a black stand up bass player we will call Smoov. The kid we are going to visit is somewhat of a ladies man, so we will call him Gigolo. Anyway, I round up Armo and Smoov, we buy a bottle of Gordon's Vodka with my fake ID, go by Mickey Ds to get some dinner and soda to mix with our Gordon's, and then set out on the forty-minute drive to Marlborough, sipping on our McDrunks.

Now, we are going to see our friend at Marlborough under the pretense of seeing Dead Prez concert. For those of you that don't know, Dead Prez is a militant rap group famous for their hardcore rhymes espousing black power and blaming the white man for society's ills. You might know them since their most famous song is the theme from *Chappelle's Show*. Armo and Smoov are crazy about them. I only know one song, but any excuse to get some of my buddies together and hammered like old times is a good enough excuse for me. Plus it's free to get in and I'm Jewish. Perfect.

When we get there, I am at that point of buzz where your body and brain together start to just say

"yup" to just about anything. Another beer? Yup. Another shot? Yup. Another shot chased by beer? Yup. You rolled a blunt? Yup…Anyway, you get the picture. We are so anxious to get to his dorm and start pounding 'em back that we literally run up the stairs. Right as we get to Gigolo's floor, I hear breaking glass.

Smoov: Shiiiit.

Armo: Smoov, did you drop the Gordon's?

Smoov: (silence)

Me: You fucktard, you can handle a bow like fucking Robin Hood but you can't hold onto a bottle of booze?

Smoov: Fuck you man.

Minor set back. Beers and blunts await. We forge on. When we get to Gigolo's room, we spend a good five minutes exchanging "HEEEEEEEEEEEEEY's"… and "YOOOOOO's." You know, the drawn-out noises that guys make when they meet up just before a night of heavy drinking. It's like some ritual, like "WASSSSSSUUUUUUUP" of Budweiser fame.

Beers are supplied too all and our goal is to get as wasted as humanly possible. We are college sophomores after all. There is only one speed at which underclassmen guys drink, and that is 0 to 120 in .8 second, break-the-drunk-barrier-type speed. We take huge swigs, we all chug at once, we rip shots of gin, and we are quickly becoming a drunken mess. Rookie, Gigolo's freshman neighbor, strolls into the room. Rookie seems to think he can drink. Rookie is in for a surprise. I chug against him, me out of a can, him a glass. I still win. He acknowledges my drinking prowess. This puts me in a good mood.

He calls Gigolo Gladiator. I guess one time Gigolo wore his lacrosse shit and looked like a gladiator from that Russell Crowe movie and the froshes dubbed him that. But he obviously looks up to Gigolo. He whips out some pot and says, "You guys wanna roll a blunt?" Rookie makes a quick jump in class; before he was just another rookie bitch, now he is a rookie bitch who is useful.

We get blunted and ride.

After a few more beers, we

are in peak form to go hit on some Marlborough sluts. Now Marlborough is not a University of Florida or UCLA. This is a northeast school out in the woods of Southeastern Massachusetts. You can guess the type of hippies and fat asses that seem to be everywhere. However, I have a knack for finding honies there who are not only fuckable, but attractive (maybe by a long shot, but still.)

at a predominantly white school. More alcohol is necessary. At this point, Slut #1 begins to fill a flask. She takes said flask and puts it in my hand. Said flask has Slut #1's name engraved on it and looks silver and expensive.

Slut #1: I am only giving this to you if you promise to give it back at the end of the night.

Me: I'm drunk.

Slut #1: (putting her index finger to my lips) Shhh. Promise?

Me: (what I actually said) Cross my heart and hope to die. (translation) You just lost a flask, bitch!

Beers are supplied to all and our goal is to get as wasted as humanly possible. We are college sophomores after all. There is only one speed at which underclassmen guys drink, and that is 0 to 120 in .8 second, break-the-drunk-barrier-type speed.

We enter one of Gigolo's girlfriends' rooms, and as expected, out of four girls, only one, who we will call Slut #1, is attractive. I am drigh (pronounced "dry") as Gigolo calls it, or drunk and high. I immediately approach Slut #1 and begin seducing her with my drunken charm. I tease and flirt, letting her know I think she is attractive, yet still tease her so she knows that I am the man and can bone whoever, whenever I want. Slut #1 is eating this up. Slut#1 is feeding me shots. I like Slut #1.

Fifteen minutes later Gigolo wants to leave. I complain that I am not fucked up enough to sit through black propaganda music

Ah…the spoils of war.

We leave her room and head back to Gigolo's room to stuff as many beers in our pockets as is possible. This amounts to roughly twelve. We are off into the Marlborough campus to see what the night will bring, drunk as skunks with a flask and a bunch of beer to tide us over once we get there. We are cruising. On the way there, me and Armo have this exchange:

Armo: Dude, remember last time we were here when I got so fucked up I couldn't even see, but I had my eyes open and was awake?

Me: Yeah.

Armo: That was awesome!

We stash about half the beers outside the concert behind a shed when we get there and manage to smuggle the rest in. The concert is in an auditorium and the crowd is what you expect when you completely mismatch the artist with the

intended audience: kind of sparse. We go to the bathroom and each chug a beer and take a few swigs from the flask for good measure. We come out of the bathroom

I am now in a porno. I have a girl sucking my dick in the passenger side of the huge front cab of the truck that probably transported Dead Prez's stuff.

and believe me when I say we were the drunkest kids there. I am browned out. Browning out is, for those not up on their party terminology, when you are blacking out, but still remember your night in snippets. You somehow manage to remember the more important details, yet can't remember almost anything else. This frequently occurs when I mix blunts with alcohol.

Well the next thing I remember, I'm standing alone in a crowd full of people (yes, you can do that) near the front of the stage right at the fault line of black people and white people. The entire black population of Marlborough has crammed themselves together nearest the stage. Standing a good yard or so back were the few white kids who

actually came to see Dead Prez perform. There was literally a valley in the crowd.

In front of me is a hot black chick grinding her ass like there's no tomorrow. It later occurs to me that since she was so close to the stage and in plain view of the group, she was probably auditioning for the title of Dead Prez Groupie.

But I am fucked up and my thought process goes more like this: Round ass…moving side to side rhythmically…never fucked a black girl before… the one song that I know and like by Dead Prez is on. "This must be a sign" I conclude as my hips involuntarily begin to sway and I step closer to her. I slip my hands on her waist, she moves closer, and we have liftoff.

Except we just took off in the Challenger.

She turns around and sees that *gasp* a white boy has his junk pressed against her trunk. Though I see the look of disgust on her face, I am blindsided by the violent shove backward. I look up and Militants are staring back at me from the stage. I have overstepped my bounds, and if I don't get out of there quick, the fault line is going to slip, and the ensuing tsunami is going to envelop all. I retreat, weaving backwards through the crowd, until I reach the outside where I see two girls smoking butts. Tragedy averted.

I promptly go to our beer stash and quickly suck down a brew to cool off. I then make my way up to the two Chiquita bananas with the cancer sticks. (I don't smoke…cigarettes.) Slut #2 is cute, Pig #1 is not. Both seem to like my style. Marlborough girls in general seem to like my style. This is not something to brag about. It helps that the dudes that attend this school don't shower regularly or have any people skills to speak of. I am like Brad Pitt to Marlborough girls tonight. I shoot the shit with them and notice Slut #2 rubbing her arms. The pig looks cold too, so while looking Slut #2 directly in the eye to indicate who I was talking too, I say "would either of you like a jacket to stay warm?" as I take it off and hand it towards the slut. But the pig grabbed that jacket

so fast I didn't know what happened. It was like putting a pie in front of Rosie O'Donnell; that shit was gone faster than I could count to zero.

Maybe she thought that I would fuck her to get the jacket back rather than be rude and just take it. HELL NO.

Me: I'll take that *yoink*

Pig #1 and Slut #2: wha...?

Me: Later.

Back into the ghetto gun show, I wade into the fray. Now at this point, my memory fades out again, but the last thing I remember was that all the white people had spread out into the gym leaving the die-hard fans to huddle by the stage. I move right into fuck-me dance mode, a mode that either gets me laid or slapped, sometimes both.

I know I danced with lots of girls, but the ultimate retelling was done by Smoov later that night, who was a witness to the whole thing:

Smoov: Yooo...so you were dancing with a few girls, and then all of a sudden two of 'em were all up on you. They were both bangin; a blonde and a brunette, but the blonde was fine. Yoooooo...I tried to set the groove on her, but it was like they were fighting over you.

Me: What was I doing?

Smoov: Man, you had this blank look in your eyes but you were dancing, man, you were busting a move. So then I backed off and me and Armo were just chillin, watchin. Then all of a sudden the brunette got aggressive, started feeling below the

belt and shit, and the blonde backed off. Then you were both gone.

Consciousness returns, and I'm outside with said brunette. We will call her Slut #3. And you know what they say about three; it's the magic number. Or it's a charm. At least one of those applies here. I go to put my hand in my pocket and lo and behold there is something shiny and metallic inside. I pull it out to reveal a flask. SCORE. In this state, I have no idea where it came from. It is too dark to read the engraving that says "Slut #1" and I am too drunk to remember. All I know is that it is filled with liquor, and at this point I thank the god of libation for bestowing this wonderful gift upon me. We share a swig or two, and then things really get interesting.

Me: See that truck?
Slut #3: You mean that huge one?
Me: (It was a semi) Yeeees?
Slut #3: What about it?
Me: Wanna check if it's open?
Slut #3: I guess we could do that...
Guess if it was open.

I am now in a porno. I have a girl sucking my dick in the passenger side of the huge front cab of the truck that probably transported Dead Prez's stuff. Sucking leads to fucking, and as drunk as I am, I'm

Me: Oh you know him? He's my boy from home.
Her: Um yeah, he introduced us. You don't remember?
Me: (no recollection whatsoever) Uh...sure.
Her: I used to fuck him all the time. We just recently stopped being exclusive.

Implying they still fuck. Bitches are fucked up. But even though I feel some remorse, I'm in too deep to stop now...figuratively and literally.

Me: (changing the subject because I am drunk and don't want to deal with sex-ruining drama) Oh baby you're good, yeah just like that.

Moaning ensued as I applied the jackhammer and coitus was back on, but only for five more minutes, when the worst or perhaps the funniest thing that could have possibly happened did. You be the judge:

He begins to get into the truck, I feel her shiver with fear. I try to open the door and run, but I am glued in the seat. This is not happening. He looks up and sees us; hot, naked and glistening with sweat.

still amazed that I am being straddled and ridden by this hot little brunette who magically appeared on my arm, not to mention the flask of hard liquor that surfaced just minutes earlier. Then she says...

Her: (Mid fuck) You're just like Gigolo...

Gigolo, if you remember, is the person we came to see in the first place.

While both of us are buck naked, the driver side door opens, and I see a backwoods-looking trucker below me (front cabs are raised up high). He doesn't see me though, but what he does see is the slut's boot. I stop fucking. She

then notices the bad man, and buries her face in my chest of man fur.

Trucker #1: What the fuck is this...a girl's boot?

As he chucks it over his shoulder behind him and begins to get into the truck, I feel her shiver with fear. I try to open the door and run, but I am glued in the seat. This is not happening. He looks up and sees us; hot, naked and glistening with sweat, INSIDE HIS TRUCK. I imagine a few things he might say before taking action. "Jackpot" and "Whooeee! We got a live couple sumbitches for the basement back in Kentucky!" The image of the gimp from *Pulp Fiction* flashes in my mind making me almost gag on the spot.

I open my mouth but no words come out. Uncertainty hangs in the awkward silence. "Awwww shit, I'm sorry," he said.

An apology? Is this a trap? What in the...

"You two kids go ahead and take your time."

And with that he shut the door. No exaggeration.

No fucking way. I am at a complete and utter total fucking loss. At this point, after checking to make sure I didn't shit myself, I burst out in laughter as the slut dismounts.

Me: Hey!? Wait!

Slut #3: Are you kidding me??

Me: (it was too easy) But he said take your time!

While I thought this was brilliant, she did not and was dressed before my hard-on could even begin to shrivel. Her boot was missing though. I knew that she wasn't going anywhere without her footwear, and she sure as hell wasn't talking to that trucker to get it. I dressed and got out.

Me: Hey man, sorry about that; we're really drunk.

Trucker #1: Shit man, don't worry about it. I wish I was hittin' that.

Trucker #2: (who must have been beckoned by Trucker #1) Hey son, were you fuckin' in there?

Me: Well...uuuh, yes sir...

Trucker #2: Well I'll be damned! (laughing) That is the coolest thing I ever heard.

Me: um...Thanks?

Surreal. I grab the boot off the ground and make off with my little trucker slut. As we walked away, I hear the parting shot.

Trucker #1: Hey man! You fogged up my windows! HAHA-HAHA.

Fits of laughter pierced the night sky, and I couldn't help but snicker a little. And although she wouldn't admit it, the slut had a smirk on her face too.

Epilogue: Slut #1 never saw her engraved flask again. And seriously, who the fuck cares? I still drink out of it and use it as a conversation piece. Right after the truck fiasco Slut #3 and I walked across campus. Then she forced me into a situation where I was supposed to remember her name. Of course I couldn't. She feigned anger. But I ended up fucking her doggy-style in her room and busting all over her ass and back about an hour later. Mid sex, my Motorola beeps in and Armo is wondering where I am. Without missing a stroke, I inform him that I am performing ungodly acts at the moment but will be with him shortly. After finishing, the slut and I go back to Gigolo's room, and Gigolo is not very amused. Apparently Gigolo had been fucking her regularly. Like yesterday. We go to my car where I pass out and Armo drives Smoov and I (snoring) back home. Gigolo eventually gets over it and is still one of my best friends. God bless him.

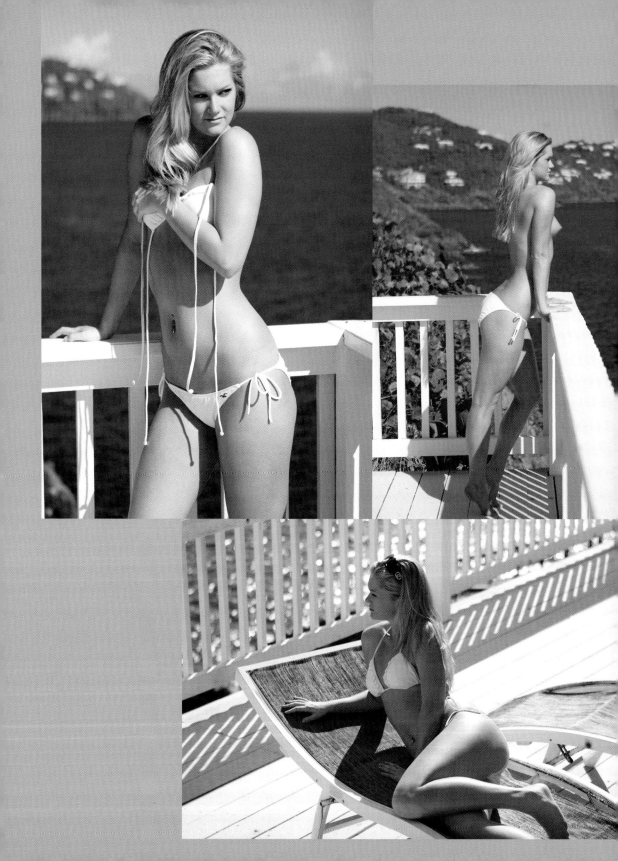

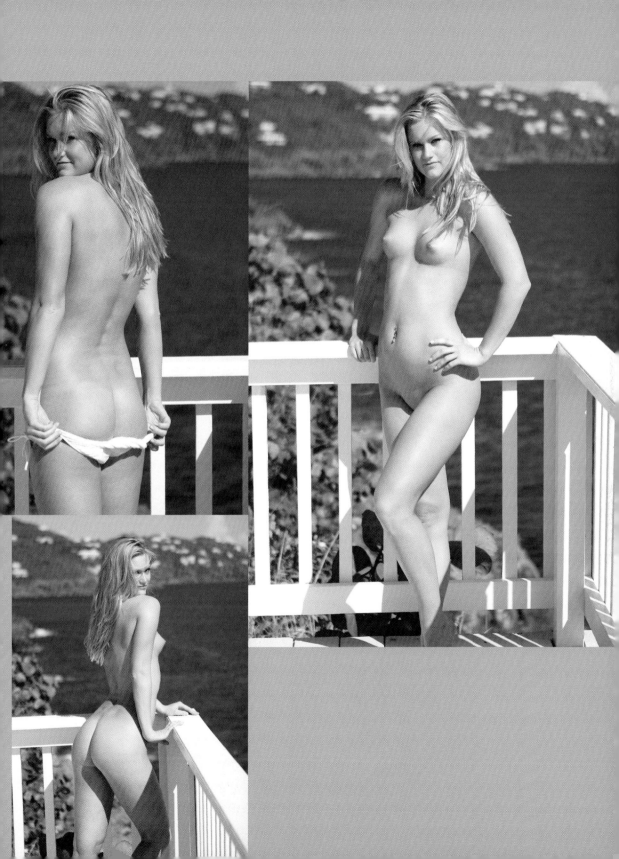

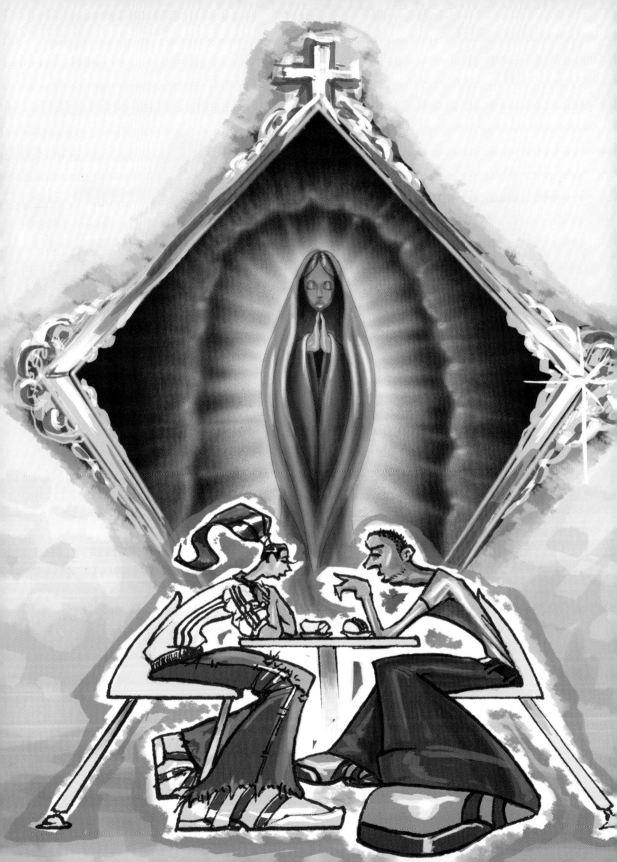

PUSSY

by **EVAN**
FOREIGN UNIVERSITY

JESSICA AND I HAD a friend named Dan in common. At least, we did until he stopped calling her.

That day, I met Jessica in the Mission for a burrito, and she was wearing what she usually wore: faded jeans and her black-and-white Adidas jacket, a glittery scrunchy holding a ponytail above her slick, dark-brown head of hair, her white teeth striking in the plump chocolate oblong of her face. She was no goddess, but quite pretty, and she had the traditional Latina-zaftig thing going on, so I could appreciate why Dan had a crush on her.

We ordered and sat down at the mustard-yellow tables, under the loud mural of La Virgen on the wall.

"He was such an asshole about it," she said, shaking her head. "I mean, I always had a good time hanging out, and I thought he was having fun too. I just don't like him like that, you know? And now I guess he doesn't want to see me anymore if I'm not givin' it up for him."

"Why are guys like that?" she asked. "Why is it always about the pussy?"

I nodded, actually much more focused on the al pastor tacos that had just arrived in front of me, but what she said next really got me to thinking.

"Why are guys like that?" she asked. "Why is it always about the pussy?"

It was definitely a fair question. It was more than fair. It was damn good, and it hit a nerve with me, because the night before I had been in bed (or rather, on top of it) with a slim redhead named Nicole.

cartoons and Italian grammar, so the problem wasn't that we were incompatible. No, the problem with Nicole was that she was one of those women who had everything planned out from the moment you kissed her. When she asked you if you wanted to spend the night, you could almost hear the clink of wedding china, and the gurgling clamor of the

> Nicole liked sex in public, and when we were in private, she made it public by bellowing like a hippopotamus as I did my best to move the bed across the room without using my hands.

Nicole and I also had history, but not like I had with Jessica, who I had known since seventh grade, felt up once at a dance, and never had any romantic feelings for since. Jessica subsequently had been the longtime girlfriend of one of my best friends during which time she and I had also become close.

Nicole and I had met on Facebook before I went away to college. When we first got together, we were like bunnies on ecstasy; in parks, on elevators, blowjobs in public bathrooms, the whole filthy sticky nine yards.

Nicole liked sex in public, and when we were in private, she made it public by bellowing like a hippopotamus as I did my best to move the bed across the room without using my hands. Naturally, even after I moved away, I kept in touch, because you don't let something like that go easily.

My bad. Nicole clung to me like a wet pair of underoos. It wasn't that I didn't like her; on the contrary, she was cool, and could be quite sweet. We shared many interests like city history, vulgar

maternity ward. We'd had a few encounters when I was back in town for visits, and now that I was back for the summer, she wanted to see me again.

The truth was, her initial seriousness had scared me, and since then, I knew that there was basically nothing that could ever make me fall for her again. I knew that the smart (and good) thing to do would have been to just be friends with her, and yet I found myself on a rainy Friday evening in her apartment doing my level best to get into the sky-blue thong she was wearing.

I wouldn't flatter myself with the thought that a dude of not-too-remarkable looks and decidedly dumpy style like me exerted some kind of animalistic

power over a girl like Nicole. But for some reason, I never had any problem getting her to make out with me, and that evening was no exception.

From the first kiss, it was all going according to my general plan. I knew she liked it when I paid attention to her neck, so I was nibbling her ear as I rounded second base. I felt her nipple perk up and stand at attention between my fingers, and she was showing every sign of enjoying it, when she pushed me back and said, "We've got to talk."

"We've got to talk," has got to be one of the most devastating phrases in the English language, right up there with, "I'm afraid the results of the blood test were not good," and "the bombing begins in five minutes." In fact, it must be one of the oldest human euphemisms, and when Mary told Joseph he wasn't gettin' any for at least nine months on account of God had got there first, she must have employed some Hebrew variant of that hated phrase.

Still, that's not the point. This particular use of the words didn't turn out as badly as I'd feared. I was expecting something like "I'm getting married," or worse, "I love you so much." Instead, Nicole just wanted to make clear that she didn't want to have sex, or at least didn't feel comfortable with sex at the moment. (Come to think of it, that might have been worse than either of the

two previously mentioned statements; after all, they would not necessarily have precluded the possibility of getting laid.)

And then the caveat, dropped in front of my horny little mind like a lump of hamburger in front of a hungry Rottweiler. "At the moment," combined with the fact that I still knew how to make her nipples stand up, meant that sex, and with any luck, the hot-as-shit, dirty-talking, ass-slapping sex, was only a matter of perseverance. I just need to bide my time, thus I put my arm around her shoulders, and asked if she wanted to watch *South Park*.

So it went for a few weeks. I'd go over to Nicole's house, and we'd watch videos on her bed, interspersed with bouts of passionate tongue-wrestling as I progressively worked my way under her layers of clothing. Despite Nicole's passion for acrobatic sex, like most women in my experience, she didn't really come easily. For her the thing was mostly manual. She liked oral, and of course, always had fun with the time-honored hide-the-pickle, but when you applied a steady, rhythmic, well

. . . the fact that I still knew how to make her nipples stand up, meant that sex, and with any luck, the hot-as-shit, dirty-talking, ass-slapping sex, was only a matter of perseverance.

lubricated finger to her clit, she immediately tensed up and her face turned bright red as she held you in a death grip and panted, followed by a spasmodic convulsion and a huge sigh when she passed into the promised land.

Armed with this knowledge, I continuously put my hands down her pants in the course of our

sessions, which she sometimes resisted, but mostly accepted, and in the course of those weeks I made her come no less than seven times with a combination of manual dexterity, tenacity, and her always-ready supply of KY.

Every time I brought her to climax, I proceeded to ask if she wanted sex, or simply whispered that I needed a condom. However, each time she told me she still wasn't comfortable.

Being the cool post-feminist twenty-first-century guy that I am, I never pushed it, never lost my cool, never let my bitterness show at the fact that she was enjoying a nice post-orgasmic glow with her pants around her ankles while I lay there fully clothed with a raging hard-on.

I figured that a) this is what it must be like to be a woman much of the time, and I could take the short end of the stick for a while, and b) she'd recognize the injustice of what was going on, and bestow upon me at least one mercy fuck in exchange for all the orgasms I'd bestowed on her.

Until one night, that evening before I went for Mexican with Jessica, when I snapped, and the conflict between brain and balls could no longer go on unresolved.

The scene was the familiar, only this time I didn't finish her off. I figured that, like me, she'd be crazy for sex if she were left unsatisfied. But I forgot that that's

not how they make 'em on Venus.

So there we were, she was naked from the waist down, as I pulled my cock out and knelt over her.

"And now," I said with confidence, "I'm gonna fuck you."

She looked at me as if I'd just said I was going to sell her for hot dog meat. Then she glanced at my erect penis, and back at my face. Her expression of shock changed to one of disappointment.

"You just don't get it, do you?" she said. "I told you, I don't want that."

Now it was my turn to be shocked, and let me tell you, it's hard to play the victim with your dick out, but somehow I managed it.

"Well, what the fuck are we doing here then?" I demanded.

The expression of disappointment and anger on her face said it all, and suddenly I understood. When she said that she wasn't comfortable with sex at

It was suddenly as clear as Steuben glass to me, and a large part of me felt sorry for her. I knew the relationship couldn't last long, I would be going back to school soon and am just not down with the long-distance thing. The nice and caring thing to do would have been to zip up my pants, hold her and tell her that I was sorry, and that although I loved her as a friend, we shouldn't go on seeing each other like this, and that maybe we should stop seeing each other at all, and then given her a kiss on the forehead and left.

I'm a good person, and I saw that that's what I should have done, but instead I said, in a petulant voice, "I still think you should suck me off."

Now, anybody who knows enough about women to fill an empty pistachio shell (which, I'm sure you've figured out by now, is more or less exactly as much as I know) knows that you can't bargain with women when it comes to sex, unless they are actually prostitutes. There is nothing less sexy than begging, however it's formulated. For women, sex has to feel right, even if the rightness of that feeling is simply rooted in the fact that they're tired, and blowing you is the fastest way to get you the hell out of their apartment.

With that in mind, I'm sure it won't be a huge surprise when I say that Nicole didn't agree with my

I made her come no less than seven times with a combination of manual dexterity, tenacity, and her always-ready supply of KY.

the moment, she didn't mean because she wasn't in the mood, she meant she wouldn't be comfortable until I met certain criteria, namely loving her, or at least promising her that that possibility would exist if we reinitiated a serious relationship.

assessment, and pretty much immediately asked that I pull up my pants and leave. Even though I may be an asshole at times, I'm no rapist, so I complied. But before I left, she said something that seemed to me both wise and sad and incredibly stupid at the same time:

"I just don't get why when you make out with a guy it has to constitute an agreement to have sex."

On the drive home, I reflected on that. I didn't know why it was either, but in a way it's true, at least after a certain point. I mean, I'm not saying that because you let some guy put his tongue down your throat at the club he has a right to violate you in his Lexus afterwards. I cheered as loud as anybody when Susan Sarandon shot the hillbilly and rescued Geena Davis.

Yet there is something about getting the blood up in a man that causes the ape-brain to take over, and even the sweetest guy can turn into a raging dickhead when denied sex after the point when it becomes expected. Although that does not excuse even the slightest harm done to another person, women should be aware of the fact that they're playing with fire when they let the monkey out but won't let him play.

It's maybe unfair to say it is pussy that does it to us. After all, maybe it is just dick that does it, and saying it's pussy is just externalizing something that's completely our own fault. But whatever it is, it drives us, and occupies our thoughts like a hitch-hiker in the truck-cab of our minds. It flits through intentions, it sometimes makes me act like an asshole, I feel powerless against it. The best I can do is to try to avoid hurting anybody, which is what we're all doing when we look for love, or at least as soon as we stop worrying about being hurt ourselves.

I never talked to Nicole again after that, and I don't think I ever will. Though it may be possible, I don't trust myself to be friends with her, because I can't think of her without wanting to taste her pussy, or bend her over a couch. The fact is that I don't wanna be friends with her, I wanna fuck her, and she can't handle that without me loving her.

And who knows? Maybe I can't really handle it either. The true no-strings fuck buddy is a rare beast, and short-lived at

For women, sex has to feel right, even if the rightness of that feeling is simply rooted in the fact that they're tired, and blowing you is the fastest way to get you the hell out of their apartment.

our thoughts when we pass a woman on the street, or when the receptionist at the dentist smiles at us, or when we meet our buddy's little sister and can't help but notice the shape of her tits under her Ramones t-shirt.

It's not that I'm proud of it, although I do enjoy my sexuality, and consider that its judicious exercise makes my life significantly more fun, spicy, and fulfilling. It's simply how it is. Even though I'm inclined to make apologies for it because, against my better

best. Most of the time, it's more harmful to pretend that what you want is a friend when what you want is a piece of ass than it is to just say goodbye, even if it makes you feel like a jerk for a while.

That's why, even though I'm leaving to do research abroad in two months, I'm still seeing the cute blonde from the next dorm.

She said she wanted a boyfriend, and that if I was leaving we should just be friends. I agreed, and said that was better than nothing. But when I hang out with her and we've had a few drinks, I cop a feel and try to get my hand down her pants. I can't help myself and if she were to stop letting me put my hand up her shirt, I probably would stop going over there.

I guess that's the difference between the desire for friends and the lust for pussy. Ladies need to understand that 95% of straight men will use the excuse of being friends to be near you, in the vague (or perhaps immediate) hopes that one day, when you're drunk, or vulnerable, or suddenly decide that they are the love of your life, their moment will come. Watch their eyes when you talk with them and you'll see the slavering dog that hides there. It's not always so, but usually it is, and when it is, there's nothing you can do to escape it but say goodbye.

So when Jessica was venting between bites of carne asada and beans that it was a shame Dan couldn't handle just being friends, I completely agree.

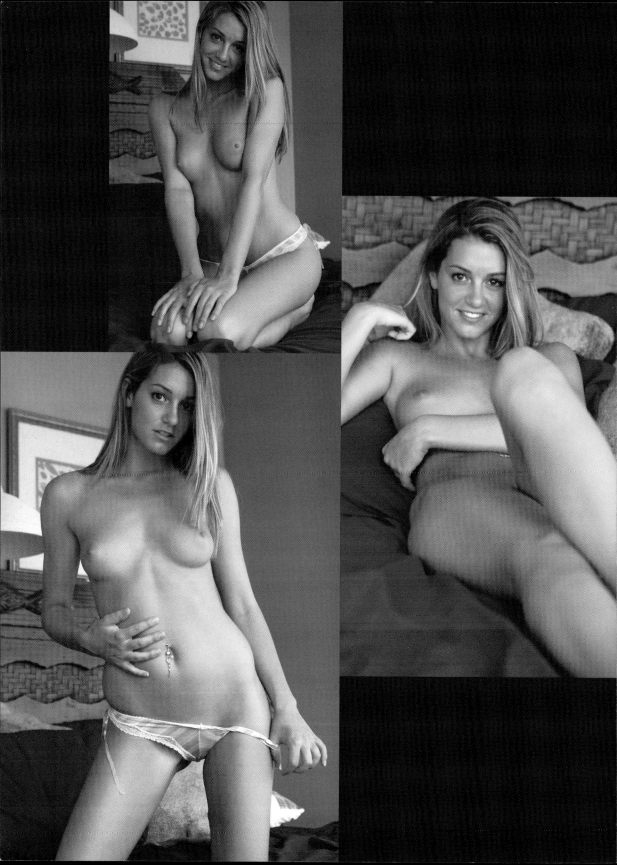

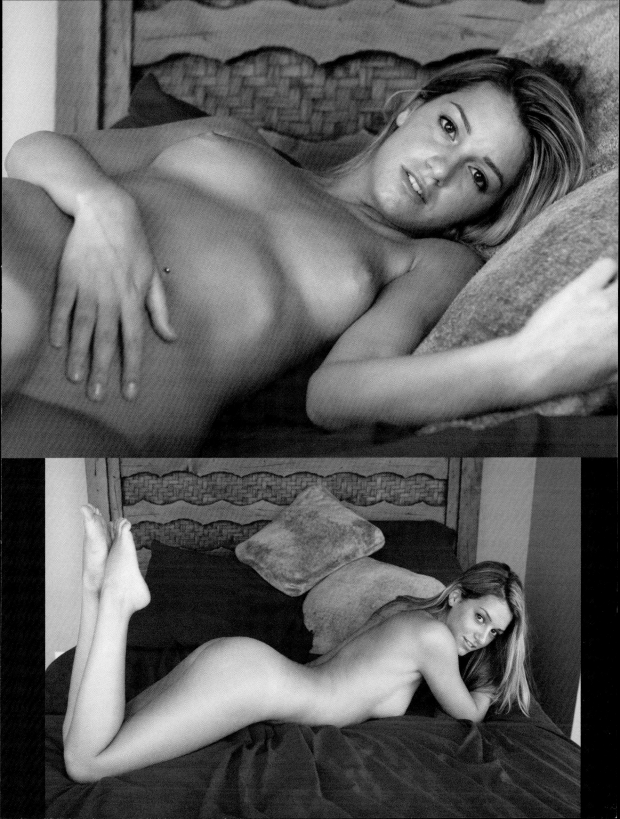

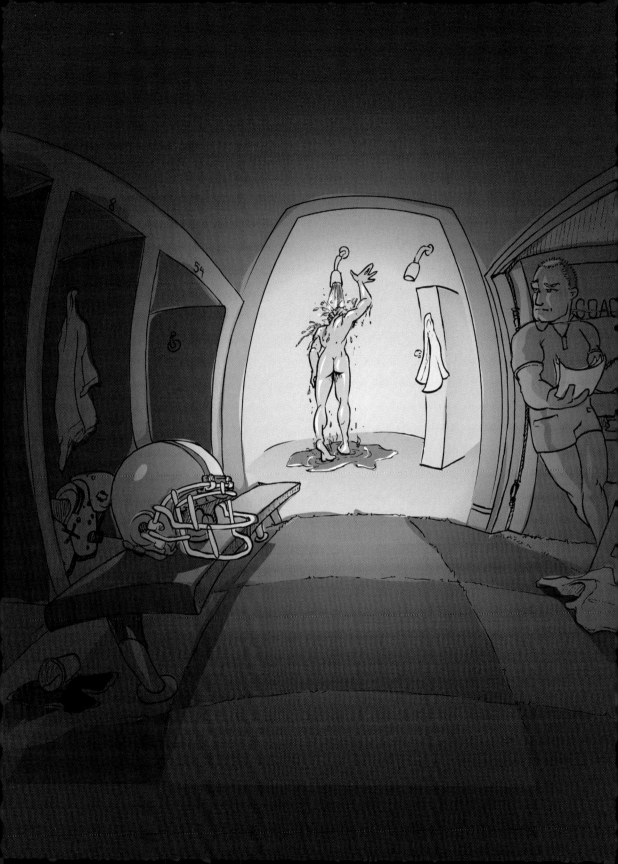

Coach

by **AARON**
STATE UNIVERSITY

I WAS CURLED UP NAKED ON the couch with Ryan, reading the newspaper, when I saw the obituary. Jim Donaldson, my old college football coach, had just passed away. Looking at the paper, I was reminded of a very fond memory of Coach Donaldson. It was hard to believe that it was almost thirty years ago, but I remembered it like it was yesterday.

Coach Donaldson was a pretty terse guy. Every year it was inevitable that at least a couple of freshmen would quit the team because they couldn't stand him. He was inhuman, they said, just too cruel to enjoy the game. Most of the older guys said to stick with him, though. His viciousness came with the territory and you'd eventually come to see his good side.

I had had a rough freshman year. I didn't play much, was constantly quarreling with my girlfriend, and had even considered transferring. When I told coach this, he sat me down and gave it to me straight. He wasn't going to guarantee me anything, but said if I stuck with him, he'd make sure he'd do all he could to help me improve and maximize my chances of playing. Coach's little talk ultimately convinced me to stay and now, nearing the end of my sophomore season, I was finally glad I did.

I hadn't been playing much up until that point, but Coach had said he might look to use me a little if our running game got shut down. That proved to be the case and I grabbed six receptions and scored the go-ahead touchdown to pull out a nail-biter that would advance us to our conference's playoffs.

I had gotten tied up doing an interview with the school paper after the game, so the locker room was mostly cleared out by the time I hit the showers. The shower stall was right next to Coach's office.

> I had had a rough freshman year. I didn't play much, was constantly quarreling with my girlfriend, and had even considered transferring. When I told coach this, he sat me down and gave it to me straight.

> Washing off after a game, especially after a big win like that, was always one of those small but unmistakable pleasures.

I was the only one washing off when he leaned his head in.

"How's that hamstring feeling, Matthews?" he asked in his usual gruff tone.

"I guess it's starting to tighten a bit, Coach," I answered. "A couple days off will probably do it some good."

"Did you see Kennedy?"

Kennedy was our trainer and physical therapist.

I'd mildly pulled my hamstring earlier in the season so I knew I should have made a point to see him, to have it massaged so it wouldn't tighten up too much. But I was so busy recounting the win that it slipped my mind, and Kennedy had already gone. I told Coach this and I immediately sensed his irritation in his scowl. His gruff tone confirmed it.

"Well, get on a table and I'll loosen it up a bit."

Showering after a game, especially after a big win like that, was always one of those small but undeniable pleasures. Your body would be sore and tired from sixty minutes of physical exertion. The feeling of hot water pouring over your body taking all the dirt and sweat with it was pure relaxation. And a massage on top of a hot shower was the ultimate guilty pleasure. But that was with Kennedy. This was Coach Donaldson who was going to put his coarse mitts on my tender calves and thighs. I let out an exasperated sigh as I turned off the water. Drops lingered on the tips of my fingers, my nose, and my penis, as I looked disappointedly down at the drain.

"Matthews, I don't have all day!" I heard Coach bark out at me.

I dried off and slipped the small gym towel around my waist. The massage benches were made of cold steel. Climbing onto them, you could sometimes notice your penis retract as the chill of the cold metal pricked your skin. I was prostrate on the table as I heard Coach Donaldson slapping the deep-heat massage lotion together on his hands. I figured Coach would continue to talk about the game, about what we had to improve to win next week. But for the first time since I'd met him he seemed human. He didn't talk about the game; instead he made a joke about his lack of skill as a masseur and recounted how he too was frustrated his first few seasons as a college player and how it took a few years for him to realize his potential.

He went right for my hamstring, the muscle that was giving me problems. It was tight and it stung as his hands dug into my skin. My back arched and my head shot up at his first touch. But he was strong and in control. The friction of his hands on my leg sent warmth throughout my body. I no longer noticed the coldness of the massage table. Coach may not have been a professional PT, but he must have learned to give a massage somewhere. Kennedy had nothing on Coach Donaldson.

The towel was tied together on my left hip and I noticed it was restricting his freedom of movement and his access to my right hamstring. Even though he was showing me his gentler side, Coach was still the boss. He told me, very directly, to lift my legs so he could slide the towel up and reach the muscle. I did so, and he brusquely jerked the towel up exposing all of my legs and part of my ass. A wisp of cool air caressed my left ass cheek sending a tingle throughout my body.

Coach continued to talk as he worked the lotion deep into the back of my leg. I closed my eyes and laid my head on my arm on the table. I could feel him start just above the back of my knee and slowly work his way up my leg, his fingers kneading me like a piece of dough as he went. He would stop and go back to just above my knee, but each time he seemed to creep a little higher, until finally I felt the tips of his fingers pressing into the bottom of my ass.

At this point Coach was talking about anything that came to his mind. He was going on about movies he had seen, people he admired, his '57

My back arched and my head shot up at his first touch. But he was strong and in control. The warmth from the friction of his hands on my leg sent a heat wave throughout my body.

Corvette. I guess he had gotten fairly comfortable, as the stern coach I knew so well had transformed into a jovial guy. Occasionally he would pause as if to reflect on something he was saying. He would momentarily stop the massage with his hand firmly resting on my ass. Then he would snap out of it and act as if nothing had happened, resuming to talk and massage my leg.

I wasn't sure what to think. I was young and confused about my life. I had my college courses and football to help keep me focused, but sometimes I

just felt so uncertain about who I was and what I was doing. I had a girlfriend, but when we weren't arguing it seemed as if we were just going through the motions of being a couple. I went to parties and did other typical college things, but I only half enjoyed them. Something seemed to be missing.

I was lost in thought when Coach slapped my butt and told me I was all set. I spun around and sat

She was a sophomore like me and had a single room to herself in an all-girls dormitory. She used to say how great it was going to be, how we could have as much sex as we wanted without having to worry about a roommate barging in. But that didn't end up being

Even though I was having sex with my girlfriend, all I could think about was Coach Donaldson.

up on the table, my bare ass pressed against the silvery metal. The towel hung very loose, as Coach had nearly torn it off, and I moved my hands to secure it once again on my left hip. It wasn't until then that I noticed I had a full-fledged boner. It shot straight through the towel. I quickly moved the towel to cover my erection, but it still looked like a tiny pup tent. I abashedly moved my head up to see Coach looking right at me, or rather at it. He held his glance for a moment as I sat frozen, unable to move or speak. Then he averted his eyes and set the massage lotion on a shelf.

"Okay, Matthews," he said, glancing at me out of the corner of his eye. "Don't celebrate too much tonight. I'll see you tomorrow morning for film."

He walked out of the room leaving me in shock and utter embarrassment. My mind instantly began to go over what had just happened. I couldn't believe it. I had gotten a hard-on right in front of Coach Donaldson! Had I enjoyed the massage that much, in that kind of way? But wasn't he the one feeling my ass? Or was he? I got dressed as fast as I could and bolted out of the locker room without saying anything to Coach, who was in his office and out of my view. I wondered what he could possibly be thinking, and I dreaded having to see him again.

I called my girlfriend as soon as I got to my room and told her I was coming over. I was feeling antsy and had to take my mind off Coach Donaldson.

the case. If we weren't bickering about something, I was usually too tired from early practice and a full day of classes to even think about sex.

That night I was more wound up than usual. I kept asking her dumb questions and fidgeting with random items in her room. I finally reached out and yanked her onto the bed beside me. I was acting more out of reflex than an actual desire for sex. I kissed her and put my hand on her breast. It was no more arousing than holding a water balloon. Yet I proceeded anyway. Soon I was on top of her, fucking away as hard as I could. But I was thinking about other things; it was like she wasn't even there. All I could think about was Coach Donaldson. I thought of the caring and humorous side hidden beneath the tough exterior. It made me curious about him. I wondered what he was like, what else he did when he wasn't coaching. Then I thought of his hand moving

forcefully over my leg, resting on my ass. Yes, Coach had his hand planted firmly on my ass, and I liked it! There was no doubt about it. But what did this mean? Was I gay? Bi? I'd had fantasies before but just dismissed them as the fucked up thoughts of a crazy, horny kid. The possibility of me being gay was never seriously considered. So I was deeply conflicted about these feelings. Then my mind brought me back into the room with Coach Donaldson. I thought about my ass cheeks being exposed to him and got thoroughly turned on. I thought about getting an enormous hard-on right in front of him, and at that moment I pulled out of my girlfriend and exploded like never before, drenching her face from hip-level.

The next day, I walked in about five minutes late for the game film. They had already started so I inconspicuously took a seat in the back. Coach was his old gruff self, shouting about what we should have done on every other play. I was hardly paying attention to the film, though. I was too nervous thinking about what it was going to be like when I spoke with Coach again. I made the decision to find out another time. I was too scared to face him, so made a B-line for the door as soon as post-mortem session ended. I was two steps beyond the door when I heard that deep voice bellow out from the crowded room.

"Matthews!"

My stomach began to do somersaults. I stuck my head back through the door, my teammates heckling me under their breath as they passed.

"Yeah, Coach?"

"I want to work that hamstring a little more today. Hop in the whirlpool for ten minutes, then get on the table. Anyone else who's still tight from the game, line up behind Matthews. We're not taking any chances on injuries this week."

I got a lot of smirks, and unsurprisingly no one chose to join me for a massage. Kennedy never came in on Sunday and most people would rather wash dirty jockstraps than go on the table with Coach.

I sat in the whirlpool with the jets on my sore muscle, contemplating the situation. Was Coach sincere in wanting to guard against injuries before the next game? After all, he did ask everyone if they needed to be loosened up. I wondered if Coach would mention yesterday's events. Despite my apprehension, I was mildly excited. It had felt pretty good. I mean, it definitely turned me on. But what if I got another hard-on? Oh Christ! Coach couldn't ignore it a second time.

I reluctantly dried off and moseyed into the massage room. Everyone had left immediately after film, so it was just Coach and me in the locker room. I was already on the table when he marched in. He asked me if I celebrated much last night as he slapped massage lotion around in his hands. Again, this was a different side of Coach than I was used to seeing. He never would have asked about my private life before. I actually ended up telling him about my troubled relationship and a few other things that were bothering me. To my surprise, he listened intently and concernedly, and even offered a little reassuring advice.

He continued to work the muscle and had moved the towel, without bothering to ask, to the same position it was yesterday, half covering my ass. I thought I felt his hand start to graze my butt cheek again, and I did all I could to resist getting a hard-on.

"How does that feel, Matthews?" Coach asked, I assumed referring to my hamstring. "It's not uncomfortable, is it?"

"No, Coach," I responded. "It feels pretty good."

"Well, you let me know if it gets too uncomfortable, okay?"

"Okay, Coach."

With that I felt his warm hand move assuredly up my leg, under the towel, and start to firmly massage my smooth, round butt. There was no doubt about what he was doing this time. I felt the towel being completely removed, and watched it dangle off the sides of the table down towards the

floor. I lay there completely nude, my hard-on nearly lifting me off the table. Coach had moved from my legs to my midsection, and he confidently worked his hands from my neck all the way down my naked body to my lower legs.

"You sure that feels okay, Matthews?"

"Yeah, Coach," I smiled as I answered him. "It feels good."

"You know, most guys wear underwear when they come in for massage. Not you though."

He laughed to himself, and I laughed too. I hadn't thought

jerked forward and back and then, to my surprise, slammed my hand down on Coach's head, pressing it into my ass, I was so overcome with pleasure.

After a few minutes of exhilarating tongue work, he stood up and told me to turn over. I did so willingly, and we both watched my erection spring to life as I planted my ass on the table. He moved his right hand over my upper body feeling my arms, chest, and nipples while his left hand caressed my inner thigh. He confessed that he had wanted to do this the previous day, and said he had always had a feeling about me. He admitted that he did take liberties with my ass yesterday, and that he wanted to devour me when he saw my erection. I told him I wished he had, but that this would more than make up for it.

I felt the towel being completely removed, and watched it dangle off the sides of the table down towards the floor. I lay there entirely nude, my erection nearly lifting me off the table.

about it. Maybe I did it because I unconsciously liked being naked around other men. Whatever the reason, I stopped thinking about it as I felt Coach's lips press into my firm ass. He worked his tongue and lips around my butt while his hands continued to graze over my back and legs. Then I felt his kisses move slowly but with definite purpose towards the center. He pulled my cheeks apart and I felt his wet, slithery tongue tickle my asshole. A shockwave of delight coursed through my body as his tongue circled, glided over, then penetrated my asshole. I

He leaned forward and kissed me. His coarse lips gently glided over mine, and then his tongue pressed forward, parted my lips and met mine warm, wet in my mouth. I reached out with both arms and held on to him, pulling him forward. Our tongues continued to swirl, as if engaged in a dance. His left hand had made its way up my thigh and was now caressing and massaging my balls. I took one of my hands from around his back and pressed it to the front of his pants. Coach was enormous, as I could feel a bulge a third of the way down his thigh.

He stepped back and looked at me. We both smiled at each other but said nothing. He bent forward and kissed my cheek, ears, and neck. I tingled all over. He worked his way down my chest, stopping to do plenty of work on my nipples. I felt the trail of moist kisses run down my taut stomach

He locked the door behind him and we immediately embraced, lips interlocking. I helped him to get his shirt off and admired his physique. He was twice as old as me but still had a brawny, muscular figure.

until he reached my cock. He bent it to the side and kissed from the base slowly up to the head. He bent it back and flicked my balls with his tongue, then made his way up the underside of my shaft, now glistening with saliva. I was already about to explode when he took my head in his mouth. He worked his mouth on it for a bit before engulfing my entire cock. My neck snapped back in painful ecstasy as he moved his mouth rhythmically up and down my cock.

Suddenly Coach jerked his head up as we thought we heard something outside the room. It was only the heater turning on, but Coach said we should move into his office if we wanted to continue, just in case someone did come in. I heartily agreed and he took my hand and led me into his office.

He locked the door behind him and we immediately embraced, lips interlocking. I helped him to get his shirt off and admired his

physique. He was twice as old as me but still had a brawny, muscular figure. He had tanned skin and a fairly hairy chest. I put my hand on it and ran my fingers through his golden-brown chest hair, taking the time to kiss and lick his tight, pointy nipples. Imitating him, I then dropped to my knees, kissing him all the way down his thick, tight belly. I kneeled at eye-level with his cock and rubbed it through his pants. I still couldn't believe how big it was, and I was strangely excited to have the chance to suck my first dick. I bit on it through his pants then rubbed some more before opening the button and undoing his fly. He said I didn't have to do anything I didn't want to, and I told him there was no way he was going to stop me. I pulled down his pants and his cock shot up like a spring, though it was the size of a ripe cucumber. It had only a mild upward curve and was smooth, almost no veins, because it was so thick. I told him I couldn't believe how big it was, and he just laughed and told me to enjoy it. And that I did.

I began by kissing his smooth domed head then proceeded to kiss all the way down the side until I felt bristly pubic hairs swirling in my mouth, the light brown tuft brushing against my cheek. I was so overjoyed I rubbed his cock with glee all over my face, and began to slap it against my cheeks. I then reared back and had a good look at the obelisk of

hardened flesh, closed my eyes, and took his cock as far in as it could go. I got about halfway over it before I felt the head hit the back of my throat. It was so thick it filled my entire mouth. It was my first cock so I was extra conscious about doing a good job. I tucked my lips over my teeth and curved my tongue to slide perfectly along its underside. I sucked in so my cheeks glided against his shaft's smooth sides, and proceeded to move my head back and forth. I don't know how long I did it for, but I could have gone on forever. It felt like nothing before, to have my mouth stuffed full of hard cock. From that point on, there was no going back.

Coach finally warned me that he was going to come. I moved my face inches from his cock and continued to stroke away, my hand brushing up against his coarse pubic hairs. He groaned and a huge load of white, gooey cum exploded from the tip of his cock. The first shot hit me on the cheek and I moved in closer. My nose and lips also got doused before I put my mouth back over it to sop up the rest of his juices. I stood up feeling somewhat proud at the pleasure I had given, and more fulfilled than ever before in my life. We stayed in his office talking for some time, kissing and fondling all the while. I went to Coach's house that night, where we continued right where we left off.

Needless to say, I broke up with my girlfriend shortly thereafter. I had found a much more satisfying relationship.

I spent a lot of time at Coach's house over the next two years. And I found out what he did when he wasn't coaching. He did me. I always visited him after games, and most other nights for that matter. Sometimes I would only spend a few hours, usually having great sex. I also spent many nights there, wrapped in Coach Donaldson's arms. I was voted captain my senior year and we would talk strategy, intertwined and naked in his Jacuzzi. We would always joke about who we thought were sexiest amongst the new recruits, and whose dicks we would most like to suck. It was great fun to be able to change and shower with a group of guys and then have someone to relive the fantasy with. I used to kid him that he had the best job, watching a new set of hot bodies year after year. He would just smile as if to say "you sure are right."

We spent a lot of time together, and had a lot of great sex, but I never expected it to last beyond graduation. He always remained the older, more experienced guy, sort of a mentor. I continued to call him Coach and would often go to him for advice about my problems and other things. I wondered if Coach had other guys like me, if he found someone new every couple of years. I kind of figured he did and I couldn't really blame him. Hell, I was glad. He made my college years some of the best of my life.

I sighed and put the paper down, reached over to Ryan, and pulled him toward me. I planted my lips on his and moved my hand onto his cock, feeling it swell in my grasp.

"We better take care of this so you can get some sleep," I said. "It's getting late and you need to be up early in the morning."

He was, after all, the star runner on my track team. I couldn't have him up all night and tired for the big race tomorrow. He looked into my eyes and smiled.

"You'll get no argument from me, Coach."

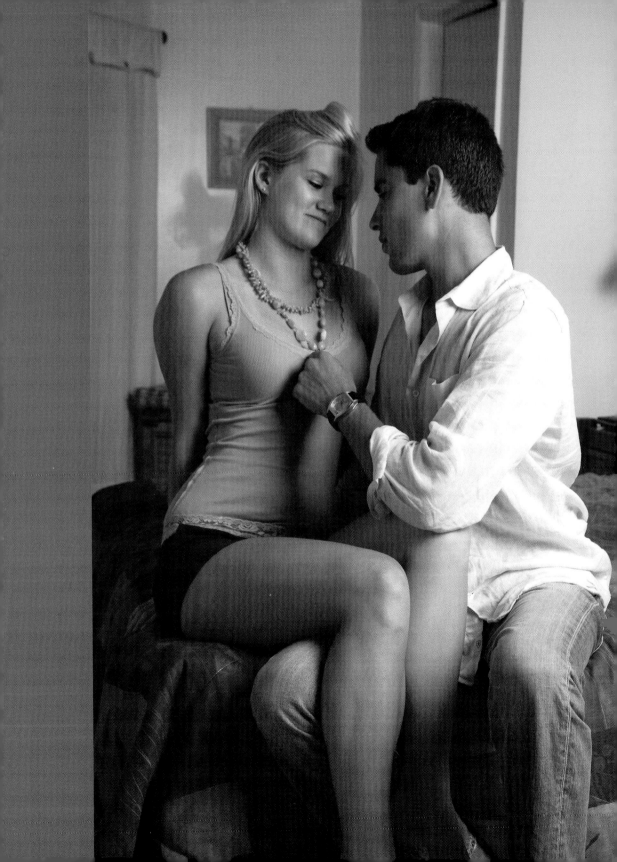

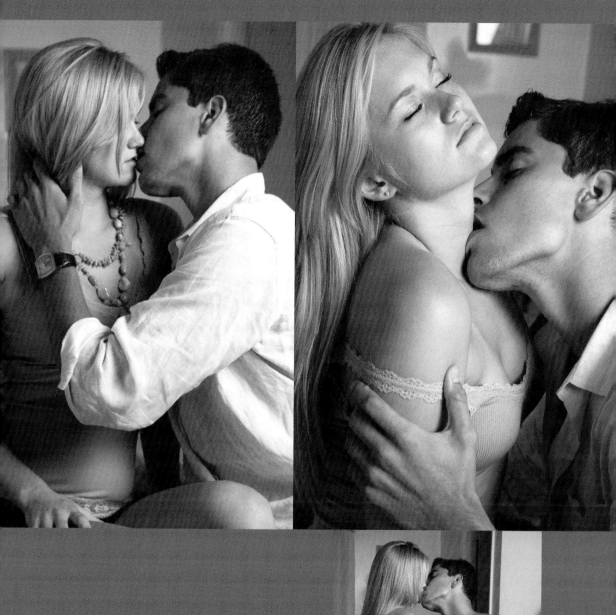
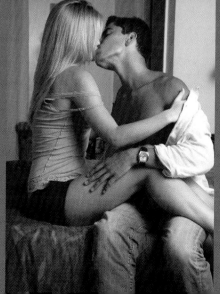

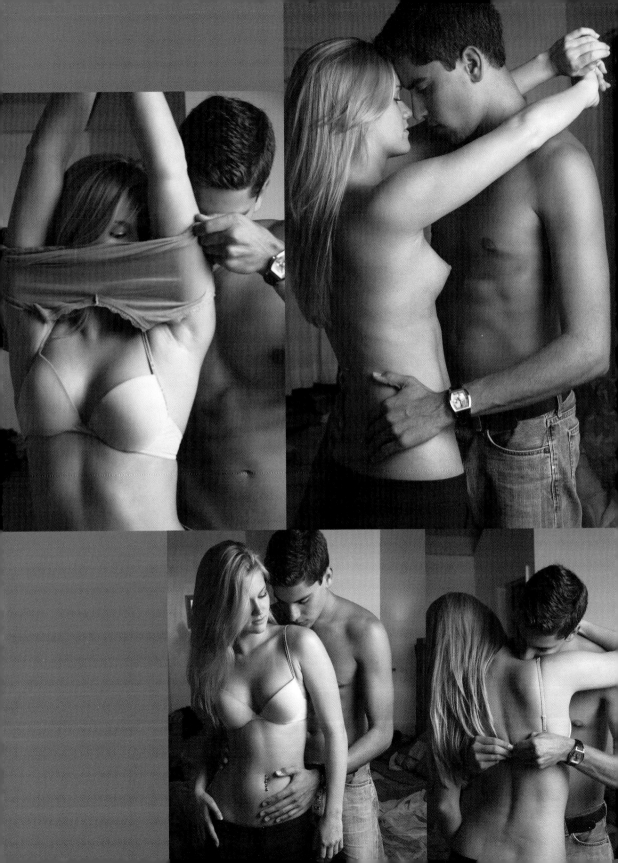

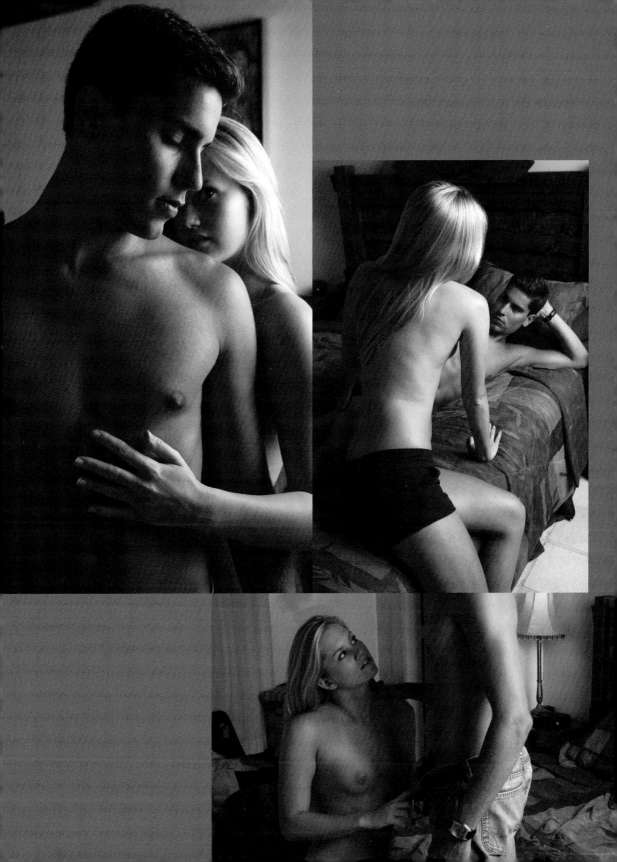

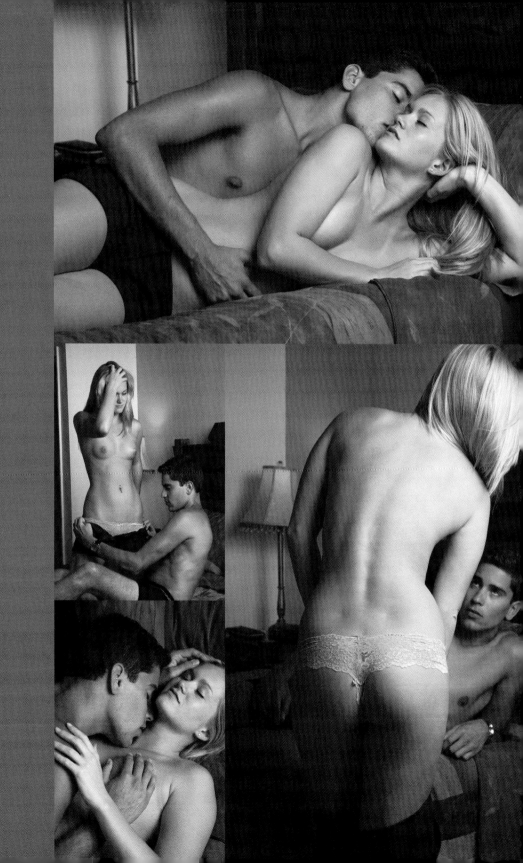

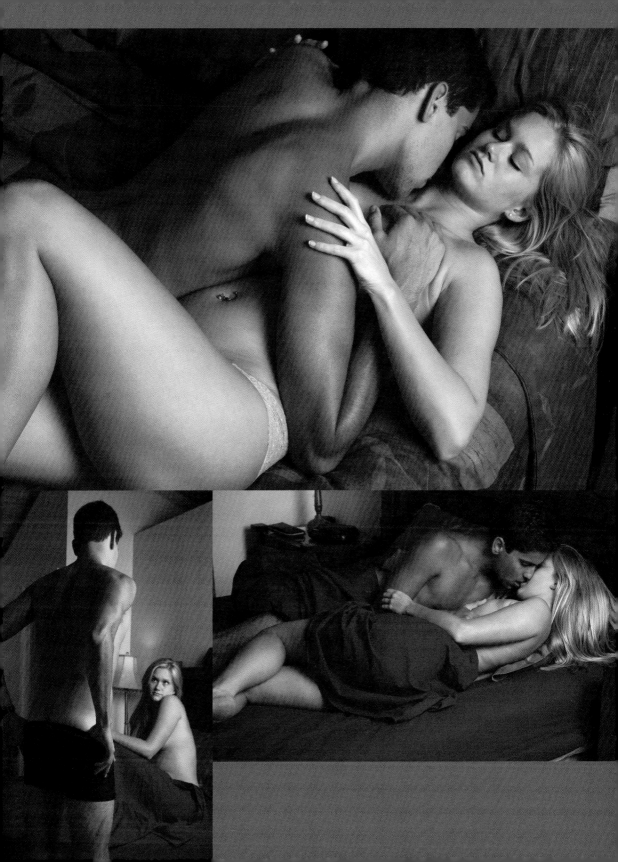

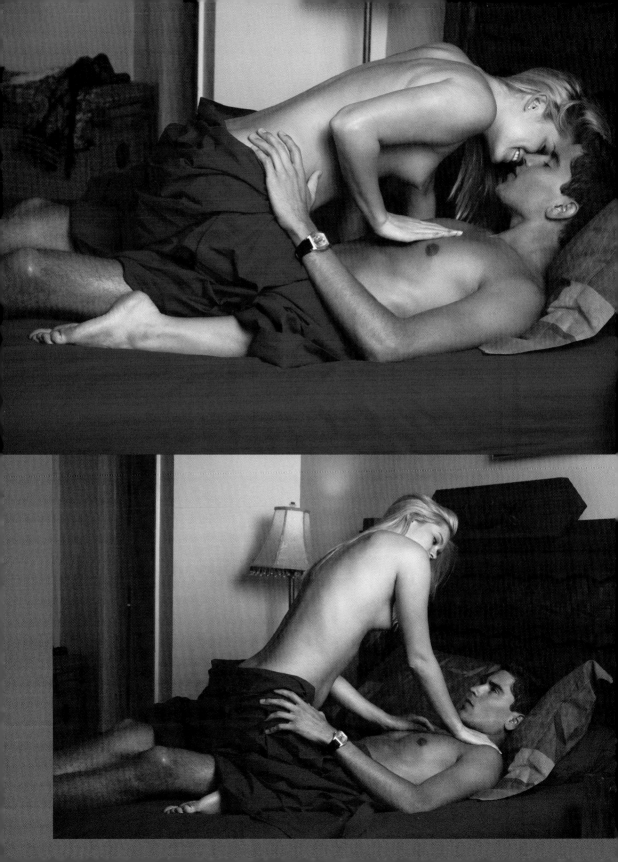

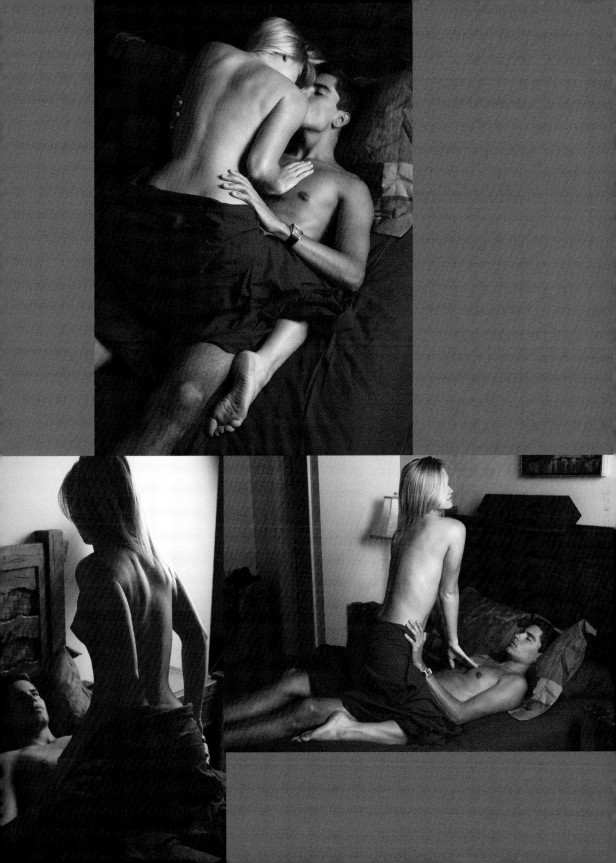

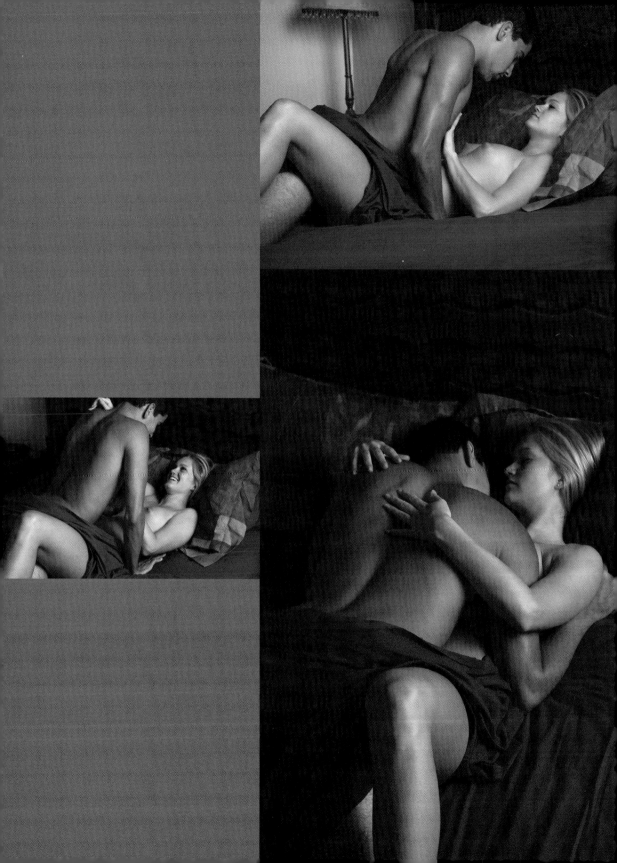

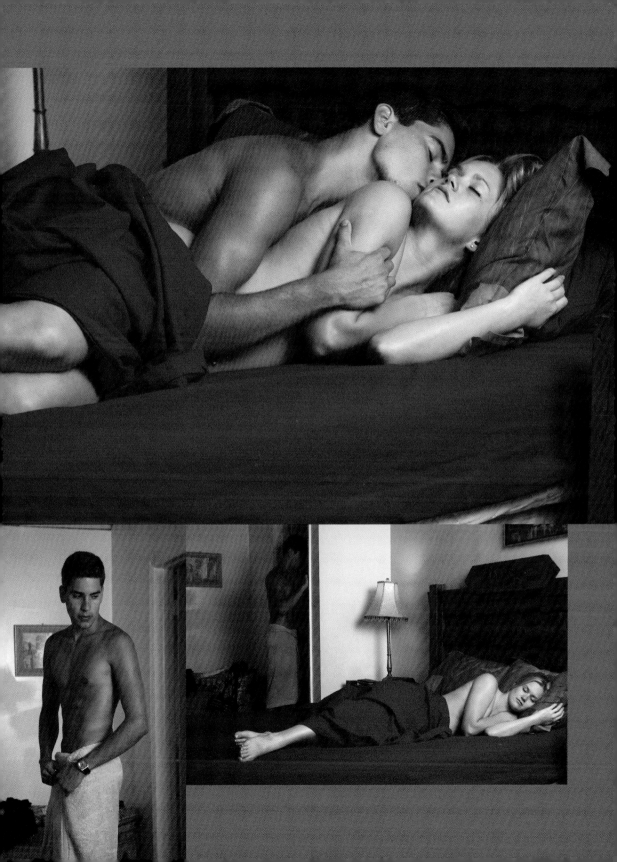

My Penis

by **RENÉ-MARA**
LARGE PRIVATE UNIVERSITY

I GREEDILY SCOUR THE INTERNET for free porn. I masturbate every chance I get. I emotionally detach myself from the people I am sexually involved with. And I am a NOT a guy. Though I am missing the Y chromosome, when forced to define myself sexually, I must admit that I am "manly." I find myself wondering: how much of my sexual identity defines the way I perceive myself?

Through no fault of my parents, who incidentally are great people, I grew up repressing my sexuality. It

> ## Through no fault of my parents, who incidentally are great people, I grew up repressing my sexuality.

would be both convenient and fashionable to blame my past sexual woes on "the oppressive nature of society," even though the word "society" becomes meaningless with such careless use. The true reason behind my repression was much worse: ego. I was a conceited elitist, forever seeking ways to rise above everyone around me. Sexuality represented a baseness that I wanted to avoid, allowing me to ultimately look down on those not as morally enlightened as myself. So, I hid behind the veil of being straight edge. I was Catholic at the time.

Yeah, I was an asshole.

Within the span of one year—that being, of course, my freshman year of college—I awkwardly worked my way through sexual discovery, complete with the wonderfully clichéd drunken hook-up that culminated in the loss of my virginity. It also, unfortunately, led to the disintegration of an important relationship with my cousin. A few words

Looking back, I realize that the sex was terrible: it hurt; he came within five minutes and was too drunk to "find the hole."

of advice: if your cousin comes to visit you from Texas with his devastatingly handsome loser of a friend, it is probably not a good idea to fuck the friend, multiple times, with your cousin in the room one of those times, and then deny it.

But I am being honest when I say that the overall experience was worthwhile. Looking back, I realize that the sex was terrible: it hurt; he came within five minutes and was too drunk to "find the hole." He thought that he was quite the Casanova. I didn't have the heart to tell him that he was terrible in the sack. He left for Texas at the end of the week to return to his life as a high school senior (note how I tried to casually slip that in). I wasn't bitter and really don't care if I ever see him again. But my cousin felt that he needed to defend my honor, whatever that means, and hit his friend. Apparently, I was taken advantage of, even though I distinctly remember knowing exactly what I was doing the entire time. I'm glad that my cousin was able to educate me on how I should feel about losing my virginity; it was most helpful.

I am happy to have avoided the nonsense and pain of emotional attachment that many girls feel upon waking up next to the guy that popped their cherry. At that point, I viewed virginity as something to be over with—the true spirit of a man—so

that when I meet someone I care about I am not completely inept.

I may have lost my virginity to this "stud" from the south, but my real sexual awakening didn't come until I finally came. I had tried masturbating with little success a few times during my high school years, but immediately felt guilty and upset with myself for even attempting such a thing. I threw away the phallic-shaped toy I had tried in vain to use, fearing that every time I saw it I would be reminded of how I let myself fall to such depths of depravity.

I had to wait until I was eighteen to finally have an orgasm. I assure you that I have been making up for lost time ever since. One evening, while stoned, I was watching TV, and felt the urge to touch myself. I settled into a rhythm and soon experienced that characteristic explosion. I loved the feeling of complete harmony and escapism, even if it was so short-lived. Attention to all the guys reading this: girls like to masturbate, and if they are at all like me, they do it a lot. Good luck finding a chick that will admit it, though! After all, being sexually intelligent isn't a desirable characteristic for young women.

I must confess that I do occasionally exhibit character-istic feminine qualities. Feeling down about the lack of male suitors in my life, I made the bold

and pathetic move to sign up for an Internet dating service. I have no qualms about revealing minute details of my sex life, yet I find myself embarrassed to admit that I was lonely and desperate for some male attention.

Anyway, from what I saw on his profile, Jason appeared to be a normal guy, or at least as normal a guy who signs up for an online dating service can be. I met him on Friday, we fucked on Sunday. I'm not a slut, but I am sometimes naive in my romantic pursuits; I thought we had a "connection." It was the night before my nineteenth birthday and I was completely happy, as any person would be having sex after a nine-month dry spell. I remember glee-fully singing "happy birthday to meeeeee" on the walk back to my apartment. We soon slipped into the routine of meeting at his apartment and having sex. I knew that simply fucking him did not consti-tute a relationship, but I rationalized the situation by making excuses: I argued that his busy work

As I was leaving the next morning he muttered from underneath the covers, "Have a nice day." That fucker. Knowing then that I would never see him again, even if I couldn't admit it at that moment, I replied, "Oh, I will."

schedule only allowed us to meet late at night at his apartment What else is there to do but have sex at that point in the night?

I fell for him; I fell hard. I assure you that it was beyond my control. He is a twenty-three-year-old brooding sarcastic musician; I never really stood a chance. One night, I asked him what we were doing, to which he replied: "I am not looking for a relationship right now. I was burned bad by my ex-girlfriend." I probably should have been more cautious after having seen pictures of his ex-girlfriend filtering through his screen-saver on his laptop. I also probably should have asked him what he was looking for before I had sex with him. I casually said that I was cool with the situation. Using this opportunity to his advantage, Jason then informed me that he intended on starting the patch in order to kick his addiction to cigarettes. I thought, "great, he cares about his health." But then he unleashed the world's greatest "breakup" line, even better than "it's not you, it's me." He explained that his severe addiction to cigarettes would cause him to experience intense physical withdrawal, rendering him unable to see me or call me for the next few weeks. I stared at him quizzically for a few moments trying to comprehend what had just taken place. I'm not sure which is worse: that I tried to understand and sympathize with his alleged plight, or that I ever thought he was worth my time. As I was leaving the

next morning he muttered from underneath the covers, "Have a nice day." That fucker. Knowing then that I would never see him again, even if I couldn't admit it at that moment, I replied, "Oh, I will." then left.

No problem, though, because I am the modern woman, able to fuck around for the sake of fucking, right? As a perennial optimist, I choose to see the good in this situation: I learned a lot about sex and my own body. I found myself in positions I thought I was too shy to try. I learned where to place my legs, how to read body language and find a rhythm between two otherwise colliding forms. As fun as the sex was, I must clarify that to this day no man has ever given me an orgasm; I have had to continually rely on myself because I am just that awesome—or, in my fantasies, Angelina Jolie is just that awesome.

Since I just lied about being optimistic in an attempt to be sarcastic, and I am, in fact, very cynical, I must recognize the bad in this situation: I allowed Jason to make me feel cheap and insignificant, to reduce my feeling of self-worth.

There were a number of other unfortunate experiences preceding my month-long delusion with Jason. There was Aaron, who basically forced his cock down my throat at a party, then came on my chest. At the time, I thought it

130 **boink**

was the greatest thing as I stumbled back to my summer apartment and somehow ended up at my friend Megan's apartment instead. I was relieved to find that she was still drunk too. We took a shower together (sorry to disappoint: even though I do like chicks, we were too tired for any action beyond standing naked in front of each other trying to unlock the mysteries of the hot and cold shower handles).

Then there was the morning I woke up next to a girl named Jessica and that same bastard Aaron, under some odd mesh curtain hanging from the ceiling in the apartment of a Saudi Arabian exchange student. Seeing that I was awake, Aaron grabbed my hand and pulled it down to his dick, indicating that he wanted a hand-job. Annoyed and feeling physically ill, I tried to free my hand. He was rather persistent, but eventually gave up and released me. After his failed attempts at sexual gratification, he informed me that my gracious hosts had prepared a Saudi-Arabian feast for us and that it would be terribly rude of me not to eat. Apparently he must have forgotten that trying to force someone not as strong as you to perform sexual acts isn't exactly polite or gentlemanly either. So with my head still spinning, I found myself eating spicy chicken and chunks of rice with my already defiled hands. Splendid.

Seeing that I was awake, Aaron grabbed my hand and pulled it down to his dick, indicating that he wanted a hand-job.

I have bragged to friends about all of these experiences and many more as though they are conquests. In my attempt to take control of my sexuality I have let myself be defined by the people, more specifically the guys, I am involved with. In the process, I have lost the power and self-respect that I so desperately seek. I talk about sex like I am a man and I move from experience to experience pushing personal boundaries and gender stereotypes, but to what end? There is little substance behind anything I've done so far.

Despite this realization, I can't honestly say that I will never again have sexual misadventures or make mistakes. As a human, it is impossible to control. To quote Jerry Seinfeld: "It's like my brain is facing my penis in a chess game." But after my (metaphorical) penis has won the past few rounds, I think it is my brain's turn to take the lead. I guess maybe I am an optimist after all.

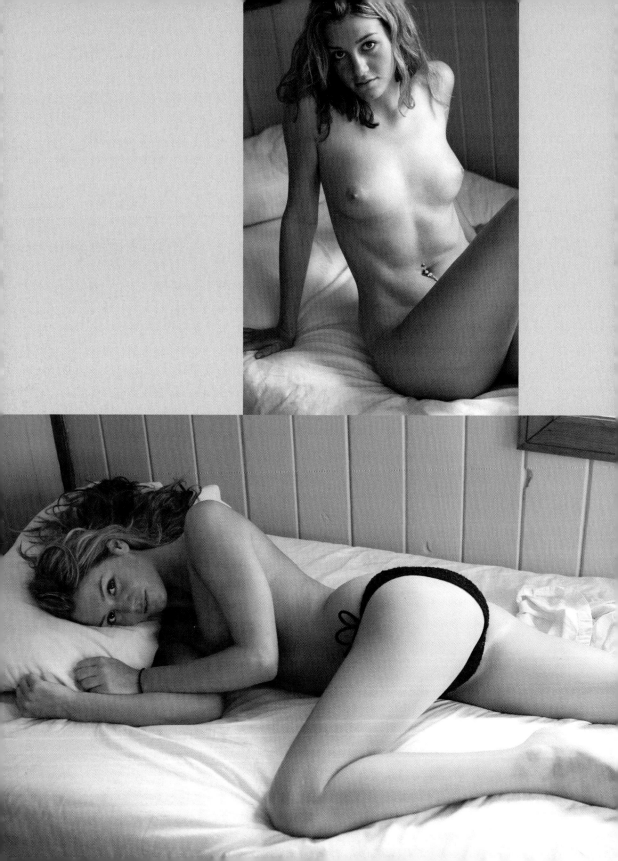

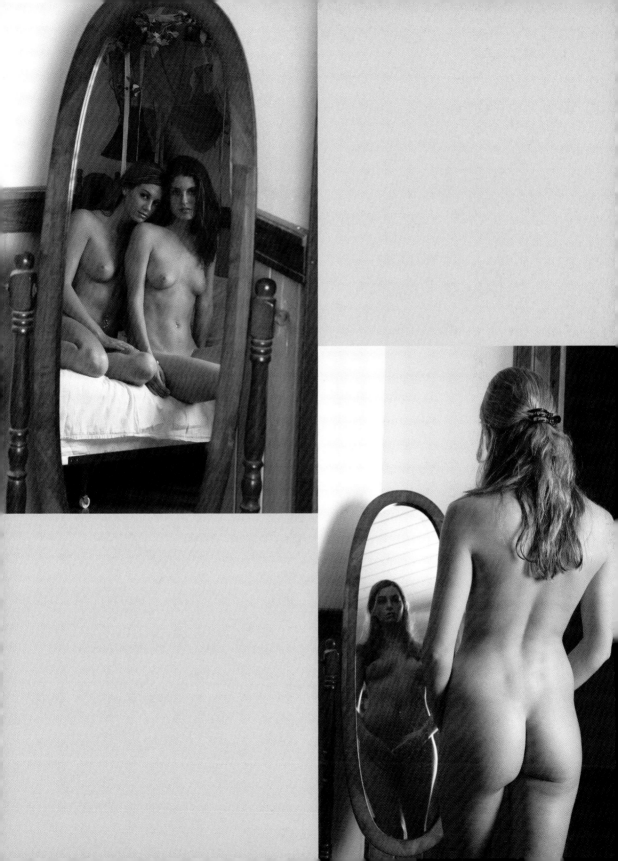

Breaking Bottles

by **GARY**
PRIVATE UNIVERSITY

I'M ANGRY. KIDS ROAM AROUND campus at night with Ginsbergian glasses, looking like they want answers. Trying to start up the beat again, are they? Well it's not about looks, you know. I watch them slowly make their way towards my Civic, over the horizon of my dashboard, these people who think that as long as you can see it—even feel it, hear it, touch it, smell it—that it's there, that people will respect it. How can I tell them that it's not about perception? How can I explain a true Kerouacian cowlick (as opposed to these carefully shaped, street-lit shams) isn't the result of hair gel? It comes from sleepless nights, crouched in a corner with dilated pupils, fearing what's inside of yourself.

A seagull cries above, from the top of a telephone pole.

"Dude, that seagull's fuckin' loud," one of them says. I'd like to lean out my window and tell them that it was also a trumpet solo and a person crying and an alarm clock, and that their artsy glasses imply that they should already know those things the professors don't teach. But I'm breaking up with this girl in my car and I have to pretend to be thinking about that, when I really just want to be on a balcony in the Avenir Hotel in Paris. The red light district. Just watching the prostitutes below me, and thinking "Shit, I'm in France."

"So what do we do now?" she says, raising a bottle of Coke to her lips. The Coke hangs there, suspended like the apple in Magritte's *Son of Man*. I wait; making sure it was a defense mechanism and not actual thirst that caused the bottle to rise. It's a glass bottle, which I

Yet I distinctly remember thinking, "Here was a real girl, with real things, and real sadness." And I was dizzy with the authenticity of it all. Lying there, in the grass, panting, she had whispered that she liked the danger of possibly being caught.

didn't even think they made anymore. I don't know where Heather gets all that legit stuff from, but she has somehow attached herself to its insides. Her mother died in October last year and poof, all of her objects suddenly had history.

Our friendship had ended that night after the funeral, among her objects and the gravestones, in sorrow and in lust. But even then, as we found ourselves palpating each other in the shadowed cemetery in some mutual quest for solace, I was just falling in love with the objects she had surrounded herself with. Our consummation was just the start of an endless trail of Mongolian scarves and antique tea cups. Yet I distinctly remember thinking, "Here was a real girl, with real things, and real sadness." And I was dizzy with the authenticity of it all. Lying there, in the grass, panting, she had whispered that she liked the danger of possibly being caught by a ghost. I didn't laugh. I remember, I didn't even smile. I was naked and there was dew all over everything. She was on top of me and all I could do was watch as she bit her lip and transformed our friendship into Eros before my eyes.

The Coke bottle's still up there. She can hold it as long as she'd like, pretending not to face the moment, but the condensation—clinging to the label—is slowly stripped off by gravity and occasionally drips into her lap making dark circles on her denim skirt. I watch one bead as it travels down the letter "C," tracing the contour of the bottle and then drops; thinking to myself: you couldn't hold that one up, could you?

She may have heard my thought because the bottle was suddenly put back in the cup holder. She unbuckled her seatbelt, got out of the car and walked

around it twice, tied her shoe on the front right tire, then got back in and rebuckled her seatbelt.

"I really don't know. I just know I'm not happy," I say, shuffling my feet in their little automotive compartment, shifting the snow mat around. The Beat kids have drifted away and their echoed shouts, saturated with red wine because that's what they think they should drink, sound somewhat convincing because of the distance. To these people alcohol and pot are more than entertainment. Drunk or high is the norm they should naturally revert to—it's their state of suspension—when they don't have any responsibilities to perform, which is most of the time. I've never been high in my life because I'm afraid that before I know it, I'll be one of them. I'm afraid I'll like living like that.

I'm not very critical because, of those few men I respect, most share that proclivity. Reefer-smoking jazz great Louis Armstrong titled one of his records *Muggles* as a tribute to his favorite herb. Open up any autobiography from Charles Darwin to Johnny Carson and they all reminisce about their college days—and many others—spent getting plastered. Johnny Carson once said he was a responsible drinker; he only drank in places that had walls. Maybe I am the one who is out of the loop, missing the libation of success. Somehow it got them places.

I hear a smash. The coke bottle is missing. It went out the window with a half-hearted lob. See, that's what happens. I don't pay attention and glass breaks. Those guys who walked by with the tight pants, they make their living off of not paying attention and don't get any crap for it. It's what they pride themselves on, what they write about. I once read a piece by one of them:

I don't care about anything. Even this.

That's the garbage they expect to make a living on, raise a family on. Red wine and bad poetry. They think that's what it's all about just because right now it's getting them laid. And here I am, getting laid, and not liking it because my future is

"I'm going to be lost without you" really means "I won't have anyone to waste my life with."

racing away from me, toward the horizon, like some hyper-speed plate tectonics.

"I'm going to be lost without you." She moves her hands to her stomach the way my mother did when my sister was inside her. If there was actually something in there I would cock my head, like a bird that suddenly notices the bars all around it. That's not the way it's supposed to be.

"I'm going to be lost without you" really means "I won't have anyone to waste my life with."

"Heather, we can still talk to each other." And why did you throw your bottle out the window? Because it was an artsy thing to do? Because it seemed like an unclassifiable and unscripted action? That's what you live for, right? I think to myself that, if it hadn't been for me, that bottle would still be alive. It could still help liquids to defy gravity; to stand vertically instead of just flattening out in a puddle. That bottle had power and I screwed it all up. Goodbye to the last glass cola bottle on Earth. I'm just wasted from exhaustion now because it's late and I want to be in my bed but I can't move the car until Heather wanders out in to the night and fades away into the streetlights.

"This just sucks. I don't understand why you're doing this. I try really hard to be a good girlfriend. Can I do anything better?" Teal good-luck ring. Israeli hookah. Socks from an authentic Nazi uniform.

"I hate that I love you. Doesn't that make sense?" I had a hard time getting that out. It was the point of no return. I'm really not like those people. My glasses are big because it's easier to see things. I don't carry condoms around with me, like candy. I don't know what color my boxers are right now. I like not having that pressure.

"I'm gonna have no one left. It's gonna be hard to have no one," she says as her hand reaches down for a cigarette in her pocket. She forgot that they're not there because she's trying to quit. The hand returns to her lap.

"I know. It's gonna be hard for me too." I can't check the clock without turning the car on but it's probably around 3:30 now. I don't even know what's going on anymore.

"Well, do you wanna just fuck then?"

"Excuse me?" I thought we had almost reached the end of the road.

"We don't have class tomorrow. And after tonight I'm not gonna wait around for you to change your mind. I'm gonna move on and find someone else. So this is it."

"Do or die" is the way that people live these

days. As if extreme emotions are insurance against not really being alive. After her mom died, I bought into that for a bit. We always ran around saying "Okay, I'm all in," because anything less wasn't living. We thought in terms of "do or die." But that's over, so totally over.

"How about I just drive you across the turnpike back to your dorm and we call it a night?" The tears start now. Mascara and sadness and illogic, all dripping down her face. Tear ducts must not have much logic if all it takes to get them pumping is the prospect of one night with no sex. I didn't see that coming.

So that's the release. Everything we've said has finally become real. I've been in a cockpit for hours, flipping every emotional button and trigger I could find, trying to shoot off some sort of sympathetic firework that would suddenly give the night enough significance to make the whole thing still seem real in the morning. How depressing that the trigger was what it was.

As she sobs, I finger my keys, the notches, the rings, bringing the whole clump dangerously close to the ignition. Hardly breathing, I eye Heather while lining up the key. It's so close, and she's not paying attention, so I slam it in.

Starting the car, I drive across campus, with the radio booming, air blasting, tears dripping, leaving the broken bottle in the parking lot for some sucker tomorrow. Past the gate, past the hitchhiker statue, I pull up in front of her building, the car still running.

The headlights hit the wall. Heather gets out, taking her tote bag, grabbing some of her miscellaneous objects she spots buried in the nooks of my car. There's more than she first expected and she has a hard time carrying them all. She kicks the door closed with her sneaker, still sobbing, and walks up toward the building, huddling over her items as if they were a child, afraid the air might cause them to catch cold. Silhouetted against the wall by my headlights, she looks like a convict escaping from jail.

I see a skeleton key that doesn't open anything slip to the ground. Then a pair of movie star

"I hate that I love you. Doesn't that make sense?" I had a hard time getting that out. It was the point of no return.

sunglasses. Soon, in a cathartic avalanche, her arms go limp and everything piles down around her. In her surrender, Heather appears almost to be floating, unbound, looking up and bawling into the heavens, surrounded by a halo of her items. I just sit there in my tiny car because she's intangible now. It's lit up like a movie set on my windshield. She's so lost out there, bawling behind the smudged glass. So disoriented and so beautiful, like heather, the plant.

I would like to smoke it—heather, that is. I imagine it tastes like a soul and would fill me up with something that could combat this tepid image of life: the freeze-framed wrongs, partially committed, that stare down at me with punk-ass expressions; and the now scattered pieces of garnet-colored glass that used to keep me going.

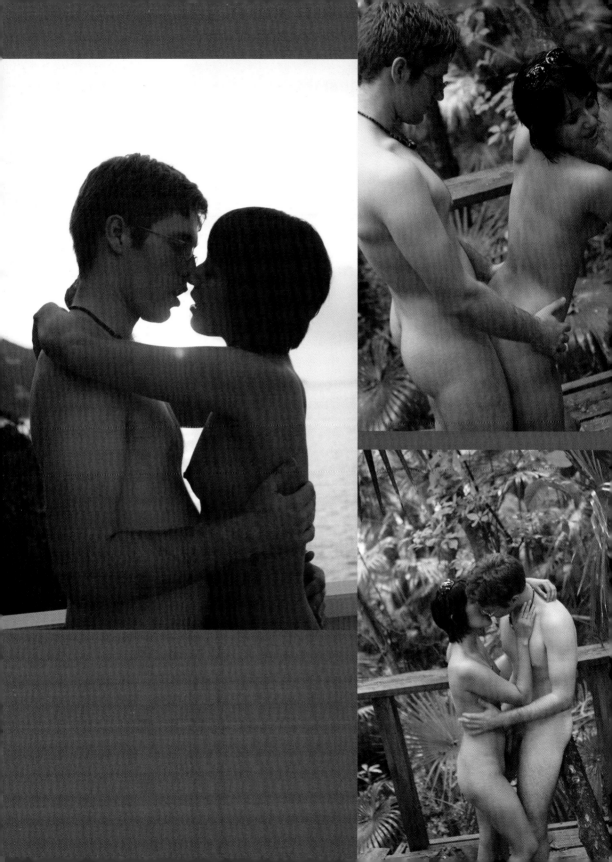

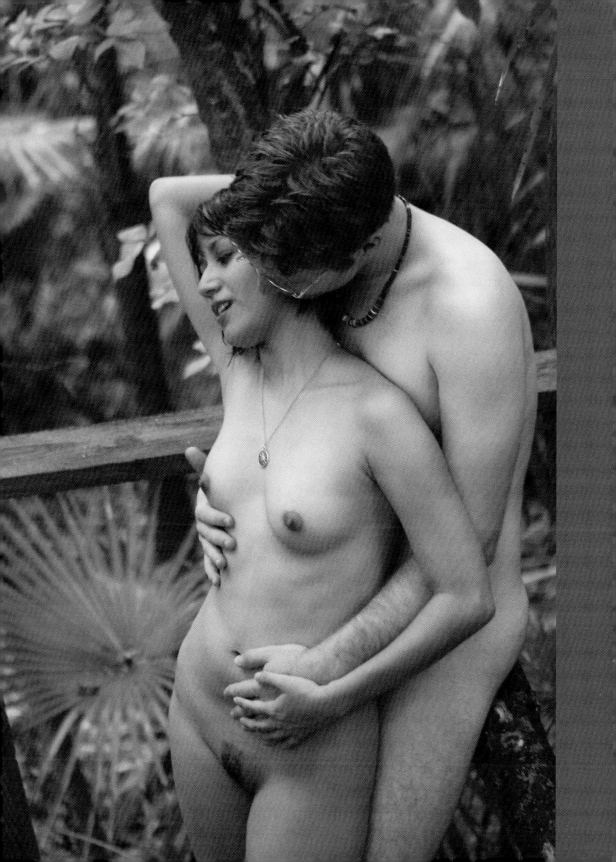

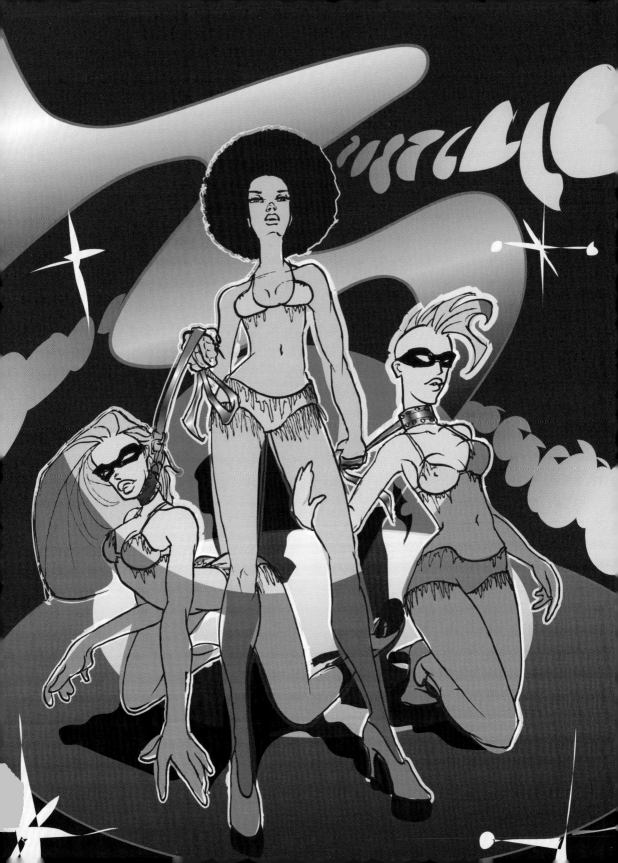

Inside Joke

by **VANESSA**
PRIVATE COLLEGE

"SO THIS THING HAPPENS how often?" I asked Jordan as we walked toward Club L & L. The L's stood for "Leather and Lace."

"About once a month," he replied as he took me by the hand and led me toward the bouncers at the entrance.

We didn't have to wait in line outside the place because Jordan was on the guest list. Of course. He knew one of the promoters so we didn't even have to pay the cover. But as we walked up the steps, I could feel the eyes of all the people behind the velvet rope upon us. I looked back at them and smiled sheepishly, trying to let them know that I really was one of them, not some arrogant elitist who didn't stand in lines.

Jordan was the sexiest boy in my creative writing class. He was twenty-two. He was also a poet, a bartender, and had a hook-up just about everywhere in the city. I was barely twenty-one and although we were classmates, I still felt a little star-struck by the preferential treatment he got when we went out. We had been seeing each other for a few months, and the relationship was hot and happy, if not overly serious. That night, we'd decided to try something a little different. Jordan had heard about this fetish/art show, so we picked that instead of a strip club, which was the other idea we'd been considering. I guess something billed as "performance art" seemed a little more respectable. But the truth was that we both just really wanted to see some tits, a fact about me that I hadn't yet shared with Jordan.

"Is it the same artists every time?" I asked.

"It varies—there are so many people into this freaky shit, they apparently have hundreds that want to be involved."

As soon as the doors opened, the noise began to envelop us. I had to raise my voice to ask, "So what are we in for?"

"My buddy tells me there's usually a bunch of visual art; paintings, photos, sculptures and stuff. There's supposed to be a burlesque tonight, sometimes there's a topless fire-dancer, and a fetish fashion show too. God, it's crowded."

Inside the club it was so dark it took a few seconds for my eyes to adjust. Red lights, hidden in the floor, gave the place a cave-like feel. It was packed. People were practically standing on top of each other, yelling to be heard over the DJ's throbbing house beat. The room was steamy, and smelled like a combination of Mai Tais and latex.

"This is crazy," I said.

We'd spent the previous few Saturday nights very low-key; lounging in sweatshirts, watching movies, drinking beer, and of course having sex. So I felt like I'd stepped into another world. I was dressed for clubbing. I had tight pants, heels, and a white, low-cut top on. But I looked completely out of

But the truth was that we both just really wanted to see some tits, a fact about me that I hadn't yet shared with Jordan.

place next to the Halloween scene at L & L. I hoped that I wouldn't feel uncomfortable the whole night.

We slowly worked our way through the sea of bodies toward the bar. Upon reaching our destination, we ordered two Jack and Cokes and clinked our glasses in recognition of our adventurous sprits.

"You are a little vixen, you know."

I nodded and thanked him, charmed, as usual. Jordan was exactly the kind of boy I liked—confident without being cocky, and a little androgynous. He had adorable curls and long eyelashes. He waxed his chest, which his friends gave him shit about, but I loved. He also had the most beautiful cock I'd ever seen—perfectly bowed upward to hit my G-spot.

"So when's this burlesque supposed to happen?"

He looked at his watch. "Should be any time now. Feeling antsy?"

"I guess." I leaned in. "I feel totally weird here."

"You mean because we look so normal? I feel a little out of place, too."

Looking around the room it seemed like everyone else was wearing an elaborate get-up: retro, leather, Goth, girls in rubber dresses, men in drag, it was as if every sexual sub-culture had a representative present, in full uniform. I felt like I was in some bizarre movie or perhaps I was witnessing the back lot party at a studio that had just shot a sci-fi flick, a porno, and an Andy Warhol bio-pic. There was exposed flesh everywhere you looked.

I maneuvered us toward the stage. Jordan was directly behind me, pressed in by all the other people. We reached the front just as the MC signaled that the show was about to begin.

Jordan snuck a hand into the side of my pants, and pulled me by my hip closer to him. He massaged my lower back a little, which he knew made me crazy. I pressed my butt up against him, hoping to feel him get hard.

He announced we were about to witness the sultry Amber and her obedient Subs. Three girls came out on stage accompanied by the sound of deep drum and bass. They were all tight-bodied and very attractive. They had on bright blue-fringed hot pants, blue bikini tops, and platform stiletto heels. But two also wore black eye-masks and studded collars. They vamped around, bumping and grinding in unison, kicking their legs up high and flipping their hair to the music. The music was primitive, rhythmic and hypnotic. Jordan snuck a hand into the side of my pants, and pulled me by my hip closer to him. He massaged my lower back a little, which he knew made me crazy. I pressed my butt up against him, hoping to feel him get hard.

After dancing for several minutes, the girls all turned their backs to us, pulled the strings undoing their tops, tossed them over their shoulders, and turned around to reveal three sets of perfect breasts. The tall black one in the middle, obviously Amber, produced a metal leash which she clipped to the other two girls' collars. I bit the inside of my bottom lip and threw a look back at Jordan, who mouthed the word "Wow."

Amber was clearly in charge. She held the leash, leading the other two around while they crept toward the crowd and back again. Finally, she jerked on the leash, and the two girls stood still with the chain taut between them. Amber glared at the audience and I could have sworn that she was staring directly at Jordan and me for several seconds. She then spun around, bent over, and grabbed her ankles, fully exposing her ass to the crowd. With a jerk on the lead the two slaves obediently moved to her side, got down on their knees and began to lick the back of her thighs all the way up to her butt cheeks. I fidgeted a little, feeling the warmth between my own legs beginning to rise. After several minutes of this "grooming," Amber stood up while shaking her hair, put a hand on each girl's head, and pushed them to the floor simultaneously. They began licking her feet and toes as she towered above them. Mimicking feline behavior the slaves began to paw at each other. Amber watched them as their play escalated until they were wrestling and tumbling on the floor of the stage in a ball of skin and fringe. Finally, Amber reasserted her control and led them off stage on all fours.

Jordan reached around and gently closed my gaping mouth. When his hand touched my face my body responded with a shudder in acknowledgment of the increasing sexual tension.

"What do you think?" Jordan said.

"Hot! I don't think I've ever seen anything like it."

The DJ was still playing, but the noisy reaction of crowd swallowed the music. We were still packed in. With Jordan's cock pressed against my backside, I started thinking about getting out of there and getting busy. Sensing my mood, he wrapped an

his eyebrows and smiled. Then she leaned over and kissed him too, and I was surprised to find that I didn't feel at all jealous.

"I'm Jordan," he said, as she let go of him.

Amber was the personification of grace and self-confidence. I couldn't believe she was totally at ease, balancing on two-and-a-quarter-inch Lucite heels in the middle of a crowd that had just seen her mostly naked.

"Are you going on again later?" Jordan asked.

"No, I'm headed home," she replied, "I'm having a few people over, do you guys want to come?"

Jordan looked at me. "What do you think?"

"Why not?" I said. "I was just thinking it was time to get out of here."

.

As we followed her white Honda through unknown neighborhoods, I told Jordan I was worried about what he thought when she kissed me.

"I was worried you'd get jealous, too," he acknowledged.

"I'm not, honestly. I guess I trust you."

"Courtney, I really, really like you. I don't want to mess that up. I won't lie, I'd like to be able to experiment, but if what we might be getting into tonight is too much..."

"Oh shut up," I said, and smacked him on the thigh. "Are you saying you want to be my freaky boyfriend?"

He laughed and nodded, "I guess I am."

"Perfect," I said. "Now let's go to this party."

I could have told him then that I was into girls too, and I was starting to feel a little embarrassed that I hadn't done it earlier. But, I was still secretly a little nervous about what we might be getting into. I still wanted to do it, but I silently shared Jordan's concern that it might mess things up between us.

.

Amber lived in a gorgeous old house. She must have had roommates, but we couldn't tell who they

> To my surprise, instead of shaking it, she pulled me in and kissed me on the lips. She was a warm mixture of glitter, sweat and vanilla.

arm around me and we started swaying to the underlying beat.

Amber appeared moments later, in a lavender silk robe and a white scarf taming her afro.

She stepped off the stage right next to us. "Thanks for coming," she said in a velvet voice, her fake eyelashes swishing. "I'm Amber," holding out her hand to me, "I saw you two from the stage, you guys are newbies, right?"

"I'm Courtney, how could you tell?" I said self-consciously glancing down at my outfit as I took her hand. To my surprise, instead of shaking it, she pulled me in and kissed me on the lips. She was a warm mixture of glitter, sweat and vanilla. I didn't know what to do. I worried that Jordan would be upset. "Great show," I said as I pulled away. I looked over at Jordan. He raised

were because there were people everywhere. Even by candle light, I immediately noticed that we were once again inappropriately dressed. Everyone there was in robes, lingerie, or nothing at all. Some were kissing, fondling, and even having sex. There were baskets of condoms and bottles of lube everywhere. All the furniture was covered with dark blue sheets. More tribal music filled the place.

"Are you serious?" I said to Amber, as she disrobed and dropped her clothes in a hamper by the door.

"Oh yeah," she replied, "This place is serious. It is also by invitation only, strictly adult, consensual, and safe. Got it? Nobody exchanges fluids other than saliva. There are clean sheets in every closet. If someone says 'no,' you leave them alone. Sorry for the smack down, but rules are rules."

We nodded.

"You can play with anyone you want," she said, "but I invited you, and you must come with me first." She smiled at her little pun.

She poured us each a glass of wine and led us to a bedroom at the end of the hall. There was one other couple, lazily kissing on a couch. When they saw us with Amber they acknowledged her and left the room. Amber lay back on the bed. I had moment of panic. Then I thought "what the hell," if Jordan can handle this

then he can handle anything.

As Jordan and I sipped our wine, our eyes met, and we both started nervously laughing.

Amber eyed both of us. "This isn't really your scene, is it?"

"No," Jordan said, "but I'm curious."

"Me too," I chimed in.

"That's what I figured," Amber smiled. "Take a few deep breaths, we'll just take it slow, okay?" She grabbed a remote from her bedside table and as the stereo lit up, Jill Scott's voice, smooth and relaxed, floated toward us.

Before I could ask her what exactly we were supposed to do, Jordan had taken my hand, squeezed it, and pulled me down on the bed next to him. Amber moved to the other side of him and he

I gave him a wink and repositioned myself until I was straddling his face. I leaned against the headboard for support while he sucked gently on my clit. Meanwhile, Amber rubbed a condom onto his cock, doused it with lube, and began to fuck him while she played with my hair.

took turns kissing me, then Amber, then me again. The taste of vanilla on his lips, which I'd recognized from her kiss, was intoxicating. We slowly undressed each other until both Jordan and I were as naked as Amber. The light played off her ebony skin, and I reached across Jordan to touch her. She closed her eyes, and Jordan watched as I slowly began

exploring her breasts. She quickly reciprocated and we were soon rubbing our thumbs in little circles on each other's nipples.

Jordan was on his back, still transfixed upon us, with his cock at full attention. "Hey, don't forget about me?" he playfully chided.

"Never." I gave him a wink and repositioned myself until I was straddling his face. I leaned against the headboard for support while he sucked gently on my clit. Meanwhile, Amber rubbed a condom onto his cock, doused it with lube, and began to fuck him while she played with my hair. I could feel his lips hum against me as he moaned with each stroke. But he was careful not to neglect me despite his growing excitement.

When Amber sensed that he was close to coming, she knowingly stopped and suggested that we change positions. Once I was on my back, she crawled on top of me, and dangled her breasts over my mouth, while Jordan knelt behind her. I began sucking on Amber's puffy nipple while Jordan put on a new condom and slid into my pussy. No lube was necessary at this point. And as he moved in and out we both took turns fingering Amber. I could feel the orgasm rising in the pit of my stomach, and as my tightening muscles urged Jordan on—he pumped faster and faster. I

could hear Amber's breathing quickening too. I reached up to caress her cheek, as Jordan continued his assault with one arm now hooked under my thigh allowing even deeper penetration. Amber responded to my touch by moving her own lips to mine, and arched her back to ensure that Jordan's free hand still had full access to her. Her mouth was sweet and warm, and Jordan was hard inside me, my hands clutched desperately at their bodies urging them on until I finally exploded. I came so hard that my bucking motion pushed Amber back into Jordan, knocking him off balance just as he started to come. Suddenly we were a tangled heap of heaving flesh, like the casualties in a round of naked Twister.

We lay there for a while, panting, unable to move or speak.

"You little liars," Amber finally managed with a chuckle. "You acted like virgins when you got here."

Jordan and I just laughed.

When we finally began to recuperate, Amber asked if we were ready for round two. We looked at each other and thanked her, then politely declined. "I think we've had enough for our 'first' night," Jordan told her. She nodded graciously in reply, kissed us both again and left the room to attend to her other guests as we got dressed.

• • • • • • •

On the way home we were both starving. So when I saw a sign that said "Joe's Diner, Open 24 hours" I insisted that we stop.

"I love after-sex eggs," he said, spearing his scramble.

"Jordan, I need to tell you something."

"You've done that before, is that it?"

"Not exactly," I said, "but, I guess you should know…"

"You've been with a girl before?" He was not accusing. He was just asking.

"Yeah," I said. "But there is no need to be jealous. If I'm in a relationship, I'm in a relationship, you know? I won't fool around with anyone else, male or female, if that's the agreement we make."

"But you did just fool around with someone else," he said, pointing his fork at me.

"Doesn't count."

"Why not? Because I was there?" he asked. I nodded. "Okay. Just for the record that was really hot, but not something I want to do all the time."

"That's totally fine, me neither," I assured him.

"So, are we laying some ground rules or something?"

"Yeah, no fucking anyone else unless we do it together?"

"Deal." He sipped some coffee.

I breathed a sigh of relief. Jordan started laughing.

"What?"

"This!" he said, and pointed at his placemat. I looked down at mine and read the words "AWESOME THREESOME." We both moved our plates to reveal the breakfast special: the threesome was pancakes, eggs, and bacon for $5.99. By the time the waitress came over to clear them we were both nearly rolling on the floor laughing.

"What's so funny?" she asked.

"Sorry, it's just an inside joke," Jordan said.

"Yeah, you had to be there," was all I could manage before cracking up again.

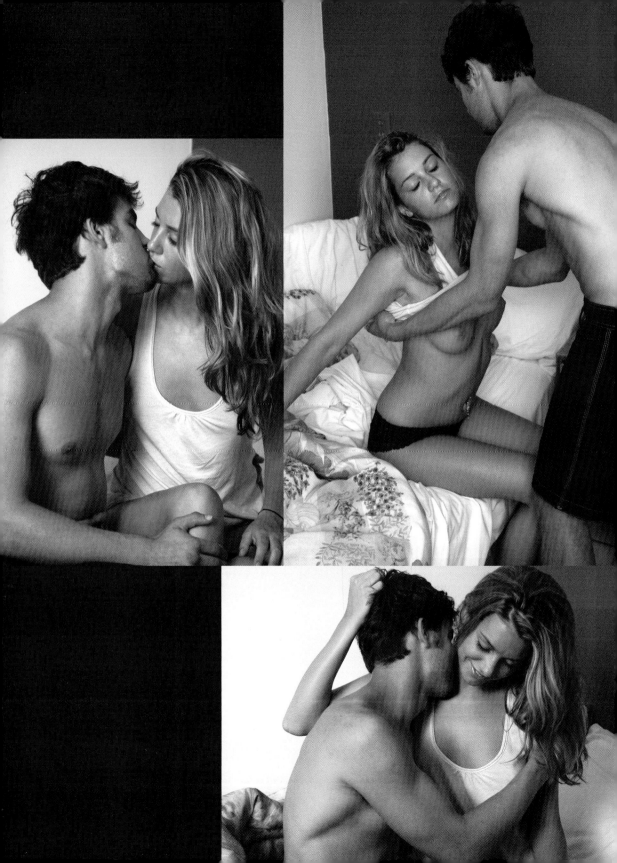

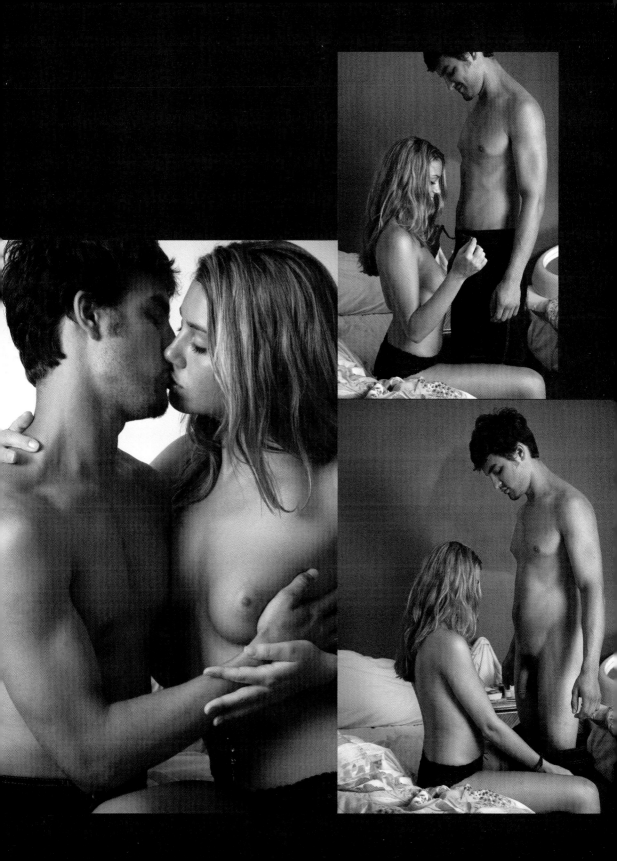

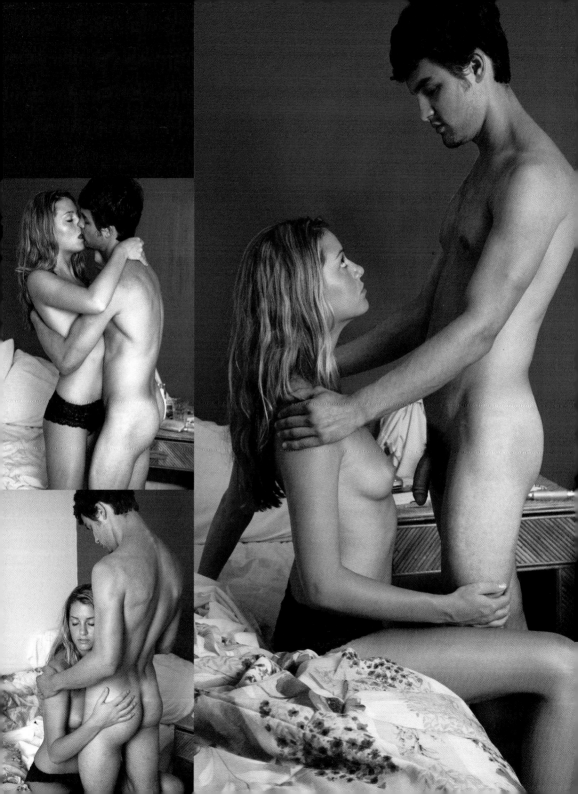

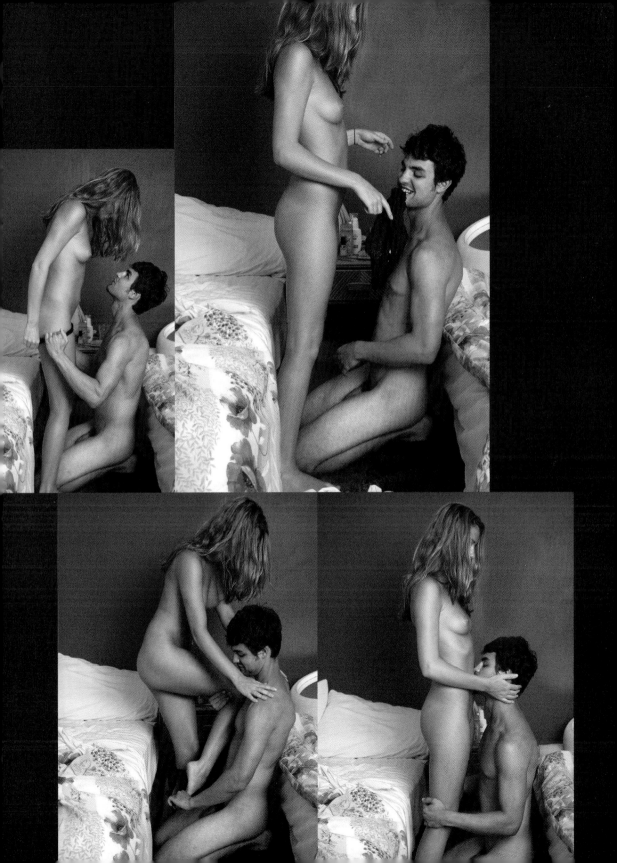

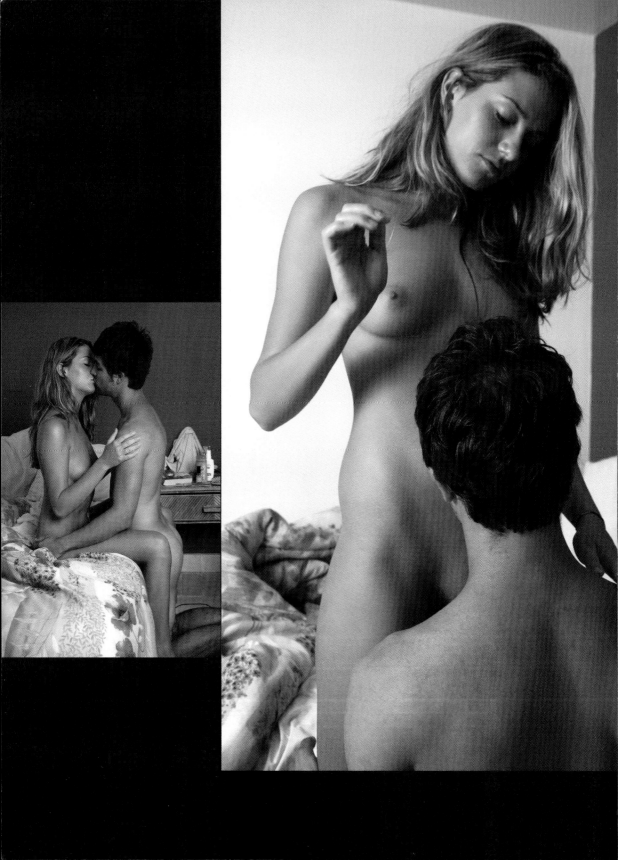

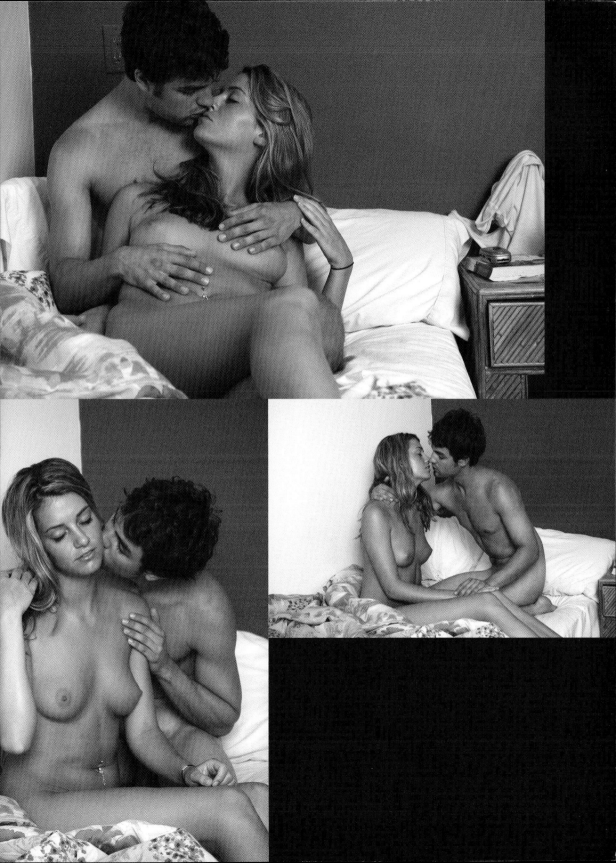

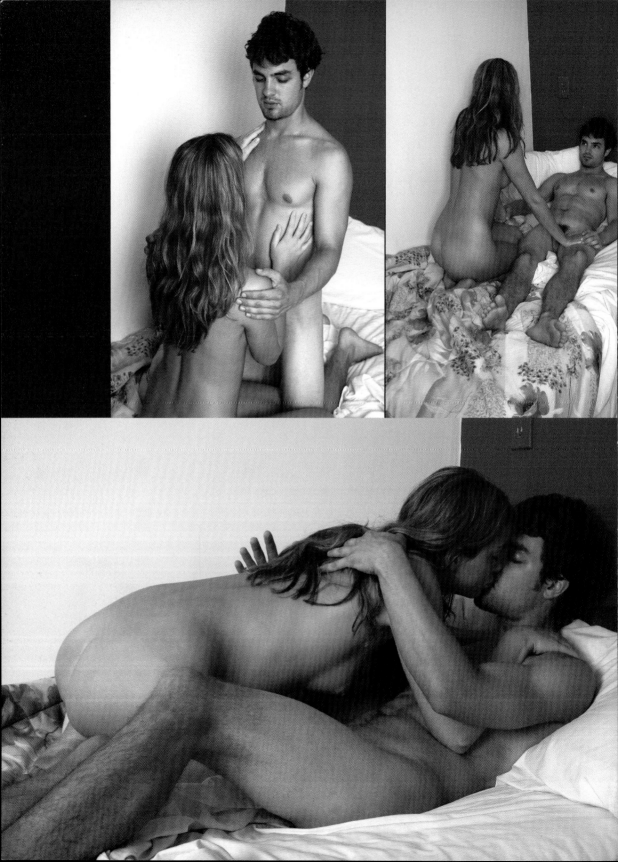

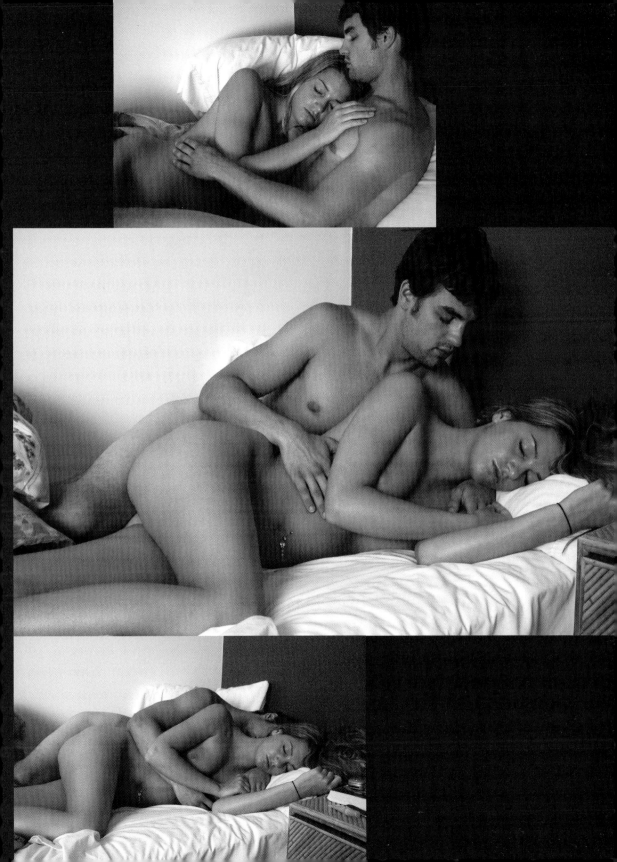

Being Queer
(But Not Being Gay About It)

by **JORDAN**
PRIVATE COLLEGE

WHEN I WAS SIXTEEN, I HAD this really pretty girlfriend. I liked her and so did everyone else. She liked me; it seemed perfect. And even though I often thought about having sex with her, I kept refusing. My excuse was that the physical pleasure would be outweighed by the eventual pain on account of the raging mental disorders which she kept trying to smother to death underneath a big happy pillow of perfection. But I was sixteen and still really horny, of course, so I ended up having sex with my best friend and breaking up with her. I justified my actions concluding that it would have never worked out, we were too different. She liked that really crappy Christian-leaning band Switchfoot and Thomas Kincade paintings. I liked the Sex Pistols, Kurosawa films, and boys. My best friend was a dude.

As it turned out, my three-year-long habit of downloading those thirty second preview clips from male-on-male sodomy websites actually meant more than I thought it had. That's not to say I was never interested in girls or the prospect of fucking them, I had always liked straight porn too. But as the relationship with my closeted-psycho girlfriend progressed, I found myself becoming less and less interested in the prospect of the sex we were never going to have.

Admittedly, I was always a pretty "gay" little kid. I indulged in many of the gateway habits of a future-gay child: I was artistic and sensitive, good at conversation and dancing. I even liked shoe shopping and drama class. But I guess I was able to offset suspicions in high school by adopting interests that lend themselves to being a bit aesthetically queer: punk music, French literature, and self-taught Japanese and guerilla

As it turned out, my three-year-long habit of downloading those thirty second preview clips from male-on-male sodomy websites actually meant more than I thought it had.

filmmaking. I masked any stereotypical developments of effeminacy with varied, cultured interests that branded me merely as "strange" rather than "homosexual."

I never fully realized my innocent little attraction to my best friend was overtly gay, until the night we kissed and fondled and fucked on the floor. We never did it again, never even so much as brushed hands or talked about what happened. But after it happened the realization hit me that maybe I could completely categorize my sexuality with those tragic three letters I had long ignored. I started going around town looking

for people with similar interests, the primary one being the enjoyment of fucking other men. But I quickly discovered that the local gay scene was full of effeminazis whose only concept of culture was the interracial orgy portrayed on last week's episode of *Queer as Folk*. I was quickly alienated from the "community" for my failure to care about who swears they blew a Backstreet Boy or what dosage of creatine is best for optimum gym results. I didn't know the words to "Seasons of Love," never wishfully sang "Girls Just Wanna Have Fun," and never tried to emulate a sassy black woman's vocal patterns to make my lame comebacks sound wittier to my straight girlfriends at the club on Friday night. As it turned out, the only gay friends I did make were all lesbians who seemed to have active, admirable interests in art and life, and who introduced me to Michelle Tea and told me not to trust Kathleen Hannah.

My life as a gay male ended almost as soon as it began. I certainly wasn't interested in dating or having sex with the fellows I could meet at the weekly *Sex and the City* viewing parties downtown. And my best friend, the only boy I had ever felt really attracted to, had found a girlfriend and was happy with her. I was all but resigned to a celibate life of isolation and self-loathing when one of my lesbian friends showed me

an old copy of this radical 'zine called *J.D.s*. The Xeroxed pages—now faded, staples weakly holding on—contained this totally thrilling, unapologetic mess of Sharpie-scrawled homo manifestos and queer punk cut-and-paste icons (think: scummy shirtless boys with chest tattoos) just begging to be worshiped. Splayed across the cover was the formative philosophy of *J.D.s*—"Don't Be Gay." With that, I understood the central psyche of the so-called "Queercore" movement that *J.D.s* and its creators were promoting, a mentality that I too would embrace as my own sexuality developed.

Queercore, as I learned, started in the mid-80s as a counterattack to mainstream gay and lesbian orthodoxy on behalf of radical, typically punk-affiliated queers. The movement criticizes the self-segregation of gender and sex supported by the larger gay community, instead aiming to promote sexual diversity and non-normative behaviour. Queercore is characterized by its punk attitude and inherent DIY culture as a means of conveying its beliefs in radical self-creation as a necessary tenet of identity—blending the subcultural style of punk with the necessary logistics of homosexuality, something not normally supported by such rough and tumble crowds. Yet, Queercore is above all dedicated to rejecting the conventions of homosexuality. Moreover, the movement rejects the idea that sexuality must be ultimately definitive of one's own personality, affiliations, actions or attitudes. *J.D.s*, published by G.B. Jones and Bruce LaBruce, was principally responsible for introducing the movement itself. Indeed, it reinforced something I could not ignore, instructing me to not be "gay"—but to be something better, smarter, tougher.

This publication helped me realize that you don't have to be gay to be queer. I finally understood that I could be the cool kid I always wanted to be without having to wear any sort of orientation on my sleeve. Fucking guys is something I do sometimes; loving dudes is an occasional

But I quickly discovered that the local gay scene was full of effeminazis whose only concept of culture was the interracial orgy portrayed on last week's episode of *Queer as Folk*.

by-product of my sexual needs just as sex is sometimes born from love. But whether you are queer or not doesn't mean you have to let this one aspect of your persona totally define who you are. If people ask, I state it simply: I love, and sleep with whomever I want.

Discovering the true nature and psyche of my sexuality has also meant discovering other people just like me, appreciating that not every man who sleeps with other men is a total stereotype. Sure, it took me a while to figure it out, to understand who I am by virtue of who I am not. But I get it now; I really get it. And, well, I think that's pretty cool.

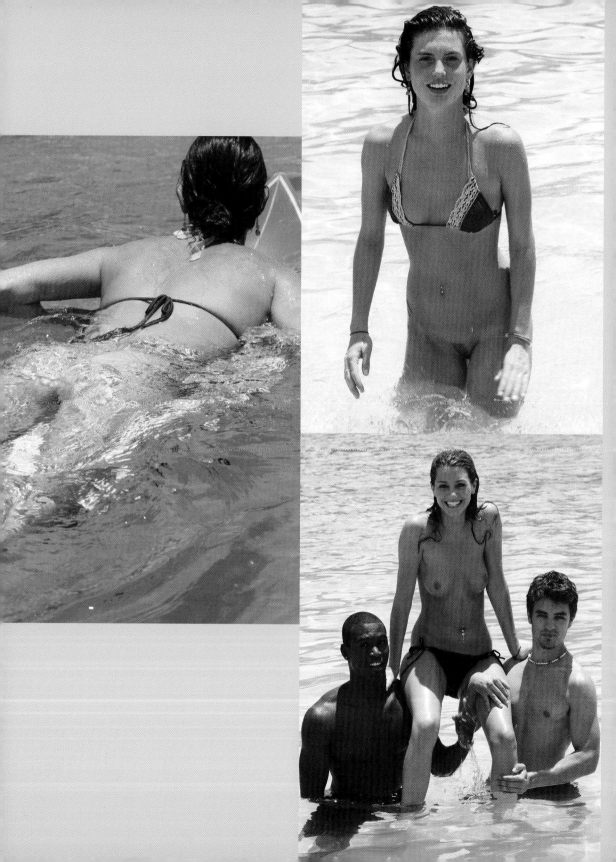

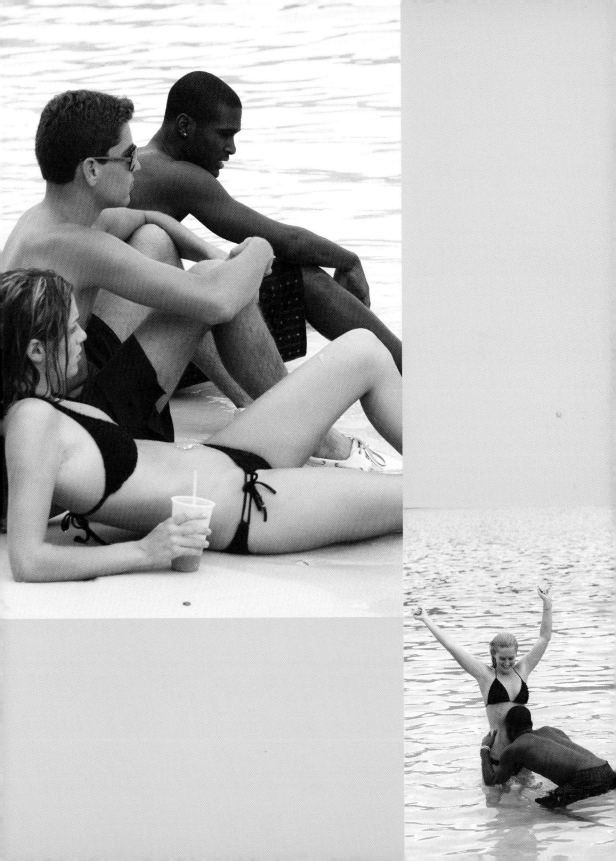

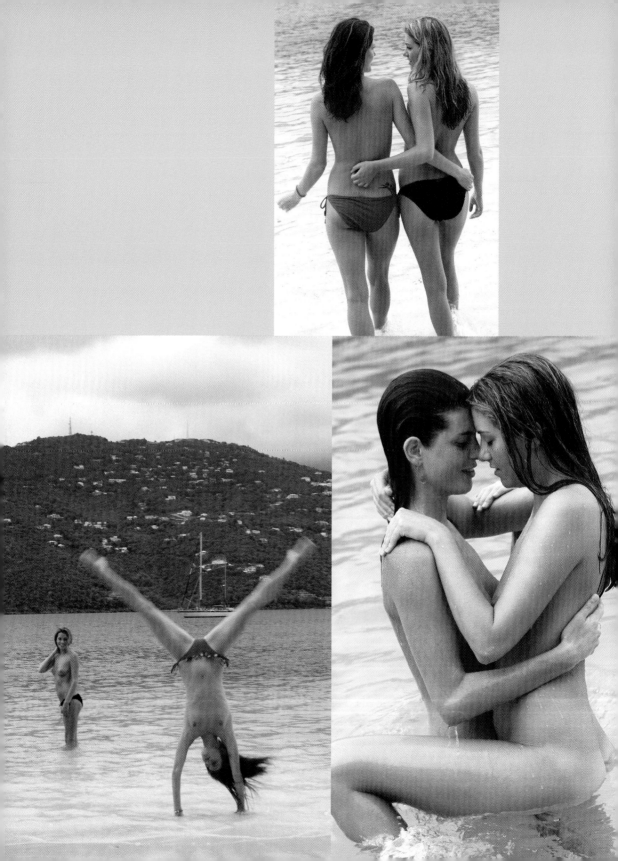

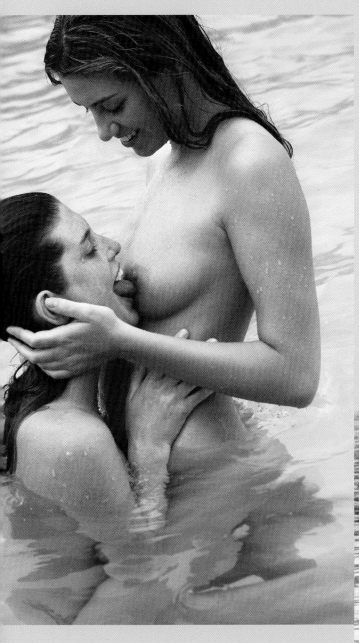
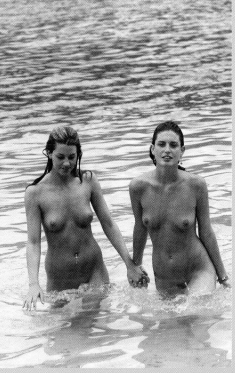

Madness

by **SAMANTHA**
STATE UNIVERSITY

IT'S A FAMOUS STORY among our friends, now: "how two of our roommates fell in love." But talked about incessantly, it, of course, either gets simplified or over-dramatized in the retelling. Though it's hard for me to imagine a version more dramatic than the real events.

It started with a kiss that would make any guy drool. Halloween weekend of freshman year, drinking in the back room of our dorm, we were drowning in sexuality and Natty Lights. Just a few months out of high school and here I stood, surrounded by horny guys and equally horny girls. By now, only a few weeks into our friendship, the sexual energy between Jen and me must have already been tangible. Somehow we ended up making out in the middle of the room surrounded by rowdy guys. We woke up the next morning hungover with alcohol oozing out of our pores.

Jen and I slept in the same bed every night, but it didn't seem strange since she was good friends with all my roommates and the five of us always stayed up till early morning talking. I remember cuddling with her like I cuddled with all my best girl friends, except I didn't want to move when she had her arm around me, fearing she might think I was uncomfortable and switch positions. I didn't mind that my arm fell asleep every night; Jen was comfort for me and I looked forward to her warmth.

By now, only a few weeks into our friendship, the sexual energy between Jen and me must have already been tangible. Somehow we ended up making out in the middle of the room surrounded by rowdy guys.

Jen, Melissa, me lying on our futon. The room is dark. Melissa, one of my roommates, is asleep after watching the movie. She's snoring and the DVD menu screen keeps replaying its circus music. The air is hot and Jen's breath is in my ear. We move closer to each other. I don't think. I can't think. I turn my face slightly. Her breath is on my cheek now. More. Her breath is on my mouth. I taste her without touching her. Our lips touch. Tongue to tongue. Melissa stops snoring, we turn our heads and giggle quietly to ease the pressure between our legs.

Every night after the first "real," sober kiss we would cuddle a little closer and steal more in the dark. We perfected the silent kiss, trying to hide our desire from our roommates. On drunken nights we would dare to go a little further, especially on those when we left the party early to sneak back to the empty dorm. I marveled at her perfect

little nipples and she touched me in a way I had never known throughout my high school years of dry humping and neck sucking. Always willing to try anything once, I went down on her first and had to assure her that licking pussy wasn't as bad as we all had imagined, before she would reciprocate. In the morning, we'd try to wake up before anyone else so we could put on the panties that were hidden in the sheets or change positions so it wasn't so obvious that I had my hand down her shorts.

This became our routine: hang out before, between, and after class, cuddle at night, sneak kisses whenever we could. After a while, it didn't seem scandalous at all. The whole relationship—despite the secretiveness and the seemingly taboo aspect of the girl-girl situation—felt simply natural. We loved each other. Remarkably, it seemed, gender wasn't an issue.

But we never did allow ourselves to be open about our relationship. We never announced exclusivity. Instead, we allowed our friends to find out in their own good time (when they happened to walk in on us or when they realized that that sound at night wasn't rain pattering the window but tongues exploring). We still brought home guys on an almost weekly basis, presumably to keep up "straight" appearances. This was mutual torture. Having heard me moaning in the next room, Jen would cry into my shoulder when I finally kicked the guy out and came to bed. I would burn with jealousy after watching some guy fondle her in the corner of a frat house but then quell my anger with her pussy when we got home. But we both became less and less forgiving with every heterosexual drunken hook-up and gradually the anger and painful jealousy transformed into rage.

It was around this time that my group of friends thought it would be fun to form a "fight club," to deal with the frustrations of being around each other all the time, every day. There were unspoken rules—no biting, scratching, pulling hair, etc. and no hits to the face—but it never really got violent

until Jen and I decided to go at it. We'd take turns punching each other repeatedly in the arms and legs or we'd wrestle with so much pent-up frustration (I always felt like shouting, Why can't we be open about this? Why do you still kiss other people? Why are you so devastatingly needy? Why don't I stand up for myself?) that bruises would build up on our bodies. I remember a guy pointing to my bruises and asking me during an English class, "Jane, are you in an abusive relationship?" I answered with a smile, "Yes, with my best friend," and we both laughed. Why did we laugh?

Freshman year came and went. Most of the time, it now seems, Jen and I spent in bed talking and crying and opening up to each other in a way that neither of us had ever done before. When asked if we ever got sick of each other, I'd respond "When I'm with her, I feel like I'm with myself." We were the proverbial peas in a pod.

When we moved into our own room in a neighboring dorm for sophomore year, we decorated it with a pug calendar and pictures of us. The first day officially living together we argued about who used the wrong screws for the futon. And the tension never lessened. There were the mornings that she woke me up and motivated me to study and there were the nights that I gently pulled her shirt over her head,

Occasionally the fights would turn very dark. Bottles of pills would appear in Jen's hands with the threats. Always the threats.

being careful not to disturb her soccer-induced dislocated shoulder. But the screaming fights continued and she would grip me so tightly afterward, not wanting to let me go for fear I would leave forever. And we played this game with ourselves, trying to "break up" this relationship that was never really whole: "We shouldn't kiss anymore. We're not good together. Tomorrow will be our last kiss." Our friends advised going cold turkey. But frequent nights after smoking pot in the neighbor's room, we couldn't stay away from each other. Our love was the elephant in the room that we kept trying to hide behind the 70s-style curtains.

Occasionally the fights would turn very dark. Bottles of pills would appear in Jen's hands with the threats. Always the threats. But the next morning: "Where's my allergy medication?" "I threw it out

I don't know why I keep living with Jen, when the relationship was so mutually destructive.

with all the rest of the bottles." Jen is unstable, I would think. We must take care of her. I must be there always to protect her. So I'd have sex with her to calm her, to keep her mind off the pills, to fill the void. But sex began to be accompanied by nausea, and I knew that I was starting to isolate my heart from my body when we were together. I was building a wall between us.

I detached myself more and more, trying to avoid the severe claustrophobia I felt whenever she nuzzled me and told me to never let her go. I slept over a guy's house once, twice, and didn't come home until morning. She'd cry, scream, pout. The second time I woke up with eighteen voicemails from her, including one saying goodbye. I took the elevator up to our room on the seventh floor, getting more nervous with each floor. Would I see her dead in the shower? I could imagine checking for her pulse. What would I do then?

She was alive, but had taken twenty Sudafed, the only pills we had in the room. She had written a suicide note. "And I peed before I took them so I wouldn't piss myself," she confessed. Her heart was racing and she obviously needed medical attention. But she refused: "I have work!" Six hours

later, we finally got her to the hospital and sat in the waiting room watching the Super Bowl.

Jen had made a lot of enemies that night before taking the pills. She kissed our friends' boyfriends, picked fights, demanded attention. But we put aside the anger to focus on getting her help. Things started looking up. We breathed a sigh of relief. But, of course, something like that doesn't just blow over.

Things continued to change. I pulled away more than ever, pushing her to depend more on her other friends, and even started to date a friend of a friend, long distance. I kept it as secret as I could, only talking to him on the phone when Jen wasn't in the room and never talking to her about my early-relationship excitement. Of course, she knew what was going on and could feel that the sex was becoming one-sided. I couldn't just lie in bed all day with her anymore.

I sneak into the other room, after our night of frat house parties, to say goodnight to Jeff. I'm smiling, listening to his voice, feeling the butterflies of growing attachment. Jen busts into the room, yelling something I don't remember, and hits the phone out of my hand. The battery breaks and slides across the floor. She pushes me. I fall backward into a closet, gripping the clothes around me to keep from falling over. She comes at me and I'm legitimately afraid. I dodge her and run out of the room and upstairs to our friends' room. I sense her following me.

Crying in my friend's arms, the main thing on my mind was not the fact that I had just seriously felt afraid for my safety, but rather concern for Jen. Only when I knew that she was with a mutual friend was I able to get control of myself.

We spent the next day on suicide watch. Jen lay on her bed nearly comatose, while we called Jen's therapist, and finally went to our Resident Assistant for help. A young South American man, a resident therapist, came to our room and offered support. It was fruitless; Jen wouldn't talk to anyone. Two of our friends and I watched *Finding Nemo* while Jen lay on her back, tears in her eyes, staring at the ceiling. I was next to her, holding her hand. Eventually, the others left and I told Jen stories until she fell asleep. The next day, she decided that she needed to transfer schools after the quarter ended.

I don't know why I keep living with Jen, when the relationship was so mutually destructive. I think I saw our relationship as split into two very different, contradicting halves: the connection between best friends, and the bond that defined her as my ex-lover. While she attacked me as an ex-girlfriend, with all the jealousy and fury of a person whose love was no longer returned, I comforted—I wanted to comfort—her as a best friend. I was able to be strong for a friend, but inside my rage and frustration were building exponentially.

Drunk Saturday night. I hook up with some guy, come home, something snaps. I'm not thinking; I can't think. I grab scissors and slide them against my forearm. Blood oozes. Jen comes home, sees me, calls our friend Brittney. Meredith, our suitemate, comes home, takes Jen into the next room while Brittney sits with me.

My muscles tense, fingers squeeze into fists, eyes clamp shut. Blood runs down my arm, cools and congeals onto my skin, pillow, and sheets. My mouth screams, my body screams. Brittney holds me by the shoulders, fingernails digging into my skin, holding me down while my fingers stretch, reaching toward the scissors, toward nothing. Jen slams open the door, Meredith trailing behind her. They both are yelling.

Blood runs down my arm, cools and congeals onto my skin, pillow, and sheets. My mouth screams, my body screams.

Meredith: "Jen, leave her alone. Leave her alone. Don't go near her!"

Jen reaches for me, pleading, sobbing. My legs flail towards her.

"Get away from me! Don't touch me!" I can't have her near me, trying to hold me. She flies into the unstable coffee table, scattering papers, spilling water, snapping it off its legs. Meredith pulls her up and out of the bedroom door. There are shouts and banging doors and sobs.

I am a ball. Feet tangle in the sheets, knees are tucked under my breasts, blanket over my head. I feel Brittney sitting next to me as I wail.

I press my foot rhythmically against the wall, rocking back and forth. "I can't do this. I can't do this."

My friends didn't tell my parents anything and we all woke up the next morning with the great hope that this would all end when Jen went home the next quarter. We had a week left until spring break and the pressure was coming from all sides. When I, supposedly the strong one, finally broke down, our friends didn't know how to handle it anymore. We needed escape, release. The week between quarters was that escape for most of us. But I was just starting to face reality.

I'm at home in Indianapolis over spring break. At a neighbor's party I down five, six cosmopolitans. Beer after beer after beer. I black out, then eventually make it home and supposedly call Jen on my cell phone. "Fuck my life. I'm going to lie here forever. Forever. Alone." Jen is helpless, four hours away. She calls my house. My parents run upstairs. I'm on my bed, blood smeared everywhere: on the carpet, on the tile, on my sink, on my clothes, and on the sheets. Fuck you Mom! Fuck you Dad! Fuck Jen fuck Jen fuck Jen! Mom leaves my room, Dad takes out his hearing aid so he can't hear me screaming, swearing at him. He watches me in horror, waits for my head to spin and green slime to spew from my mouth.

I awake the next morning, still drunk. My arms tucked under my body, blood smeared and dried. My eyes puffy. Face swollen. Mom asleep on the floor.

I really never wanted to kill myself, no matter who tries to convince me otherwise. I never slit my wrists with the intention of bleeding to death; I took a blade to the side of my forearm simply because I needed to feel pain. I felt so many conflicting emotions—I still do, but I guess now I can deal with it day to day instead of suppressing it and letting it emerge all at once in a drunken craze—and I wasn't used to feeling such deep hurt, anger, rage. I just wanted to bring that pain to the surface and I didn't know how.

My parents made me see a therapist, but it took me a long time to stop spouting what I thought she wanted to hear and actually open up. I started talking not only to my therapist, but also to my friends and family, about how trapped I had felt in my relationship with Jen and how helpless I felt. I had always tried to keep up happy appearances while I dealt with Jen and our desperate situation on my own. My catharsis came when I realized that I was allowed to show sadness and anger and pain on the surface. And that I was allowed to ask for help, or even demand it.

"When we remember we are all mad, the mysteries of life disappear and life stands explained."

Jen visited me a few weeks ago and it seemed that the impossible had happened: we were able to just be friends. After a year during which I couldn't talk to her without having a panic attack and another during which we tried to rebuild our friendship over the phone, we finally were able go out drinking without screaming at each other or fucking each other. The first quarter after she left school, I remember sitting in the room that was now my own with my body tense and expectant. I realized that I had been in a constant, tangible state of fear and anxiety when we had lived together because I never knew what kind of mood she would be in. We would have good days, but most of the time she would get angry about something and the fighting would be intense. I had to learn to relax again and let go of the fear. As Mark Twain said, "When we remember we are all mad, the mysteries of life disappear and life stands explained." I have experienced madness, the type of insanity that takes hold of your very core. But doesn't the act of falling in love embrace madness? Giving yourself over to someone else, body and soul and mind. Isn't there a touch of insanity in that?

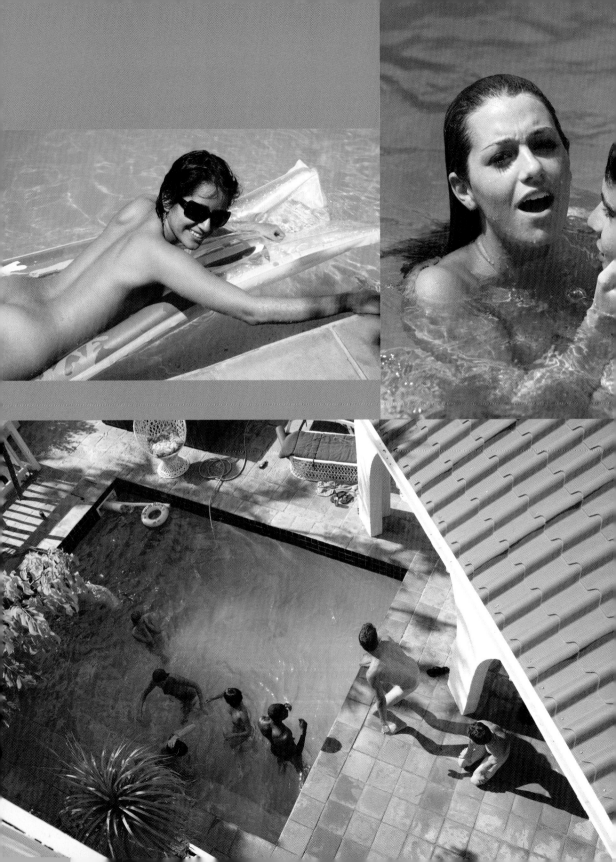

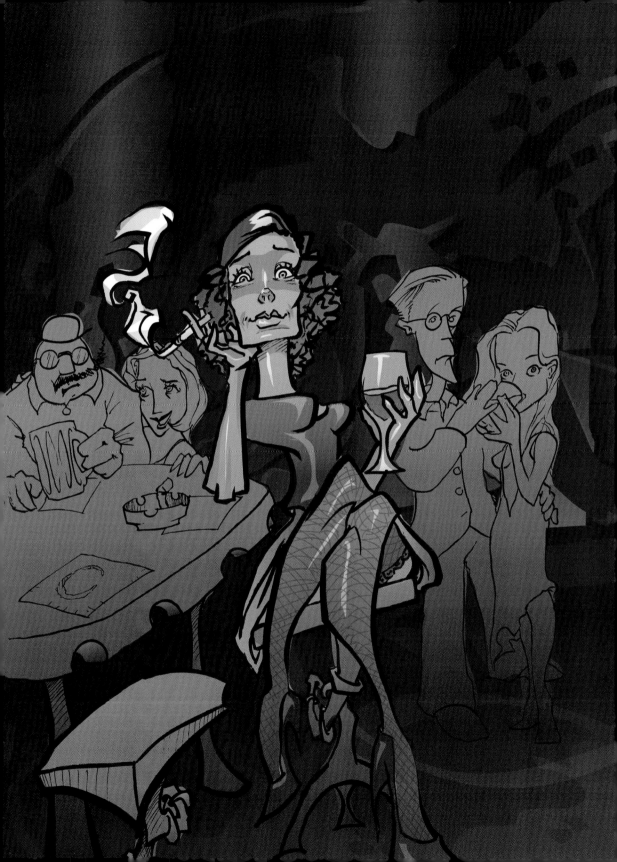

Digging for Ithaca

by **ROB**
STATE COLLEGE

VICTORIA'S LIPS TASTED OF ash and stout: strategic, wise, and drunk as they glided against mine. The pale skin on her neck was smooth but pliable, dignifiedly weighted by its thirty-five years. The dense air of a Dublin summer night curled through the front door and into the hotel lobby. I felt it lick the back of my neck as I turned into the kiss. I was engulfed in a pulsing, warm haze of raised neck hairs, tobacco, and perfume. Lilac. It reminded me of the large, purple flowers that clustered in a corner of my yard, looming high and fragrant in my childhood.

I was twenty, newly single, and in Ireland to study James Joyce during Bloomsday, a national literary holiday held in his honor. At 8:00 a.m. on June 16, 1904, the original Bloomsday, the fictional Leopold Bloom of Joyce's *Ulysses* took his first steps from his front door—his Odyssean Ithaca—and into the Dublin streets. A century later, I was sitting in an academic symposium session, a comfortable,

Most importantly, she wasn't afraid to let our eye contact linger to excitingly uncomfortable lengths.

familiar place for my egghead sensibilities. Twelve hours after that, I was contemplating my first steps away from my better senses and towards a woman who, despite the fifteen years between us, compelled me forward with her ironic humor and her cavalier posture—wrapped in a sleek beige skirt, her legs crossed at the knee, her elbow propped on the table, chin in her palm, and playful, alert eyes. She was kinetic, bold, and assertive. Her laughter was unchained but never too much. Most importantly, she wasn't afraid to let our eye contact linger to excitingly uncomfortable lengths.

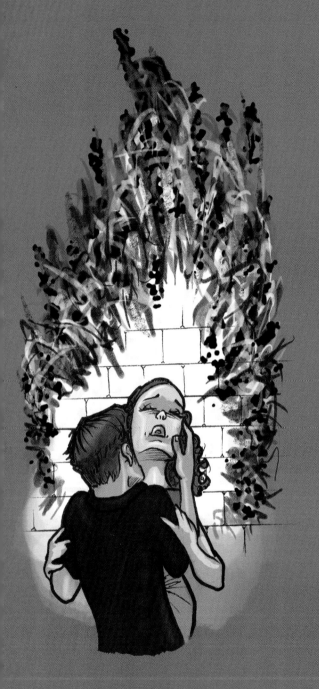

We met just after the exceedingly bizarre Bloomsday street parade. Imagine shutting down the stocky, antiquated streets of dirty Dublin and filling them with puppeteers on hallucinogens. After the avant-garde stilt show, out-of-place African drum ensemble, and drunken street performers, came the finale. To the strains of a symphony, a Joyce impersonator, complete with eye patch and fabric wings, was hefted on a crane, assaulted with ten-foot industrial fans and confetti, and swung recklessly above the cheering crowd. Let's just say I've never been able to view my heritage quite the same way ever since.

I retreated with friends-of-the-moment to a pub half a block from Joyce's statue on O'Connell Street. Victoria was sitting at the far end of our massive table with an older crowd, and our groups slowly mixed. While my young Irish friends played up their accents to the wallets of American forty-year-olds, I wrestled my way through a handful of thirty-something competitors and planted myself next to Victoria. I choked back my apprehension, gathered my wits, and committed. We talked emptily about Bloomsday, Joyce, her photography, my writing, our accents, the shithole politics of my native Boston and her native London—the nonsense conversations you have with anyone you meet abroad until someone gathers the daring to expose a genuine part of his or her personality. Thankfully alcohol was created for that very purpose. Once that hurdle was cleared, we fell into the frighteningly earnest confidence that can only happen among strangers who will never see each other again.

She was returning to school for painting, had a strong literature habit, and was just out of a relationship with a rock-star wannabe who couldn't keep his pants on around his groupies. I was here on academic business, actively seeking misfortune, and two weeks free from a girl I might have married had she not moved a continent away. Victoria drank stout, walked like a lady, and wasn't above popping

a squat in an alleyway when nature called. I drank whiskey, spouted high rhetoric, and had been electrified with cocky ecstasy by escaping a near mugging the night before. She continually fiddled with and admired my chaotic, dirty-blond hair, which bent against her touch, only to spring back like bamboo seedlings. My fingers traced the developing lines on the back of her hand.

We made an unspoken agreement not to ask about our ages at first. By the time we got around to disclosing, it was four hours into the night and too late to back out. We were already hand-in-hand, manacled to our choice with acceptance and laughter.

• • • • • •

It was 3:00 a.m., June 17, 2004. A century before, Leopold Bloom chased the young Stephen Dedalus through the Dublin slums. In this episode of *Ulysses*, the narration slips into a hazy absinthe dream in which Bloom's identity is shattered into the multiplicity of thoughts, expectations, and desires that compose him. Fed by the kerosene of a brothel's red lamp, Bloom's burning mind unfurls itself, fancying him a pathetic victim, a benevolent dictator, a cross-dressing submissive, and all the other manifestations of his id and superego. Bloom eventually escapes the breakdown

unscathed. The readers don't get the same luxury, having had to come to grips with their own fragments being laid before them by Joyce's dissecting pen.

It was another bar, two hours after the hotel. After we'd split from the rest of the group and found a dark corner booth and two more rounds. It was a trashy tourist bar, painted in a dirty, garish yellow that got more offensive with every drink. Germans, Swedes, Japanese, and the ubiquitous Irish-Americans gave us dirty, intrigued looks when they glanced away from the blaring televisions. We didn't care: we entwined and devoured each other as if digging for some hidden treasure without a map.

"You're a gorgeous, lovely woman." I really should have been slurring my words at that point, but I wasn't, "Truly lovely."

She blushed and nuzzled her hairspray-laden brunette curls into my hand. "Stop it," she said.

Victoria drank stout, walked like a lady, and wasn't above popping a squat in an alleyway when nature called.

She shook her head at me and I caught a hint of the embarrassed disbelief that a fourteen-year-old girl must feel when she's unable to handle her first compliment from a boy. She ran her hand along my chin, up my cheek, and wrapped her fingers in my hair. She gave it a tug, she dug herself into the crook of my arm and spoke, her breath burrowing my neck like entrenched wisteria, "I like you. A lot."

Her response shocked me in its youth and simplicity. For all her experience, stories, and years of dating, she treated me with the kind, open affection that usually precedes having one's heart truly broken for the first time. I laughed and tried to say something witty.

• • • • • • •

She was traveling with a man—a roommate. I didn't ask, she didn't tell, but the bed was obviously not an option. But in the pitch black of her hotel bathroom every touch and sound was amplified. He snored on, clueless of the warm bodies on the cold tiles ten feet away. Even though it was only kissing, his presence made it exciting, like the first time you have sex in a car: a dirty, open secret. But we had to stall. Neither of us had condoms. This set us alight with frustration and we dashed to the drugstore. At the hotel door I laughed: she'd forgotten her shoes. I, the responsible one, offered to go back and get them for her, but she grabbed me by the hand and took off, almost skipping as she bounced barefoot through the alleys.

The nosy night porter, who thought we were laughing just a little too much, threw off our plan. His dirty looks drove us into the basement lobby,

insecure manhood: I wasn't a boy being preyed upon—I had initiated contact, out-charmed competitors twice my age, and followed through in a way that the awkward, un-dateable seventeen-year-old I once was could never have imagined possible. Her girlish antics, her blushing, and her young openness contrasted with the bold, travel-wizened, cosmopolitan front she'd put up hours earlier. Just as I was seeking sophistication, I suspect she wanted to temporarily lose the responsibility and good sense that comes with each decade of life. At nineteen you can let yourself fall to pieces

The foreplay was an arm wrestle, except that half the time you were playing to lose.

and—somewhat in spite—to the ladies' room. There, against the stark canvas of white tile and antiseptic lighting, our inner multiplicities cohered, divided, reconfigured, and exploded outward like paint on a Pollock. The foreplay was an arm wrestle, except that half the time you were playing to lose. The scratching nails and gasping breath barely registered, dwarfed by the head games. Social roles and power dynamics twirled like a kaleidoscope: pliant, firm, bitch, butch, sub, dom, cock, cunt, lord, slave. As the elder, she was given authority. As the man, I was given dominance. We shredded these social expectations to tatters, struggling for power and giving it freely as the mood struck.

We indulged in our selves and our anti-selves. It was an accomplishment, fancying myself a man who could convince an older, intelligent, more demanding woman to bed him. It validated a young,

when your musician boyfriend fucks a groupie. At thirty-five you don't have that luxury anymore. I gave her an opportunity to feel guileless one more time.

• • • • • • •

Her hotel window faced west towards Heuston Station, where my Galway train would depart in eight short hours. We returned to her room and watched the sky turn from velvet purple to the otherworldly blue of pre-dawn, wrapped up in each other as the man in the other bed slept. We never ended up consummating. At, literally, the brink of coition,

For all her experience, stories, and years of dating, she treated me with the kind, open affection that usually precedes having one's heart truly broken for the first time.

we hesitated. I felt a sobriety of self—play is play, acting is acting, but the reality of having sex in our disguises made us pause. The spell was broken and there was no point in having sex anymore. It would have felt forced and artificial.

Even so, we melted into the experience of each other. A line had been drawn, but within that line we were free to do as we pleased. We continued to admire our respective entropy and evolution, our growth and decay. We whispered intimate details about our thoughts and pasts. Like Leopold Bloom, the fragments of our cohesive selves were laid out before us. We became free to explore the elusive facets of ourselves that we seemed to find in each other: her lost innocence, my unbuilt confidence.

It was 8:00 a.m. on June 17, 2004. A century before, Leopold Bloom returned from his all-night odyssey in the slums to his wife Molly. Their marriage was fraught with difficulties, but Molly was still his beloved port of origin. He reclaimed his fractured self at her side. In the tradition of Homer's *Odyssey*, Leopold's epic journeys cease when he has at last made his epic return to himself, his wife, and his home soil.

The sun painted the squat, gray buildings of Dublin with an orange tint. Victoria looked tired and travel-weary. She wanted to come to Galway with me, but the pieces of her she'd left in London couldn't be abandoned any longer. We lingered in a kiss at the front door of her hotel room, and I caught a flare of whimsy in her eyes. We shared an intimate smile and I sent her off to her native harbor.

I launched into the streets, heading for my hostel and my westbound train. I headed for my bags, my books, my clothes, my phone cards, my train tickets. I headed west until I hit Galway Bay. It was lush, beautiful, magical, and humming with life. A city made of legends. But I sat on the rocks by my choppy Mother Atlantic, looking towards home. The waves crashed—intermittent, chaotic—the same as they did in Boston Harbor. Like Odysseus on the shores of Circe's island, I sat in the midst of endless splendor, plenty, and novelty. Like Leopold in the brothel's haze, I sat in a pile of my own fragments that, if explored, could offer me nuanced knowledge like I'd never known. Yet I only sat, staring and shaken, yearning for my Ithaca, my Molly, myself.

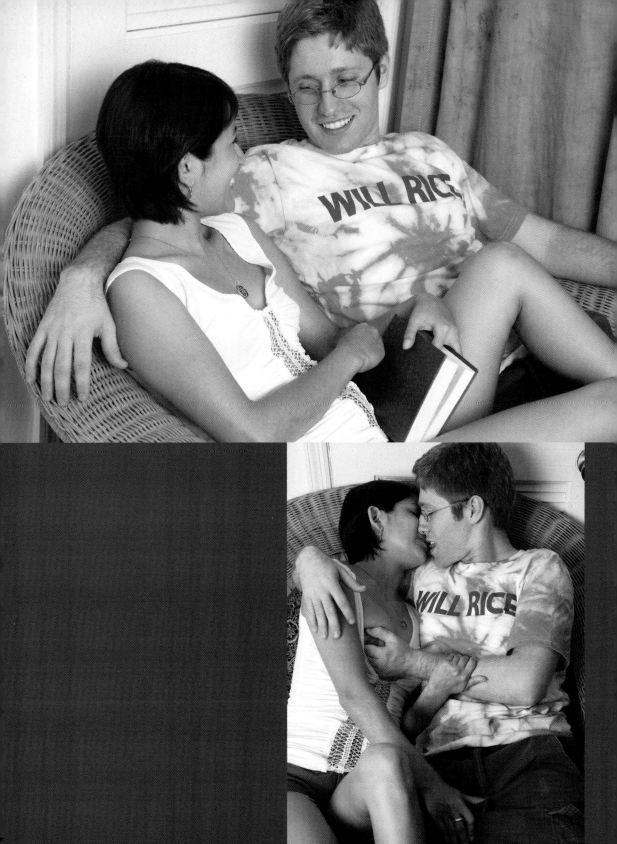

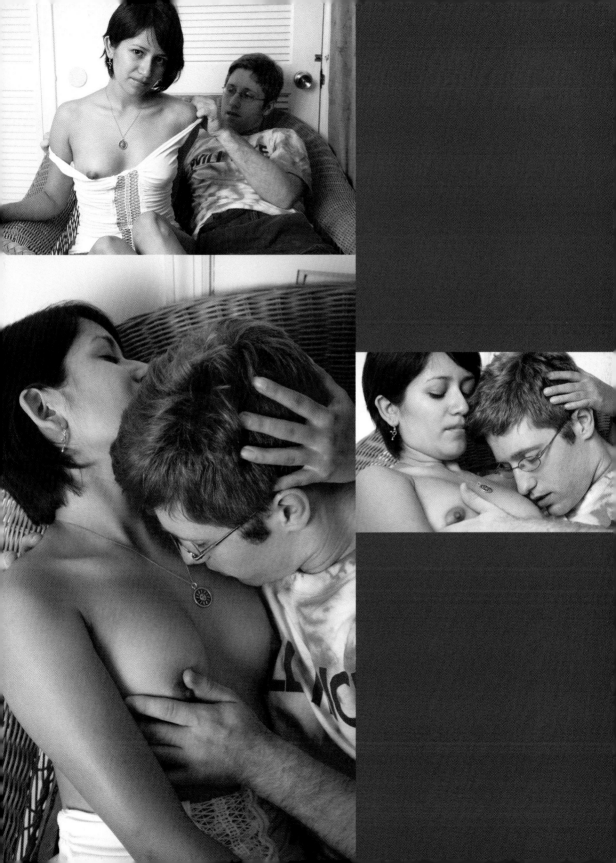

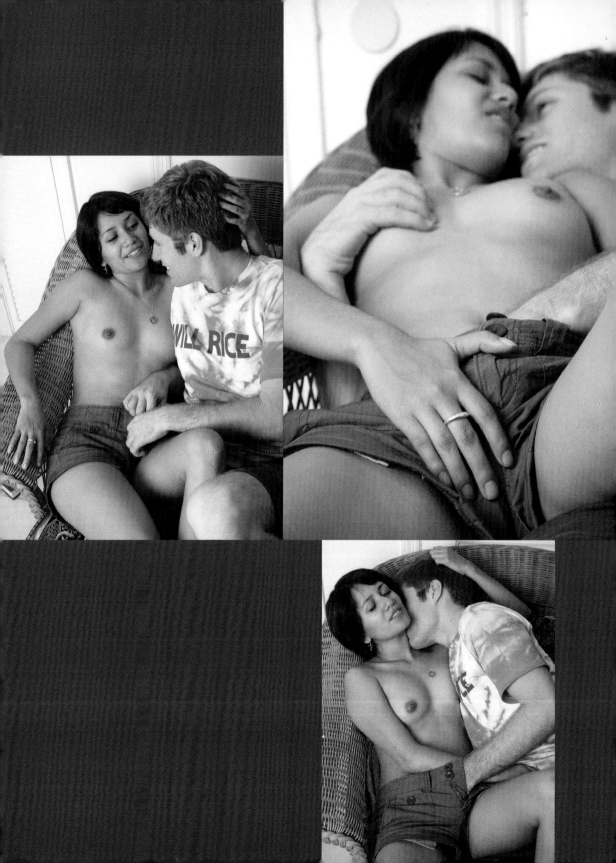

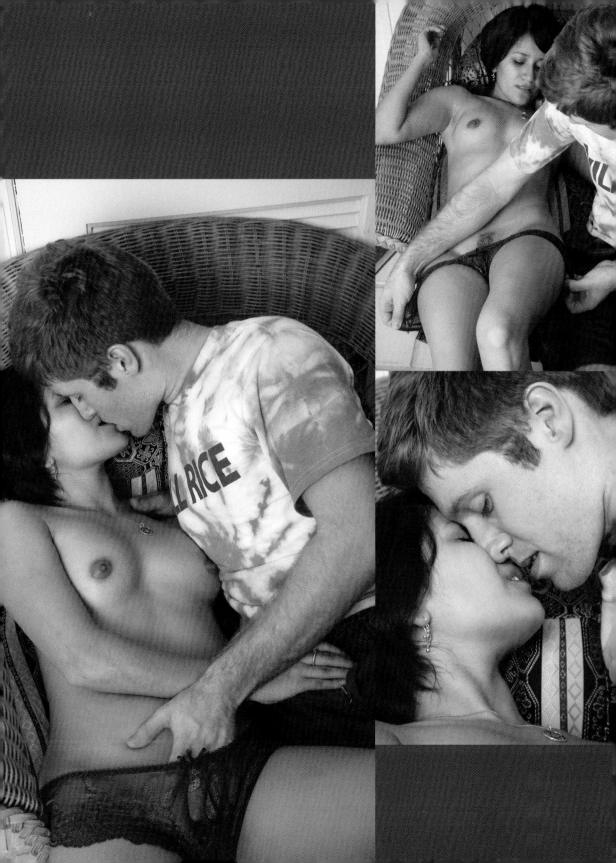

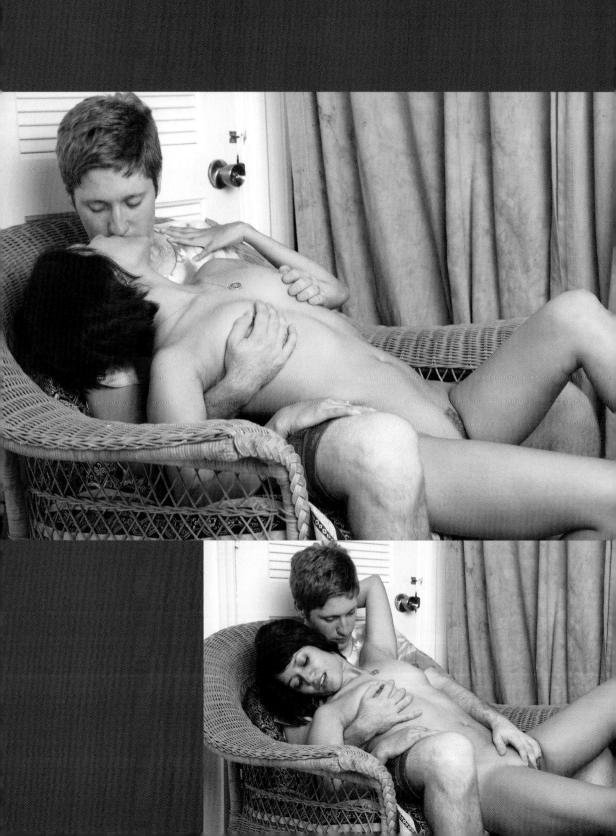

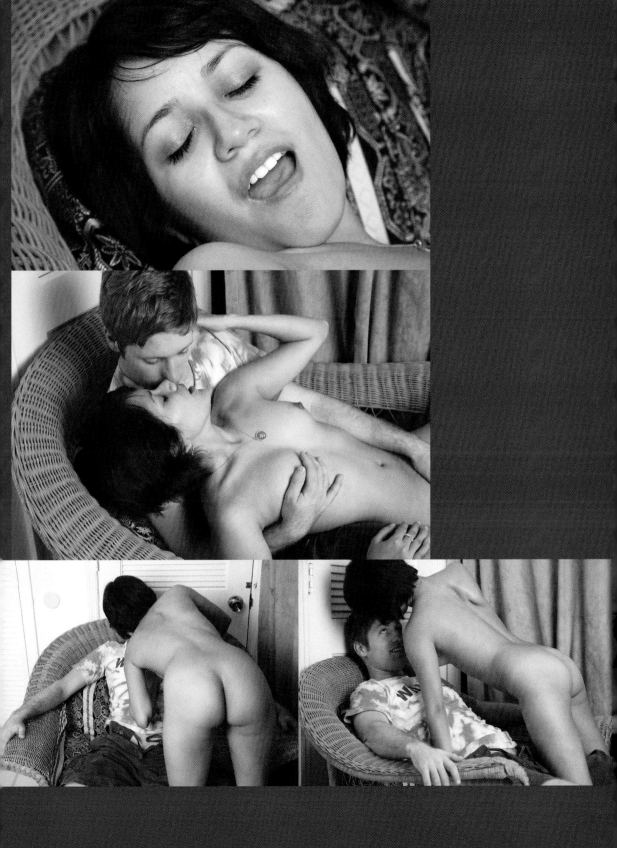

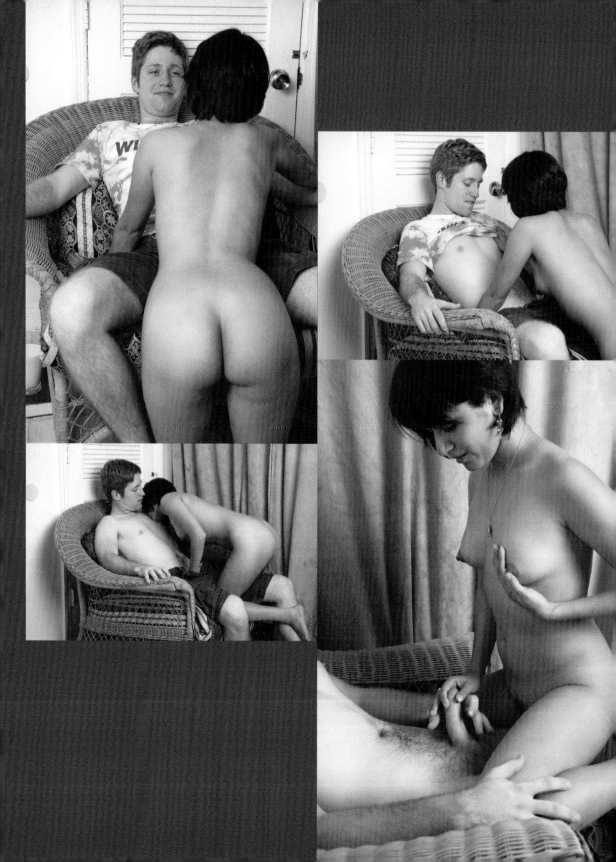

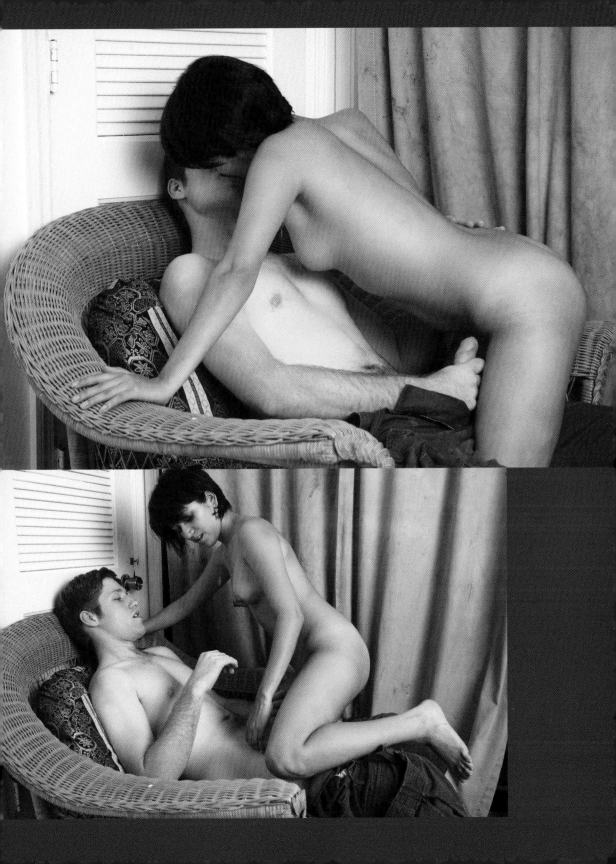

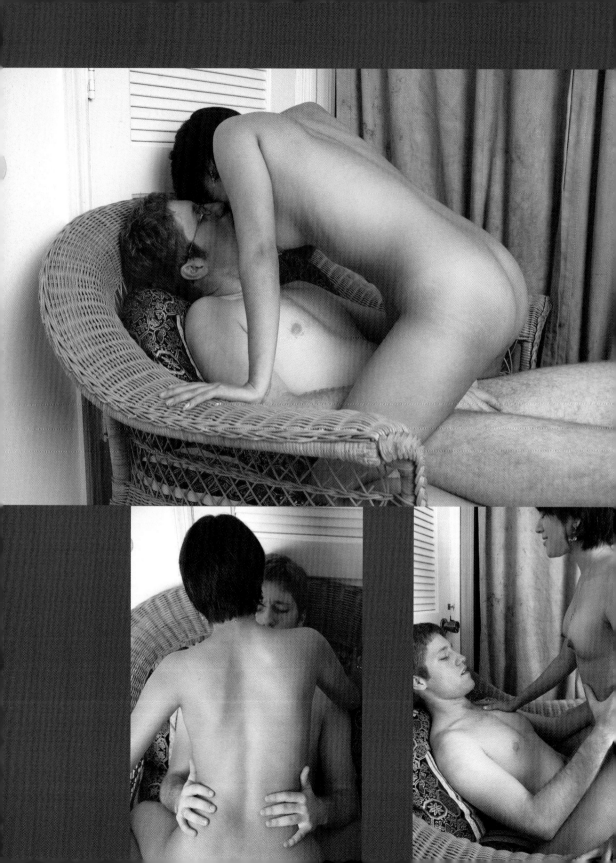

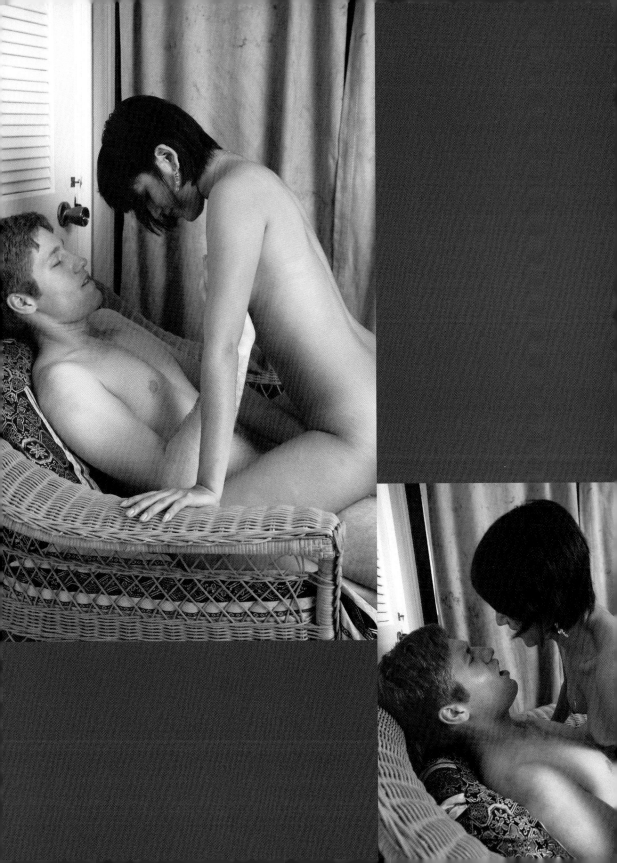

The Quiet Ones

PRIVATE COLLEGE

I ACCIDENTALLY DROVE WITH my headlights off. Thank God for that nice driver who flashed his brights in my face, helping to prevent a possible collision. About a half hour earlier, one of the Sigma Nu brothers had handed me a bottle. I squeezed my nose and, without even eyeing the label, took a gulp straight from the wet rim. Bacardi 151—the stinging sensation trailed down my esophagus and ran into my stomach like the fuse on a firecracker. Now, after a series of raunchy text messages, I'm sitting here at the wheel of my old Mercury Cougar, tongue still tingling from the taste of rum.

It's a chilly Friday night. Red cups litter the sidewalk, and hungry drunken students have begun filling Gino's pizzeria. The campus police just raided a party on Counter Street, so I'm avoiding a crowd of disappointed party-goers as they stumble toward the bars.

When I swing left onto Walnut Street everything is quiet and dark blue. There's just one light that illuminates the blacktop with a cone-shaped glow. I park on the opposite side of the street, a few houses down from number 17, and punch the words "I'm outside" into my cell phone. I unwrap a piece of peppermint Orbit and begin chewing frenziedly. I flip down the visor and examine my face in the mirror. The reflection pleases me; my eyes look sultry and dark, I think, not too smudged up from the long night.

By the time I'm ready to step out of my Cougar, there's a dark figure creeping slowly along the perimeter of the yard, dodging shrubs and heading towards the road. This after-hours meeting relies on me being as stealthy and as quiet as possible, but I can't help the loud giggle from escaping my mouth. This is exciting.

In the glow of the street light, Chris's toothy smile is a sharp crescent moon. He hangs back a bit, staring at me. I know he can't believe I actually came. Something about his boyish appearance—the tortoiseshell glasses and messy brown hair—spreads warmth through me, and I reach towards him, wrapping my hands around the back of his neck. Our kiss is short, but deep, and it ends with a bite on his bottom lip. I feel his body harden against mine. Leaves sound like crumpling paper bags as the wind blows them down the street.

The truth is I could drive to 17 Prospect with my eyes closed; in fact, I'd slept here dozens of times this semester. But this is the first time I will be sneaking in through the basement window— the first time I will not be crawl-

ing under Nick's washed-out blue sheets. My baby's at a basketball tournament in Buffalo. Tomorrow morning, when he gets back to Ithaca, I'll be meeting his parents for the first time.

Number 17 is set back from the times I imagined what it'd be like to fuck Chris. You know what they say about the quiet ones.

● ● ● ● ● ●

The moment we reach his room, and he closes the door behind us, I am hit by a wave of false sobriety—one of those moments of clarity and truth

This after-hours meeting relies on me being as stealthy and as quiet as possible, but I can't help the loud giggle from escaping my mouth. This is exciting.

the road, and Chris and I walk the perimeter of the lawn, close to trees, out of view of any of the other housemates who might happen to glance outside within the next few minutes. We creep slowly towards the side of the house, right up to the basement window. Chris jumps down first then reaches up to grab my hand. I follow. It's as simple as that. Crickets shriek at us from every direction.

For the past month, every night when Nick and I'd get back from the bars, Chris was still up typing away on his laptop. He takes his computer very seriously, something the guys ragged on him about to no end. After Nick and I had finished messing around, I'd wander into the kitchen to grab some water. And although I pretended not to notice, I caught Chris's eyes peeking up from his monitor as I passed, wearing a pair of Nick's boxers rolled up to the top of my thighs. Those were

which unexpectedly poke through the haze of liquor and lust. I panic a little inside, but I keep it cool. He is nervous too—he immediately goes to his laptop to "check his email real quick." I take my jacket off and toss my purse on the floor next to his desk. He leans over his chair, looking at the screen and then glances back at me as if to say, "No really, this will only take a minute..." The sight of his face illuminated by the monitor is what does it for me. I remember all those furtive glances in my direction and again become very aroused.

I walk up behind him, pressing my breasts against him as I lean over and closed the laptop.

"You can check your email later."

He turns to face me—he is taller than I realized. I tell him to sit down, place my hands on his thighs and bend over to kiss him. He runs his hands up and down my back. I sit on his lap, straddling his crotch and letting my skirt hike up to my waist. In the grand tradition of secret hookups, we move fast. He reaches under my shirt to unhook my bra. Then my sweater, shirt, and bra all come off in one deft move. With his face pressed into my tits, he clutches my thighs, stands, and lifts me up with my still booted feet wrapped around his waist. He walks me to the bed and lays me down on it. Then he takes off my Uggs and socks, and reaches into his pocket to retrieve a condom. I feel the crotch of my panties

getting warm and wet. He quickly takes off his shirt and pants, and I can see his cock trying to poke out from his boxers. Without hesitation, I sit up and pull down his boxers—I can't wait to wrap my lips around him. He can't wait to fuck me. He deftly slips the condom on, pushes me back onto the bed, hooks his thumbs into the waistline of my skirt and panties, and shimmies them down. His hands then work their way back up my legs and using his thumb again, he rubs my clit, and slids it down my parting lips. I am more than ready. In one fluid motion he pushes my legs back so that my ankles are by my ears (thank God for those yoga classes) and enters me so deeply I involuntarily gasp for breath.

"God…that's quite a move!"

"I saw it in a movie."

"That must've been some movie."

Apparently he watches a lot of those movies. He fucks me lying on the bed, kneeling on the bed, standing, bent over the desk, sitting on the chair and on the floor. We finally collapse in a sweaty pile on his bed literally panting until we both pass out.

• • • • • •

I awake in a panic. The sound of crickets has been replaced by the shrill chirps of birds. Where the fuck am I? What am I doing? The sunlight stretching across Chris's bed sheets tells me I've stayed with him for far too long. Brunch with Nick's folks.

My head aches. Chris's still passed out beside me, his baritone snoring barely muffled by the pillow. I scan the carpet and notice my inside-out sweater topping off a pile of fabric. I pull on my denim skirt and Ugg boots then shove a tangled up thong into my purse. Fuck—Nick and his parents will be here any time now.

It takes all my strength to throw open the basement window. The air is brisk, and as I step out onto the cement I feel as though I'm emerging from a cave. I use my arms to hoist the rest of my body up to ground level, swinging my knees up on to the cement where it meets grass. Then, covering my head with my jacket, I make a run for it. Curses spill from my mouth at the contents of my purse jangle noisily at my side. Across the dewy lawn and down the street, I don't look back until I reach the Cougar. The sound of my car door makes me wince, but thank God it's before noon—I doubt any of the other housemates are up to witness the escape.

I make the decision to drive around for a bit, let the crisp wind hit my face, clear my head. My nails tap rapidly on the steering wheel. Thank God I was sober enough last night to at least park down the block and not in the driveway. I pull back my hair and check my face in the visor mirror. I unwrap another piece of gum and mist myself with the perfume that I keep stashed in the glove compartment. The neighborhood seems to be waking up now. I look at my watch—it's nearly eleven—time to go back. I do one last makeup check and let out a deep breath before pulling in front of number 17.

• • • • • •

"So tell me all about the tournament!" The living room smells like pumpkin pie, and everyone is all smiles, except Nick.

"Eh, it was a goddamn mess. Clarke pulled a hamstring, Masterson couldn't make any shots, the whole goddamn team just fell apart," he says.

And although I pretended not to notice, I caught Chris's eyes peeking up from his monitor as I passed, wearing a pair of Nick's boxers rolled up to the top of my thighs. Those were the times I imagined what it'd be like to fuck Chris.

I think about how I cheered for him at the basketball games, threw my pompoms in the air as he ran the length of the court, sweat dripping down his forehead.

"I'm sorry, babe." Nick smirks, as if to let me know it's okay, and musses up my hair as he walks by.

"Danielle, Nick tells us you cheer for the team?"

"Yeah, but we don't cheer during off-season, unfortunately. I wish I could've been there to cheer him on!"

His parents nod, giving me a warm smile. The three of them sit across from me on the couch, and I plop down in the scarlet recliner. Parents fucking love me. This is no problem.

Nick's talking about the ride and how his dad almost hit a herd of cows that wandered into the street. We all have a good long laugh at this one.

"Would you like some coffee? Nick, where're the coffee filters?" I ask, rising from my seat.

"Oh honey, that's okay, we had some on the road."

"Are you sure, Mrs. Andrews? It's really no trouble." I sink back into the recliner. "I hope everybody's hungry—The Union Street Diner has the best blueberry waffles," I say.

Nick's mother is eyeing me with a puzzled expression.

"Or, if you don't like waffles," I continue, "they have omelets that nearly melt in your mouth." I put my thumbs in the pockets of my skirt and shift myself up higher on the chair, hoping there's something on the menu that will make Mrs. Andrews stop staring at me that way. Now her eyes are practically burning a hole into me.

"…whenever my parents come up to visit we always go to Union Street Diner. I'm sure you're all hungry from the long drive, how long did it take you?" I'm twisting a piece of blond hair around my finger.

Nick notices his mother's squinty-eyed expression, and he follows her line of sight. I'm still going on about the diner.

"…and the sausages, well, I'm a vegetarian, but I hear they'll knock your socks off." I pause for a moment, waiting for some sort of response. "We should probably go soon—I mean, it usually gets pretty busy around this time, and we don't wanna miss out on those waffles…"

I realize no one is listening to me. Mrs. Andrews shakes her head from side to side and averts her eyes. I glance at the watch on my wrist. Then back up at Nick. His eyes are wide, and I notice his face is the color of the recliner I'm sitting in. That's when I become acutely aware of a tickle on my right leg. I look down into my lap, and instantly, I realize. It is not breakfast food that's pissing everyone off. There, stuck to the inside of my exposed white thigh, is a rolled up, cream-colored condom.

Shattered

by **NIKKI**
LARGE PRIVATE UNIVERSITY

"GUESS YOU DIDN'T EXPECT to be doing this at the end of the day," Cassie laughed nervously, breaking the silence as she gazed into Justin's arctic blue eyes.

Lying side by side they stared at the peeling ceiling, their bodies covered by a thin navy blue blanket.

"I thought we might make out or something but definitely not... I mean, fucking you? I definitely thought it would've taken longer to convince you I was a good fuck." Justin said, his body turned slightly away from Cassie.

"Oh, you were. Best I've ever had." If he only knew the truth, she thought.

Cassie sat up, her nakedness fully exposed. Her hands fluttered to the back of her head. She pulled the hair elastic out of her now only half-contained bun and let her auburn curls unravel around her face and down to her pale and freckled shoulders.

"I didn't even get your hair down. Man, next time I swear. I love your hair," Justin said, reaching up to touch a lock of the tangled mess. Cassie pulled the strands away before he could make contact. His fingers grazed her left nipple instead.

She took a quick glance around Justin's bedroom as she collected her hair into a fresh bun. *Too bad he doesn't have a single,* she thought, *that definitely decreases the likelihood of this happening again. Do I want this to happen again?* Her place wasn't an option, her one-room economy triple in the prison-like freshman residence hall guaranteed someone else would be within earshot at all times. The last thing Cassie needed was for word to get around about her new extracurricular activities, or

the particulars of her "I'm coming" scream for that matter.

After about five minutes of forgettable conversation there was a loud bang at Justin's apartment's main door. The navy blue blanket flew off the bed.

"Shit!" Justin yelled. Frantically he searched for a place to hide the used condom and torn wrapper he clenched tightly in his hand.

"Good thing you locked the deadbolt," Cassie muttered as she located her underwear, jeans, bra, and t-shirt and put them on in that order. "Certainly I'm not sticking around for an audience to my first one-night stand."

She retraced her tentative steps of only an hour ago back

As Cassie slipped the hoodie's soft material over her head she remembered her shoes remained in the bedroom.

"Hold on a minute, man!" Justin screamed before entering the bathroom to get rid of the evidence and throw on a shirt.

The man on the other side of the door dropped his backpack to the hardwood floor of the hallway.

"This'll take a while," he whispered to the chipped blue paint on the door frame. He thought back to other times after a long day at his co-op job when he'd come home to the dreaded locked deadbolt. He wondered if she'd be a redhead like all the others.

Cassie held one hot pink Airwalk sneaker in her hand when Justin looked into the bedroom. Her back was to him as she searched for the shoe's companion around the perimeter of the university-issued bed. *Why is he such a slob? Why do all men have piles of stuff everywhere? Even Matt had—*She didn't let herself complete that thought.

He flirted with the idea of grabbing his camera and capturing her forever as she was, because she'd never be that way again. He wished she'd never leave but knew she'd want to after she realized what she had just done—she had fucked an almost complete stranger.

into the living room to retrieve her blue sweatshirt. *We were just kissing. It just happened. How...? I wanted it, definitely, but I can't let anyone know. They won't understand.*

The nameless, faceless roommate continued to pound on the door which was conveniently locked from the inside.

Justin studied her silently from the doorway. He flirted with the idea of grabbing his camera and capturing her forever as she was, because she'd never be that way again. He wished she'd never leave but knew she'd want to after she realized what she had just done—she had fucked an almost complete stranger. Sure, they had been aware of each other before, but they weren't even proper acquaintances. Cassie, a nineteen-year-old Photography major, had only been involved with the campus writers'

"You couldn't handle talking to me," Cassie teased, biting her lower lip and trying to keep the red from infiltrating her cheeks too conspicuously. She savored the feeling of his skin on hers before he slowly returned his hand to his lap.

group for a few months while Justin, a twenty-three-year-old senior Psychology major, had been in the group for years. Justin had no desire to fuck the quiet newbie until she shared a revealing story about a young woman who enjoyed using handcuffs in bed. After that Justin knew he would have to find out for himself where she drew the line between personal experience and fiction.

"That was an interesting piece, Cassie. Exciting even. We should talk sometime," Justin had suggested, reaching out to rest his hand lightly on top of Cassie's.

"Yeah, I'm sure you want to talk to her, Justin," a fellow group member said, much to the amusement and laughter of the rest of the group. Everyone figured Justin was just trying to be funny as usual, but Cassie felt the shift in the atmosphere of the tiny meeting room. There was a distinct possibility in the air, a course of action that could be taken if she so chose.

"You couldn't handle talking to me," Cassie teased, biting her lower lip and trying to keep the red from infiltrating her cheeks too conspicuously. She savored the feeling of his skin on hers before he slowly returned his hand to his lap.

The group's president distributed her own story for careful discussion and dissection. Since they were no longer the center of attention, they returned to acting civilized.

Cassie crouched down to look behind Justin's dresser for her shoe.

Justin imagined himself taking her again from behind and absentmindedly stroked himself on top of his jeans. He watched as her body twisted and turned, straining to reach something behind his dresser. His eyes traced her form from the toes on her noticeably shoeless right foot to the scar on the back of her neck. He could almost feel that patch of interrupted flesh between his fingers again.

On top of her, inside of her, pressing against her, he had thrust forcefully but with careful calculation. He struggled to maintain the same angle of insertion as his muscles throbbed. Her eyes, Justin noticed, were shut tight. Close, but not quite ready for the finish, his left hand pressed against her throat as his movements slowed. Cassie's arms wandered aimlessly up and down his back. Justin bent down and whispered for her to turn over.

Instinctively, she flipped onto her stomach and moved her numb legs into a kneeling position.

I'm so close to him. He grabbed her wrists and stretched out her arms, placing her hands around the top of the metal-framed headboard. She gripped the bar tightly, bracing herself as he entered her again. *So good, feels so good.* Her head flopped forward, and she tucked her chin to her chest so it wouldn't strike the headboard as she moved back and forth within his determined rhythm. She shivered as he stroked the back of her neck, his fingernails scraping across her injured skin. Suddenly

briefly on Cassie's back. Under his dead weight, Cassie quickly pulled away, severing their physical connection completely. Justin was facedown on the sheets before he even realized she'd moved.

Almost. That was almost perfect. This could be the start of something new. Maybe not with him, but me—I can do this, this casual sex thing. I don't care about him, I can't. Cassie rolled over to face Justin, being careful to keep the physical space between them small but existent. She stared at him in awe mixed with confusion. *What the hell am I supposed to do now?*

"Here it is!" Justin exclaimed, bending down to retrieve the pink sneaker from underneath a pile of garage band t-shirts and guides on do-it-yourself

Instinctively, she flipped onto her stomach and moved her numb legs into a kneeling position. He grabbed her wrists and stretched out her arms, placing her hands around the top of the metal-framed headboard. She gripped the bar tightly, bracing herself as he entered her again.

she was highly conscious of one of her many imperfections. *Does the scar turn him off?* She hoped not, he couldn't stop now.

Justin wondered what had caused the scar, who had inflicted such damage. He contemplated kissing the pink slash, sucking in the flesh with his teeth and invading its raised texture with his tongue. Feeling himself about to explode, he figured there would be time for that during their next encounter. With a typical final lunge forward he erupted into a loud groan, and collapsed

piercings. Silently he vowed to be more careful when removing her shoes before sex in the future.

Distantly, the roommate in the hallway located his cell phone and contemplated calling his aunt in Ireland.

Cassie jumped up too fast and slammed her head on the bottom of a shelf containing some of Justin's best work. An icy blue picture frame surrounding a blooming pink flower in early Spring crashed to the floor. The shards of glass scattered about her feet.

"Dammit, I'm so sorry," Cassie said, staring at the shattered fragments helplessly. *Even if I could have glued it back together, it wouldn't be the same.*

"Don't worry about it. I'll buy a new one. No big deal."

Justin reached over and held Cassie's hands in his. He committed every inch of their connected skin to memory. Cassie exhaled loudly before breaking free of his grasp. She reached down and located the sneaker by touch alone. She slipped it over her foot and headed for the door.

"Goodbye, Justin," she said, turning around for only a second.

"See you later, Cassie," he called after her.

Justin concentrated only on the spot where he knew her scar remained while Cassie walked to the main door, unlocked the deadbolt and faded from view.

Cassie stumbled over the long-distance-conversing roommate, saved from falling only by catching herself against the doorframe. Flecks of blue paint stained her hand.

"Hey! Watch it, ho!" the roommate said as he attended to his recently kicked elbow and eyed Cassie up and down suspiciously. "No, not you, Aunt Mary..."

He thinks I'm a slut. At least he doesn't know my name. At least he can't tell anyone it was me. But Justin can. Dammit. I'm not a slut—I know I'm not—but will anyone else?

Cassie ran down the two flights of stairs in record time and didn't allow herself to take a breath until she was safely back in the anonymity of the street.

Justin retreated back into the bedroom while his roommate raided the kitchen for some Ramen Noodles. Aunt Mary kept reminding him how important a balanced diet was.

Justin searched for something Cassie had left behind, a reason why he could justifiably see her again soon. He couldn't wait until the next writers' group meeting to talk to her, to see her, to hold her in his arms. His focus shifted quickly to his bed where a piece of shiny metal caught his eye.

His bare feet ran right over the shards of glass as he approached the grey jersey knit extra long sheets stretched tightly over a much used and abused mattress. He scooped the silver charm into the palm of his hand. The engraving "M & C" stood out on the back.

Justin charged down the stairs to the street below but Cassie's auburn curls were nowhere in sight. Still barefoot, he slowly returned to his apartment, defeated.

Cassie ignored her cell phone when she saw Justin's number displayed as the caller. She raced into her dorm and up the stairs to her room. She kicked off her pink sneakers and barricaded herself in the bathroom. Remember the sex. Remember the good feelings. Remember how much he looked like Matt.

With her right hand Cassie rubbed the back of her neck. That scar was all that remained of that night nearly one year ago. Never could she forget the feeling of the blade as it sliced into her skin or the sight of the metal being plunged into Matt's stomach. The man had seemed so nice, so friendly. If only Matt hadn't stepped in when the man tried to take Cassie's purse. If only Cassie hadn't turned to run with her valuables intact. She got a scar. Matt lost his life.

"I'm sorry, babe. I just wanted to feel it again. I'm sorry. I love you, Matt..."

Cassie reached into the back pocket of her jeans. She clutched the mangled photograph tightly in her left hand. "Matt and Cassie 2nd Anniversary" was scrawled on the back, right under the Kodak logo. Cassie kissed the picture, hugged her knees to her chest and tried to remember what it was like to feel loved.

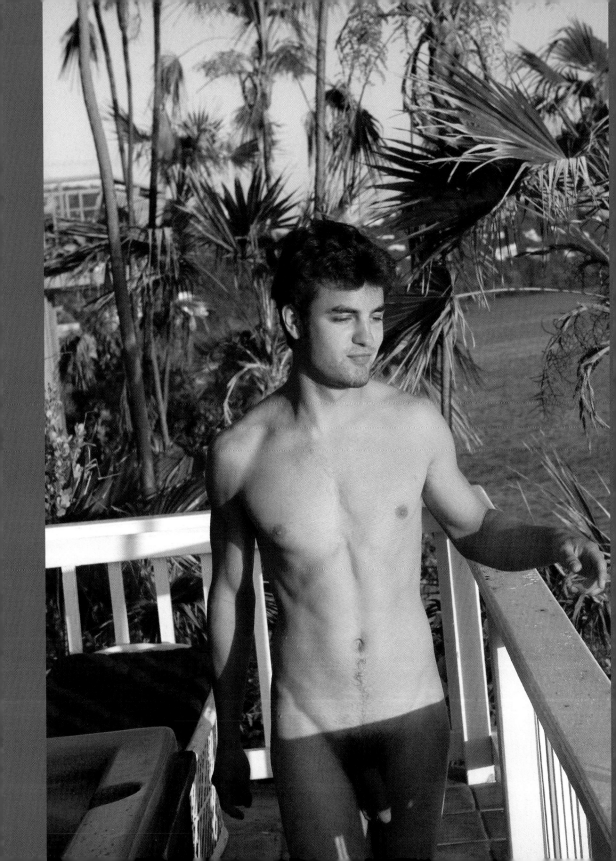

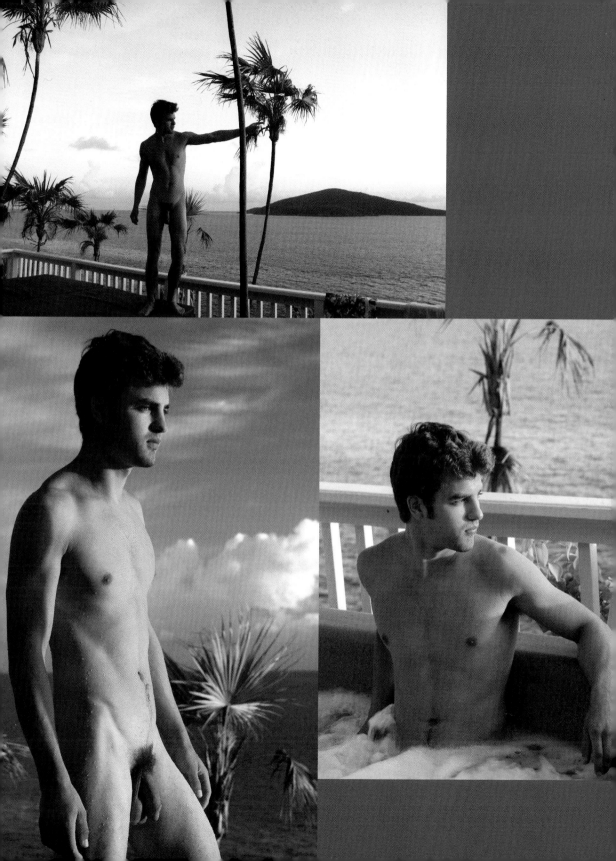

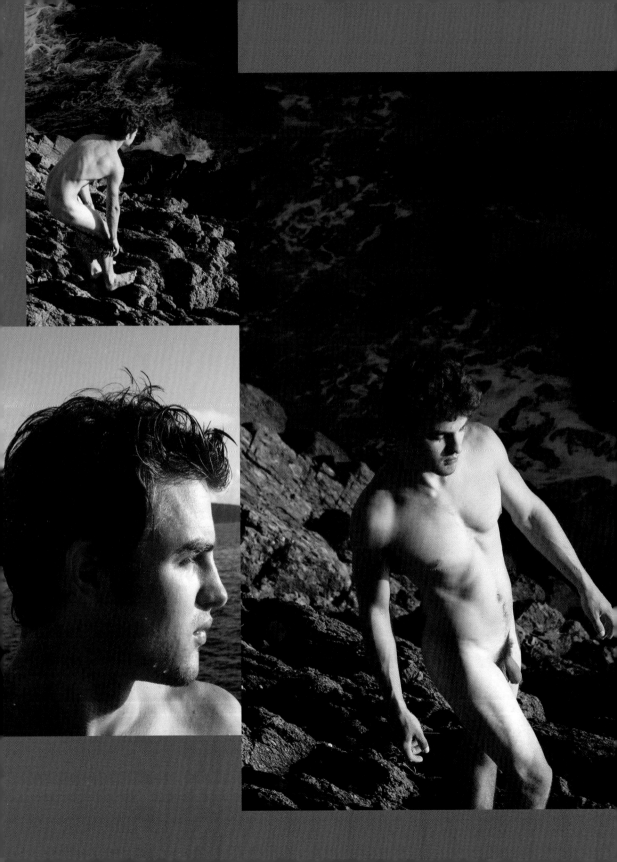

and Spice

by **RISA**
PRIVATE COLLEGE

THE CHERRY MARTINI ARRIVES and I drink it down, finding some satisfaction that I did not know I was seeking. An old man eyes me carefully from the corner of the bar, as if afraid to approach me too closely. This is nothing new, I've been stared at since I can remember, always being told how beautiful I was growing up. The way people said it they seemed to imply that I was guaranteed anything in life that I wanted. I know a lot of ugly people who are much happier than I am.

I'm not trying to be conceited. But it's funny, because I'm supposed to act like I don't know that I'm attractive. Each time some handsome man tells me that I'm beautiful, I'm supposed to react as though it's the first time I've ever been paid such a compliment, and that this time, it means more to me than anything anyone could have said. Each time it means less. Each time I assume that all they want is to fuck me. Maybe they don't realize it at the time; maybe I seem perfect, pure and virginal, though I'm sure none of them could have mistaken me for a virgin even when I was one. Somehow they know me for what I am, even when I try to be good.

I pay for my drink and saunter slowly out of the bar making sure not to look at the man who was staring at me. Eye contact would be an invitation to him to come over and buy me a drink in hopes that it is enough to ensure some kind of repayment. He keeps staring at me; I feel his gaze burn into my ass as I exit. One last look for the road. I shouldn't feel so angry about my physical appearance. So many people would kill to look like me and get the attention that I do; but your appearance becomes your persona. And even pretty girls get depressed.

The cab drops me off at my dorm. Once I'm inside my room, I realize that I hardly remember the walk up. The alcohol has numbed me just enough so that I can focus on my misery instead of my physical surroundings. Everyone else left the bar long before I chose to. Jeffrey wanted to take me home when everyone was leaving. He said I'd had enough to drink and that I should just come home with everyone else. I didn't really say much to him.

I told him, "I'll be all right. I just want to stay and have one more drink." I watched him through the mirror across the bar.

"Are you sure, Ash? Everyone's going home to bed. You really shouldn't stay out by yourself."

"I'll be alright; I'll take a cab home. Don't worry."

I know a lot of ugly people who are much happier than I am.

"I...I could stay with you. Do you want me to stay with you?" Yes. God, please.

"No, I'll be alright, Jeff. I just want some time alone." How could I tell him that these moods come and go and that my emotional state probably has something to do with the fact that I should be getting my period in the next few

I don't want to break them up, and if I ever told her, I'd be the slut who couldn't keep her hands to herself.

days? Jeff probably does not feel the same emotional upheavals as I do, if for no other reason than he has a Y chromosome.

The lights are off in my room; Zoe didn't bother to wait up for me tonight. She is curled up in a little ball under her covers like kids do when they are scared of the monsters in the closet or under the bed. I try to be quiet enough not to wake her, but the alcohol in me won't cooperate. I stumble over a pair of jeans I left on the floor. Zoe flinches. Whoops.

My phone vibrates in my purse and I go to check it. It's Steve, he texted me. It says, "I'm sorry about last night, I was out of line. Can I see you now? I need to talk to you." What could he possibly want? Steve is Lauren's boyfriend. She's a friend of mine. Last night he pulled me into his room and tried to kiss me. I went to slap him but he grabbed my hand and told me he loved me. Up until that point, it was touching, a hand running over my butt seemingly by accident, or trying to get me away from the rest of the party to talk. Talk about what exactly? Nothing important, just as long as we were alone.

He and Lauren have been going out for two years. They're the kind of couple you'd assume would get married right after graduation. At first I ignored it; figured it was just because of how close we all are. He'd never step over the line. Even when the lines started getting crossed, what could I say? I don't want to break them up, and if I ever told her, I'd be the slut who couldn't keep her hands to herself.

I go to see him. I just want to tell him this has to stop. He opens the door and tries to hug me, I pull away a little bit but he still has a good hold on me.

"Ashley, I'm so glad you came. I—"

"Why did you text me, Steve? What do you want?"

"Nothing, I swear, I just wanted to see you. I wanted to apologize for the other night. I didn't mean to make you feel awkward, but I did mean what I said."

"Steve, what are you doing? You're with Lauren; you love her, not me."

"I do love her, but I can't explain how I feel

But he kisses me anyway. It is gentle at first, his lips only slightly touching mine; then he opens his mouth and slips his tongue inside. I mean to pull away, but he presses his body against mine and I can feel his erection through his pants. He's right; there's more than enough sexual chemistry there. I never wanted to admit to myself that maybe I felt something too.

around you. You two are so different…and I do love Lauren with all my heart, but when I see you…all I want to do is kiss you. I know you and Mike used to date—"

"Yeah, so you see how wrong this is on multiple levels."

"It burns me up that he had you and let you go. He used to talk about you after you guys broke up. He would say all these awful things about you. Well, not awful, but just how guys talk…about how you were in bed—"

"Steve, stop, I don't want to hear this. I got over Mike and it was painful but it's behind me now. I don't want you to bring it up again—"

"I would defend you. You were still my friend. You always have been. I would never want to see anyone hurt you. I have your back, honey."

"I know Steve, we are friends, but that's what I don't understand about this. What makes you so sure I'm not going to go tell Lauren about what you've been saying to me?" Steve moved closer, backing me against the door.

"Because I know you feel it too…what's between us. Ash, believe me when I say I've been fighting this. I've felt this way about you since the first time I saw you, and then I got to know you, and you're funny and cool. I've never met another girl like you."

"Steve, I came here tonight to tell you we can't do this, it's not fair to Lauren. You shouldn't

even be with her if you're having these feelings; she's still head over heels for you. If she knew she'd be shattered. You need to stop doing what you're doing."

"You mean what we're doing."

"I'm not doing anything."

"Oh, don't play so coy. God, you always act so oblivious. It's not what you're saying, Ash, that lets me know how much you want it. It's all in your eyes, the way you look at me, even when other people are around. You can't fool me, Ash, I know you too well."

"Steve, it has to end." But he kisses me anyway. It is gentle at first, his lips only slightly touching mine; then he opens his mouth and slips his tongue inside. I mean to pull away, but he presses his body against mine and I can feel his erection through his pants. He's right; there's more than enough sexual chemistry there. I never wanted to admit to myself that maybe I felt something too.

He pulls me up the stairs to his room. Ben, his roommate, is mysteriously not there. I stop inside his room not letting him pull me to the bed, which I know is his intended destination.

"What's wrong?"

"Steve..." He stops and looks at me.

"I'm breaking up with Lauren. I should have before, you're right. I've wanted to be with you instead of her for so long, but I was worried you didn't feel the same...so I didn't." I didn't know what to say to him. I knew my opportunity to leave had passed. I'd already committed the sin; anything else wouldn't change things back to the way they were.

He kisses me again, and my knees go weak. I wish I could be stronger for Lauren. It's intoxicating when someone wants you that much. I wonder if I would have felt the same attraction to him if I didn't know how much he needs me here at this moment. I fall onto his bed where he slowly begins to devour every inch of my body.

He took his time. He sucked on my left nipple, then the right, slid his warm tongue down the side of my ribcage and across to my navel, sending a quiver through my whole body. He kissed gently down my pelvis, tonguing the thin strip of pubic hair until he finally reached my clit which he stroked, nibbled and licked all while sliding two fingers slowly all the way in, then all the way out of me. I writhed and bucked, squeezing his head between my thighs. I was just about to explode, when he stopped his attack on my clit and proceeded to lick down my

I spread my legs wide, grabbed him by his ass and pulled him into me hard, deep, and fast. I could feel my pussy pulsing around his cock as I finally succumbed to the most intense, full-body orgasm I'd ever experienced. His body responded immediately to mine, and my involuntary contractions milked every last drop out of him. It was perfect. Well, it was almost perfect.

We lie there in ecstasy afterwards. I stare up at the ceiling where a picture of Steve and Lauren is taped up. Even now her presence was felt. Steve throws his arm around me and holds me tight. I can feel his breath on my back, tickling the tiny hairs that become goose bumps.

"What's going to happen now, Steve?"

"What do you mean? I'm leaving Lauren."

"No, but afterwards...our friends...people will be forced to choose sides."

"Yeah, well you know me, I'm pretty much a vapid whore. I don't think far beyond the limits of what I'm going to wear the next day."

now slippery inner thighs, all the way to my toes. My whole body shuddered every time he made contact. It seemed like an eternity before he finally climbed back onto the bed, looked into my eyes and lowered himself on top of me. The instant he entered me I felt like I would cum, but his slow easy strokes kept me right at the edge until I couldn't take it any more.

"Why do we have to worry about it? We're here together, away from the rest of the world. Just the two of us." He kisses me on the cheek and holds me tight against his chest. Even now I don't want to admit that a part

of me enjoyed myself. I still don't believe him for one second when he says he was going to leave her. Even if everything else he said was true, eventually he would get me out of his system and return to her. After I hear him snoring I creep out of his bed and go back to mine before the sun comes up. A walk of shame could be fatal in circumstances like these.

I splash water on my face when I wake up the next morning. I can't believe I slept with Steve. I know in my heart that he had never cheated on Lauren before. When I used to catch him staring at my chest or running his hand over my ass, he would tell me that it was the most he could do without cheating. He always said it in a way that made me forgive him because it was just harmless flirting. It was only an innocent attraction, something that neither of us would let get out of hand. It's not that I don't feel badly, but the guilt comes from what others would think of me if they knew. I did what I did because I wanted to.

The mirror stares back at me echoing my thoughts. It was wrong, but that's what made it feel so good. I won't lie to the face in the mirror even if I have to deceive everyone else.

Jeffrey calls me asking where I am and if I'm alright. I tell him I'm fine and that I'm sorry I hadn't called him when I got back last night because I was very tired.

"You mean drunk," he said.

I laugh, "Yes, that's exactly what I mean, actually."

"I figured. How's your head feeling today, any hangover?"

"Not really, just more tired. I think I'm just gonna curl up and watch a movie to recover."

"That's the worst way to recover, are you serious, Ash? Let me take you out for coffee or something, it's the least I can do after leaving you last night."

"Jeff, you don't owe me anything; I told you that you could go home with everyone else."

"Doesn't matter, I have a guilty conscience. Please, I'm bored anyway." I can hear how antsy he was on the other line. Eh, I could go for some coffee.

We meet by the stairway that leads down to the local strip mall. Jeff is decked out in a blue ski jacket and cap. His cheeks are rosy from the cold but his smile is warmer than the sun.

"What's gotten into you?" I ask.

"Nothing, I'm just glad you came out. I haven't really gotten to hang out with you in a while, it kinda makes me sad. We used to be so close."

"We're still close, Jeff. But it's sweet of you to miss me, nonetheless."

"I know we are, but you know what I mean. After freshman year, we all kind of drifted apart."

"I know what you mean; I barely even talk to Jeff or Audrey any more."

"Yeah, they fell further off the face of the earth than you did."

"I did not fall off the face of the earth."

"You're right; it's round. Nothing really to fall off of." I give him a little punch for that. Jeff can be such a nerd sometimes.

We get lucky and grab the sofa booth just as some people are leaving it. We throw our coats to claim the spot as ours. Jeff runs over to get coffee while I stare at the photos on the wall.

"Which one do you like?" he asks me when we get back with our coffees.

"All of them really. I know, that's just what people say when they don't have any taste."

"No not at all, they are all different. Art is art when the artist is passionate about their work."

"Then why are the critics always placing judgment on this piece or that? Usually that's an indication of talent."

"Whoa, look at you go, that was a pretty intelligent thing to say. I mean, I wasn't calling you dumb…okay, I'm digging myself into a hole."

"Yeah, well you know me, I'm pretty much a vapid whore. I don't think far beyond the limits of what I'm going to wear the next day."

"Of course not, you're more the kind of girl who thinks about what she is going to wear two days from now."

He smiles at me. One of those goofy smiles I've seen on his face before. It really is just like old times. I've missed him more than I am willing to admit to him, if for no other reason than we once tried to be something more than friends. It ended badly when he decided there was another girl better suited as a girlfriend. We tried to keep things civil and sweet because there was a friendship there, but it was too hard for me and I pulled away to save myself. But time heals all wounds and we were able to regain our friendship at the beginning of the year. Besides, she was a jealous bitch, and guys can only stay whipped for so long.

I excuse myself to go to the bathroom, because I can feel my phone vibrating and I know it's Steve. He texted me again and it said; "Ash, I'm so glad you came over last night, I knew you felt the same way. Call me later, I wanna see you again tonight." I know I can't go. I have to make him want it just a little bit more than he already does. I'm not even sure I want him anymore. All the old feelings for Jeff have come back already. He meant so much more to me than Steve does.

When I come back, Jeff asks me if I want to go back to his place and watch a movie, so we leave. He puts his arm around me; he says it's cold outside and body heat makes us warmer than layers. It has started snowing again. I tickle him just a bit under

his arm; he winces and I take off running. Just as I knew he would, he runs after me. I let him catch me. We get all the way back to the bridge, and because it gets dark early, the lights are already on. He pretends like he was going to throw me over the side; he is so much stronger than I remembered.

I want him to kiss me. He wants to, but we don't. We get back to his place and after he pretends he can't find his keys, we go inside. He's already put Christmas lights up, and the soft glow makes me feel even dreamier than I already do.

"What movie do you wanna watch?"

"I don't really care, what do you have?"

"Everything really. C'mon, you're the guest."

"Got any comic book hero movies?"

"Absolutely. I have all kinds—Spiderman, Superman, Batman?"

"Superman."

"It's a classic."

We sit on his bed, and because the mattress is so old we sink in towards each other. I am barely paying any attention to the movie. All I hear is his heartbeat. Suddenly, I feel the coffee hit me. I don't want to move from where we are, but I have to. He asks me if I want him to pause the movie, but I tell him I've seen it a million times anyway so it wouldn't really matter much. I have to go up a flight of stairs because there is no girls' bathroom on his floor. I go as quickly as I can but not too quickly so he won't think I'm anxious. I should have taken my purse with me.

I get back to the room, but notice as soon as I step inside that something is wrong. The movie is paused and Jeff has a look on his face that makes my heart sink into my stomach.

"What's this?" He asks me, holding up my phone.

"My phone?" I reply unsure of what he meant.

"I was waiting for you, but your phone started playing that annoying ringtone…a lot. I didn't mean to look; I was just trying to get it to stop." He hands me my phone and I see a new text message

from Steve and a missed call. "Ashley, I'm breaking up with Lauren for you. Tonight. Please call me when you get this, I love you."

"Why is Steve telling you that he loves you?"

I can't say anything. I try to think of some lie to tell to get out of it, but for once, I can't think of anything.

"Has Steve been cheating on Lauren with you?"

"No…last night, Jeff…how could you go looking through my phone?"

"I didn't until I saw who was calling you, and I thought, why would Steve call Ashley? It's not like they are that close, and I could see on your phone that he texted you too. I shouldn't have looked, but I'm glad I did." He turns away from me and faces the window. "I can't believe you would do

that to Lauren. They've been dating for over two years, Ash."

"Jeff...I don't want Steve. It only happened once, it was a mistake—"

"Yeah, right. He wouldn't be telling you he loved you if it was only a one-time thing. I've known Steve just as long as you have, and he has never cheated on her before. And I would expect more from you if you really cared about him...you're screwing with other people's lives."

"How do you know he's never cheated on her before? I didn't do anything wrong, Jeff. He cheated on her, where does my moral responsibility come in? Just because he says he loves me doesn't mean I love him, and quite frankly, it doesn't mean he's being honest about his feelings either."

"Your moral responsibility? She's your fucking friend, Ashley! Do you have any idea how hurt she would be if she found out? She's gonna be crushed when he dumps her, but if he tells her about you, it's gonna absolutely kill her."

"It was a mistake, and I went there last night to tell him to stop with his advances, but I was weak, Jeff, and that's the truth."

"I think you should leave. I can't believe you, Ashley. Just go."

I don't know what to say. Nothing I could say can bring us back to where we were ten minutes ago. It is over.

The tears start streaming down my face as soon as I leave. I don't know where to go. I don't want to go back to my dorm. I have to call Steve. He told me to come over, and that he would leave the door open. I know my face will be tear-stained but I know him well enough that he won't ask too many questions as long as I kiss him.

I get to his house and he is waiting downstairs for me. He hugs me and kisses me on the cheek telling me that it's okay. He thinks I'm upset about us. I'm glad I don't have to tell him the truth.

"So what did Lauren say when you broke up with her?"

"I haven't done it yet." I give him a look. I'm fragile right now; I will believe his lies for now, so lie to me.

"You said you were going to. That's why you called me, isn't it?"

"No, I called you because I wanted to see you. I haven't done it yet. I tried, Ash, believe me. I had my phone in hand and everything. I just don't know what to say to her yet. Give me another day."

"Why don't you tell her the truth?" He laughs at me. A smug little laugh, the kind where you don't mean to but it escapes anyway.

"Ashley, I don't think you want me to tell her about you."

"Why not? I can handle it. And she's gonna find out sooner or later." He looked at me like I was missing teeth or something.

"Ash, are you sure you're all right? Last night you were pretty hesitant about us and now you seem all gung-ho. What gives?"

"What do you mean, what gives? I want to be with you. You convinced me last night and your messages today made feel secure about where we were going."

when he just inadvertently ruined the one thing I had going for me. Steve, right now, I just want you to make me forget about losing Jeff for a second time, and you can't even keep me in this fantasy that we started last night. He kisses me harder, and deeper, but it isn't the same. The rush is gone, it's been tainted.

I leave. I'm sure he won't break up with Lauren now. She will probably never find out either. He'll go on pretending like she has his heart forever. I don't think he ever had one. But that's what they'll say about me. What they don't know is mine has been shattered for a long time. You can't mend a broken heart with a new love, because when it gets broken again, you start forgetting how all the pieces fit back together in the first place.

> You can't mend a broken heart with a new love, because when it gets broken again, you start forgetting how all the pieces fit back together in the first place.

"Yeah, about that...Ash, even if I break up with Lauren, I'm not sure I wanna just jump right back into a relationship. I mean we have been dating for over two years."

"If?"

"No, I mean it's all about you, baby. You're my girl, in my heart you always have been. I just want to take it slow with us. Just give me some time to get my life in order." He tries to come over to me again and kiss me, as though he just made it all better. He wants me to take the scraps he's throwing me

I enter the bar and sit at my usual stool. The bartender comes over to me with a ripe cherry martini. He gives me a wink and says, "You look like you've had a rough day. This one's on me." Though I'm sure the tears are still stuck to my cheeks, I put on the usual smile that works so well with men. They're all the same in the end anyway.

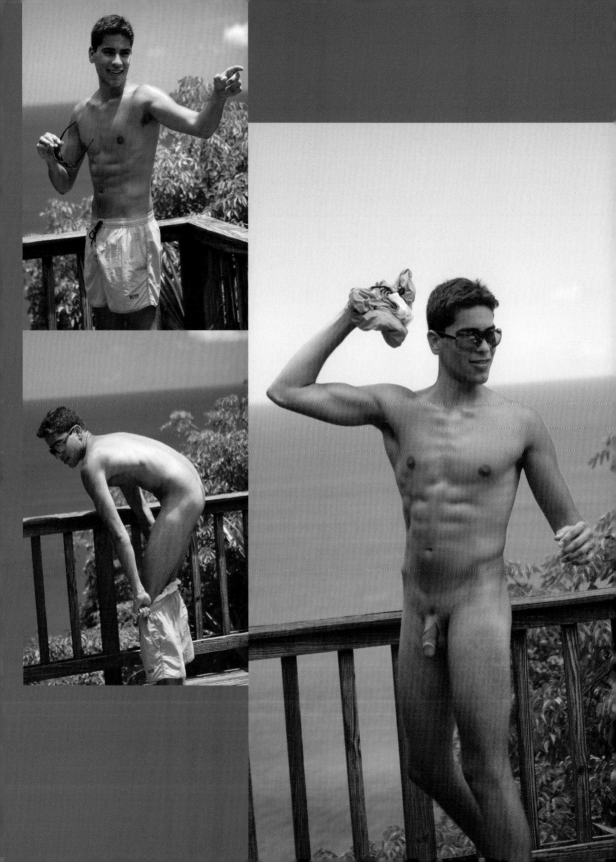

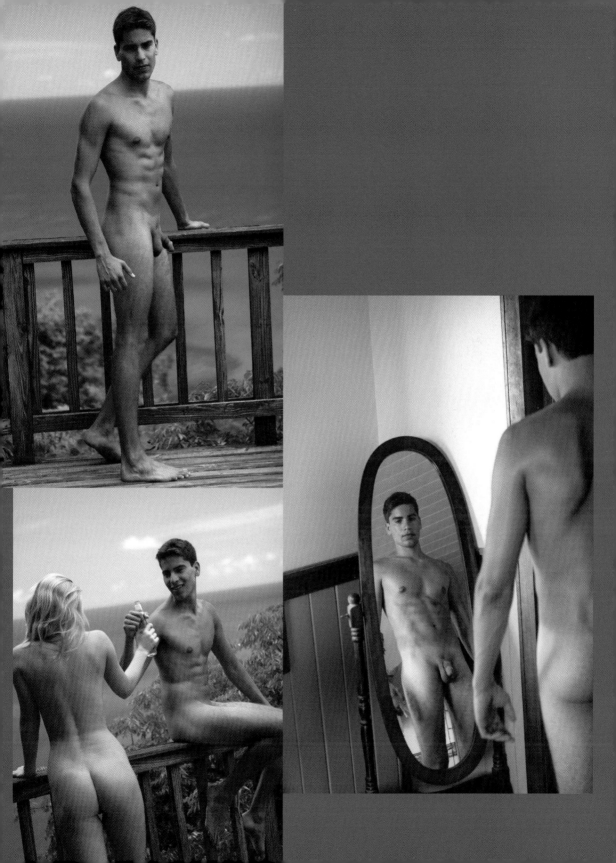

Jamie and I:

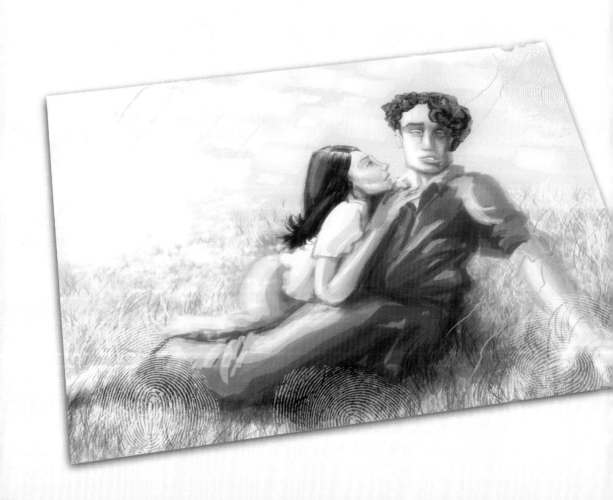

The Scraps of Memory

by **ARIEL**
PRIVATE COLLEGE

A PHOTOGRAPH: COLOR. SLIGHTLY FADED, some fingerprints visible along the edges. "October 6, 2003" on the back in blue ink. In it is a candid shot of a boy and a girl. Together, they look as if they belong locked in marble, like one of Auguste Rodin's sculptures. The boy has coffee-with-cream skin and short curly dark hair. He is sitting in the grass, glossed by the sun. His legs are folded to his right, and the girl fits perfectly behind his legs, her head rested on his shoulder. Her hair is loose, and reaches all the way down her back. She is looking up at him, and he is looking somewhere else, somewhere out in the distance.

I want more than anything to tear it up, but instead I just shove it into the glove compartment. I'm too exhausted to be upset.

The girl was me, about a lifetime ago, and the boy's name was Jamie. It was the only picture I instantly recognized in a three-year-old roll that I developed last month. We were on the lawn of Satchel Heights College, fingering the grass and bitching about our Philosophy homework. Revealed also in the roll were random shots of this and that, of my first dorm room and my first roommate, a tree here, a squirrel there. Arbitrary scraps of memory that had no real texture. But here was this one memory, among all the rest, that seemed to spike my hands, to burn my mind.

I. He was the only one I trusted at the time. "I really like this guy in my lit class," I said to him once, while we were driving somewhere. It was a lie. He rolled down the window and lit a cigarette. "Who?"

"Ian Stenza. Floppy hair, dress shirts, cuffs rolled up, sometimes." I watched for his reaction. Was he jealous?

"Mmm…I'd hit it." No, of course he wasn't. Of course. I turned on the stereo. Billie Holiday. We sung along. Blue moon, you saw me standing alone, without a dream in my heart, without a love of my own. Jamie said sometimes she sounds like she's choking on her heart, she just sounds so wounded. I extended my arm out toward him and flexed my hand in the "gimme" action. He handed me the cigarette and I sucked it into my lungs, coughing a little as I blew out the smoke.

We met sometime early on in our freshman year in one of the

dorm houses on the lawn. All the big personalities on campus lived in a lawn house. The Four Houses of the Apocalypse is what they were called, because when one of them threw a party, the axiom adhered to was "Eat, drink, and be merry, for tomorrow we die." And although everyone made it through the night, the house would be in ruins the next morning: smashed light bulbs, beer stains on the carpet, a light fixture on the chandelier wobbling from its wire like a loose tooth from its root.

The kids who lived in those houses had unstoppable energy and rumored speed addictions. They were the loud ones, the guys that spiked their hair with Elmer's glue and rode skateboards down the banisters; the girls who snorted coke off mirrors and urinals, who came shrieking downstairs to the parties, their tits falling out of their lacy babydoll dresses.

II. I remember hearing loud sex when I met him. The throbbing bass of the music probably should have drowned it out, but I could hear every sigh, every grunt, every ardent shriek. I was standing in a circle with a few strangers and Kelly and Natalia, two girls I knew vaguely from my French class. They were doused in glitter that night, tight jeans riding up their asses, lips drenched with a clear gloss that smelled acutely of watermelon Bubblicious bub-

ble gum. "Jamieee!" one of them squealed, and ran over to embrace an attractive black boy. She brought him into the circle. "You don't know Jamie, do you?" she asked me. I shook my head.

"Sorry," he said, "I'm Jamie." A muffled orgasm.

"I guessed that," I said. "Hi."

He told me that I had a nice face. I blushed and said thank you, although I'd never been that thrilled with it.

"Can I do your makeup sometime?" he asked. I laughed, and said that I don't usually wear makeup.

"Please?" More sex sounds.

We became close friends over the next few months. He was one of the most charismatic people I had ever met, and the kindest. He was interested in changing the world, and would convince me to go to meetings about protests on the war, or taking a semester to teach English in Chile, or spreading gay awareness, but he never did any of it. I would spend hours on the other end of his bed, watching his hands as they animated his rich opinions on orphans and Iraq and sex. "Why are you telling me all this?" I would ask him, "Why don't you go to a protest, or start an organization?"

"We could totally change the world, you and I," he'd say if we had been drinking.

I had been applying to a few other schools, looking to transfer to one of them. Satchel Heights didn't really have the type of literature department I had been hoping for. "Stay here," Jamie said, "I can promise you years of entertainment." I licked a stamp and smoothed it onto the corner of a manila envelope that said:

Admissions Office
Caldwell University
22 Main Street
New York, New York 10011

"I'm destined for the big city," I said, "come with me?"

"I'm not really a city man."

The first time we made physical contact: about two weeks into our friendship, during a long day after a sleepless night. I broke down. He held me tightly, a perfect hug, a full-body embrace, all of our essential parts aligned like magnets.

III. When does it begin to get easy? "Never," he said. "Matters of the heart never are." We were discussing my relationship with Alex, my boyfriend at the time. We had been dating for two months, and I was certain he was being insincere, that he had lost interest or met someone else. But maybe it was me, maybe it was my fault. When I wasn't studying, I was spending most of my time with Jamie. Alex and I really only saw each other at night, when we had finished our homework and taken showers and I had dialed his extension and climbed the two flights to his room. I wasn't sure if I could love him, but I loved being wrapped in his arms with freshly shampooed hair, and I loved falling asleep in his bed, which was warmer and more comfortable then mine. And I loved, of course, when he would throw me onto the bed and fuck me right when I walked in the door. I loved those nights; I knew he had been waiting for me, thinking of me. And I loved the way he would brush the hair out of my eyes. The skin to skin contact. The heat.

Jamie said once that there is something quiet about a happy life, something imperfect. It is afraid of the spoken word; it does not like to be talked of, harped on, glorified. "Don't talk about the good things in your life," he told me, "You'll jinx them."

"What about the bad things?" He said I should talk about them until I've wrestled them to the ground with words, but never to bring them up again. "Okay," I said, and shook my head.

I talked about it with anyone who would listen. And, as Jamie had promised, my relationship with Alex shriveled up at the command of my voice. He broke it off with me, and I, because I wanted to be dramatic, wrote him a letter:

You said you were going to stick around. So why does this happen? Why is this happening? Why is there gravity between us one minute, then an inexplicable electromagnetic push the next? What did I do? What did you do? Am I being punished for my own indecision?

And then I burned it.

IV. So I'm kissing this boy, Quinn or Quentin or something strange, some boy I met at Paint Fest in town the other day, and my phone starts ringing. I break away and look: it's Jamie. Quinn or Quentin or whatever takes the phone from my hand and starts kissing me again, sliding his hand up my thigh, under my skirt. Don't pick it up, I tell myself over and over, but my hand, which should be rested on the shoulder of this boy with the strange name, is searching the area around me for my phone. He says I can call them back, whoever it is, and tugs at my underwear. I kiss him hard while I continue to search. There it is. "Hey."

"Got a boyfriend or something?" he asks when I hang up. I say no and he shrugs. "It's okay if you do. I have a girlfriend."

"Well, shouldn't you be getting back to her?" I ask, trying to sound offended. "Nah," He says, "I need a little spice in my life." He outlines my lips with his thumb. "And you're so sexy."

This was a predicament I didn't know how to get out of, or if I even wanted to. I looked up at Quinn or Quentin and said something like "This is wrong," but I didn't mean it. And it didn't seem to matter that when I kissed him I didn't feel that rush that you feel when you like someone so much, everything else becomes peripheral, insignificant. But I did feel content. I liked him enough, and he liked me more than enough, and it helped to have someone tell me I'm beautiful, to have someone who wants you that much. And it gave Jamie and I something to talk about.

"You need to stop," he said. "Now."

"But I like him. A lot."

"Wake up, he has a girlfriend. He's obviously using you."

"You don't know anything about affairs."

V. Sometimes, in the late afternoon, when the weakening sun would leak through my window, Jamie would stretch out on my bed, the light casting shadows and an apprehensive glow on the side of his face. I would lie beside him and he would pull me into him, into that vulnerable place between his shoulder and his neck.

Most of the time I would pretend we were lovers, absorbing the afternoon sun after an hour or two of sex. I guess I pretended a lot that year. When we went out, I secretly hoped people would assume we were together. Sometimes I dressed the part of the girlfriend, a woman who would be with this man: little black dresses, romantic lacy tops, flowers in my hair.

When I found out that I was accepted to Caldwell, I immediately called Jamie to let him know. He congratulated me and said, "That's really great for you," but I heard his voice break a little on the word "great." Then he said we should go to Addison's to celebrate, the little pub in town.

VI. "Do you think love can transcend genders?" Jamie asked, hands full with a Greek pita. "I mean, do you think you could fall in love with a woman, even though you've only liked men up to this point?" My pulse began to race. Could he? I tried to answer in the steadiest voice I could manage. "It's possible," I said. Jamie looked at me for what seemed like a long time and narrowed his eyes. He said he thinks I could fall in love with a woman, and that he could, too. I laughed nervously. "Imagine coming out of the closet again. Sitting your parents down, and saying, 'Mom, Dad, I have something to tell you: I'm straight.'" Jamie smiled and said, no, it wouldn't make him straight, though. "Bi?" I asked. "Not even that." I stirred my Shirley Temple with the tiny red stirrer. "What then?" His beautiful eyelashes fluttered as he was thinking, dark eyes becoming moist, his pupils opening up as if to welcome in every word of our conversation. My brown-eyed boy. "What would it make you?" I asked again. He pursed his lips. "Human."

VII. He traces the outline of my face with his fingers, brushes my cheek with his thumb. "I've loved

I would lie beside him and he would pull me into him, into that vulnerable space between his shoulder and his neck. Most of the time I would pretend we were lovers, absorbing the afternoon sun after an hour or two of sex.

you for so long." Kisses me. I say his name. "Jamie." We kiss again, this time more immediate, more passionate, a hungrier kiss. He places eager kisses on my neck, along my shoulder, down my arm. Rips off my thin white tank top and moves to my breasts, cupping one in his hand, his mouth on the other. I almost come from the feel of his lips around my nipple. He drops to his knees, wraps his arms around my waist, and presses the side of his face to my center, just above my stomach, canopied by my breasts. He turns his face to the center, brushes the soft skin with his soft lips. Moves down, kissing the stomach. It isn't my stomach, it isn't me. His name is Johnny, and he models for Abercrombie & Fitch. He's tall and

he's tan and he has a huge cock. "I met him at a gay club the other night," Jamie tells me. "I thought he was European because he was wearing sunglasses and smoking inside." He had hoped Johnny was British because British accents really turn him on, but alas, Johnny was down from Dayton visiting his aunt. That's okay, Jamie told himself, and asked him if he minded coming in an English accent. Johnny said no, he didn't mind, and so Jamie invited him back to his dorm. "And there we are," says Jamie, "in my pathetic, squeaky twin bed with the metal-on-wheels bed frame. Johnny says he likes it rough, no strings attached." Jamie is momentarily disappointed because he's a bit more human than that, a bit more female—he wants a phone call after sex, doesn't care for one-night stands, but he's too overcome right now, too horny, to protest. So instead, Jamie kisses all the way down to Johnny's huge cock and sucks him like a Dirt Devil vacuum cleaner. And, just as promised, he comes in perfect English.

The next day Jamie picked up some raver kid somewhere in town who called himself Taz. They started dating after a few weeks. "I love this guy," said Taz, putting his arm around Jamie. "I want to shout it from the rooftops." I could see the color begin to grow in Jamie's cheeks. He seemed to like it—being loved, or lusted after, whatever the case was—but later, when we were alone, he told me it sometimes made him nervous.

VIII. "Apparently," said Jamie, "we're all made of vibrating strings of energy. Everything is. So my new thing is trying to go back to that, to get in touch with everything." He brought his hands in front of his eyes and marveled at them, then at the world to his left. "It's all so much more accessible than we're taught to believe. You can have anything you want." God, I loved him. "You're such a hippie," I said, folding up a blanket. "You know you think of the same things," he said. "What, do you think you can read my mind?" I laughed, and promptly changed the subject.

IIX. Taz switched off the TV. "The world will come to an end when a gay man falls in love with a woman," he said. We had just finished watching some movie where Jennifer Aniston gets pregnant and wants her gay friend to help her raise her baby. "It might've happened somewhere," I said. "I mean, I've heard of stories where completely straight women fell in love with another woman." Taz chuckled his hit-you-over-the-head-with-gayness chuckle. "Honey, they were just dykes waiting to happen." I shrugged. "Maybe." Taz ruffled Jamie's hair. "What do you think, mister? Would YOU fuck anything with a vagina?" Jamie laughed and kissed Taz on the lips. "You're crazy. I love the cock." Taz grinned, nose scrunched up, baring his little white teeth that looked like baby teeth, and asked whose cock he loved.

"Johnny's," said Jamie, accompanied by a wry smile.

"FUCK. YOU. You little bitch."

"Kidding. You're the winner. You have the best cock in all of Satchel Heights."

"You would know," said Taz.

His elusive maleness, his sexuality, hissed at me, taunted me, winking and blowing kisses from across the room. At times I hated him. He knew what he was doing. He had too good of a grasp on the human mind, on our weak psychologies.

The night before we all left campus for the summer, Jamie

I almost come just from the feel of his lips around my nipple. He drops to his knees, wraps his arms around my waist, and presses the side of his face to my center, just above my stomach, canopied by my breasts. He turns his face to the center, brushes the soft skin with his soft lips.

told me about the time he fully realized he was gay. He was a junior in high school, and he was at this girl Elissa's house, whose parents had gone skiing for the weekend. Elissa was draped across her bed, caressing one pink nipple with her fingertips. "Are you gonna fuck me?" she said, her voice breathy and masculine, eyelids drooping with lust, exposing the tired, glossy film the day had brought to them.

"Give me a minute," said Jamie. He sat in Elissa's bare wooden desk chair eyeing her naked white body, a body, no doubt, that belonged in one of those Botticelli paintings in his Art History textbook; when he thought it over in his head, she was the perfect lay. All throughout his freshman and sophomore year of high school, he imagined kissing her pink, pristine mouth, smelling that indelible scent on her skin and hair—the Ivory soap, the Herbal Essences, whatever the hell it was—he daydreamed about feeling the softness of her breasts with his hands and mouth, the wet silk of her hot, rosy center, imagined digging his fingers deeper and deeper inside. It wouldn't feel dirty with her, he thought, it would feel good and clean and wholesome, like making love to an angel. But now, sitting in her room, with Elissa naked in front of him, he felt nervous, not so excited.

"A minute? I've given you two years," she said, sliding her hand down to her well-pronounced pubis, which donned only a small triangle of light brown hair. Jamie folded his lips into each other and furrowed his brow.

Jamie was still fully dressed, in a cobalt blue car-mechanic jacket with a nametag that said Jesus that he'd found at the Salvation Army, and tight black jeans.

"What are you doing over there?" said Jamie. Elissa began masturbating.

"Watching you watch me." She slipped her fingers in and out of her cunt, and moved her thumb up and down along the side of her clit. "And waiting." She bit her bottom lip in an attempt to amplify the display of her sexual desire, and her honey-colored lashes fanned against the faded aquamarine of her eyes. He saw the blood start to flow underneath her skin, starting at the place where her freckled jawline began to dip and curve to meet her neck. The crimson color grew upward and out into a patch that covered almost the entirety of the cheek facing Jamie. It was the one physical thing of hers that he didn't care for—he didn't like the ruddiness of her complexion, how easily her skin responded

to heat, to wind, to cold, to excitement or touch. He liked his women with thick, white skin, something that proved hard to come across. He lost his virginity to an alabaster girl named Lilly who was just as unresponsive as her skin. She lay there in his bed, eyes cast somewhere off in the corner while he kissed her nipples, stroked her hair, and drove himself in and out of her, trying with all his sixteen-year-old might to please her; and he tried for four hours, unwilling to let her go because she was so beautiful. She had no personality worth mentioning, and she wasn't very intelligent, but she had flaming red hair and thick white skin and Jamie knew the importance of possessing sheer, aesthetic beauty.

"Come fuck me," said Elissa. "Please."

"I'm sorry," said Jamie. "I can't."

And then he left.

"But you wanted her," I said. "At one point you wanted her. It sounds like you were just nervous."

"No," he said. "I just thought I wanted her. I thought I wanted women, because that's what you're supposed to want, you know? You're supposed to want big breasts and soft skin and something warm and wet and tight to sink your dick into."

It's been three years since I've seen him. There's been the occasional e-mail, and we talked on the phone about every month for a year, but after that, all contact with him ceased save a mass e-mail from him now and then. A few weeks ago I got one in my inbox:

Dear friends and family,
The time has finally come. I never thought I'd say it, but I, along with my fellow classmates of 2006, will be graduating from Satchel Heights College at 2:00 p.m. on Sunday, June 8th. All are welcome (and encouraged!) to attend. Just shoot me an e-mail for directions, etc.

Peace & Love,
Jamie

The weather had been crappy since I'd graduated last week and today was no exception. With the season in dismal check, the clouds ate up summertime and everything remained a uniform gray. During my freshman year, the heat from the summer lingered on, probably a few weeks after the picture of Jamie and I had been taken. That year the sun was fierce, a blinding white disc eager to prolong its reign, to grace those with enough melanin with a sleek dark skin, to bite those with too little, leaving them with a band of crimson across their noses and cheeks. Jamie called it the Mark of the Displaced European Descendant. Was it made by the hand of Karma or Justice, giving a good slap to the face of every European-American for their ancestors' wrongdoings? For Amerigo Vespucci and Christopher Columbus and the incidents at Wounded Knee? For the massacres and the blood and for celebrating Thanksgiving every year? Maybe. But, whether it was because of the rise in fair-skinned freedom fighters, or simply some effect of wear and tear in the ozone layer, the Aryans were going to get off easy this summer with a pension of a few freckles.

I put in a mixed tape and pulled out of my driveway, Map-Quest directions in my lap, the photograph of Jamie and I wedged in the crook of the passenger's seat.

XI. "Oh my god," he said, "come here, you." He was taller, and his hair had migrated all the way down to his well-defined cheekbones. I had decided to skip out on the ceremony and wait outside on the lawn, where all the friends and families joined after to greet the graduates. "I can't believe you're here," he said. "Kelly, look who's here." Kelly turned from her family, her pretty auburn hair swinging over one shoulder. "Oh my god!" She hugged me and I congratulated her, and asked her what her plans were from here. Kelly looked at Jamie and they smiled. "We're moving to New York to intern at the *Village Voice*," Jamie said, putting his arm around her. They squealed and gave each other an Eskimo kiss. "Wow, that's great," I said, "congratulations. But I thought you didn't like the city." Jamie shrugged. "I'll get used to it." They told me about their apartment and how they were going to decorate it, finishing each other's sentences and speaking in tandem, looking at each other as they spoke like a freshly wed couple eager to start their married life in their newly decorated home.

"So are you guys throwing a big rager, or what?" I asked when they were done.

"Nah," said Jamie, "we're just going out to dinner."

He paused and then said, "You're welcome to join us, if you'd like."

I thanked him, and said no, I'd better be getting back on the road.

"Okay," he said, "well it was good seeing you. Keep in touch, okay?"

"Okay." I went over to them and gave Kelly a hug, then went to Jamie. I put my hands lightly on his shoulders and he grabbed one of them and kissed the top of it. "I'm so glad you came," he said. I looked him in the face as best as I could, and told him how much I've missed him the past couple of years. "I've missed you too," he said, "you were one of my best friends." We broke eye contact and I hugged him so tight that I couldn't tell whether or not he was holding on with the same intensity. When we let go, I nodded and said, "best of luck

His elusive maleness, his sexuality taunted me, winking and blowing kisses from across the room. At times I hated him. He knew what he was doing.

to both of you." They blew kisses and began to disappear together into the sea of polyester caps and gowns.

I walked away quickly and didn't look back. There was nothing particularly unique about the connection between Jamie and I. People fall in love. People fall in lust. They fall into flirtations, into friendships, into habits. And the same neurons fire away in our brains, oxytocin pumping away, dopamine flowing through, attaching us to whoever happens to be there. An addiction. It was all just an addiction.

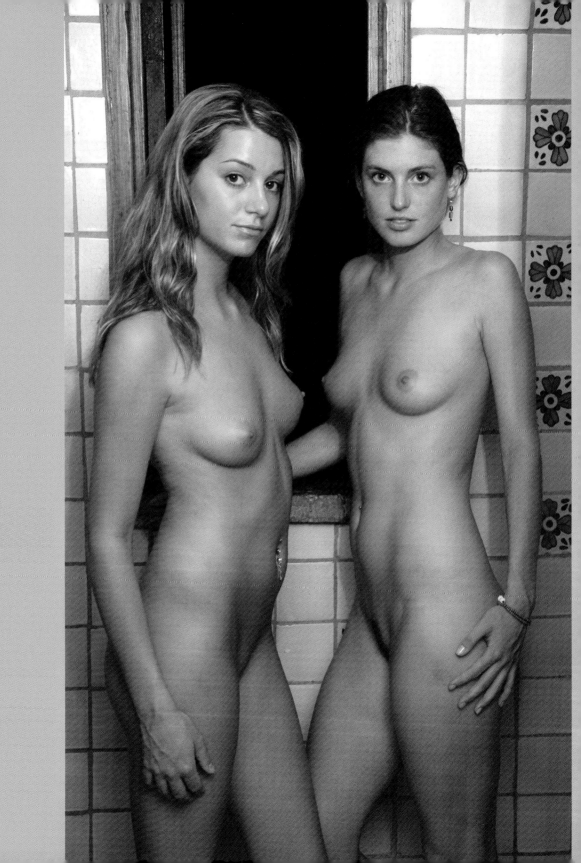

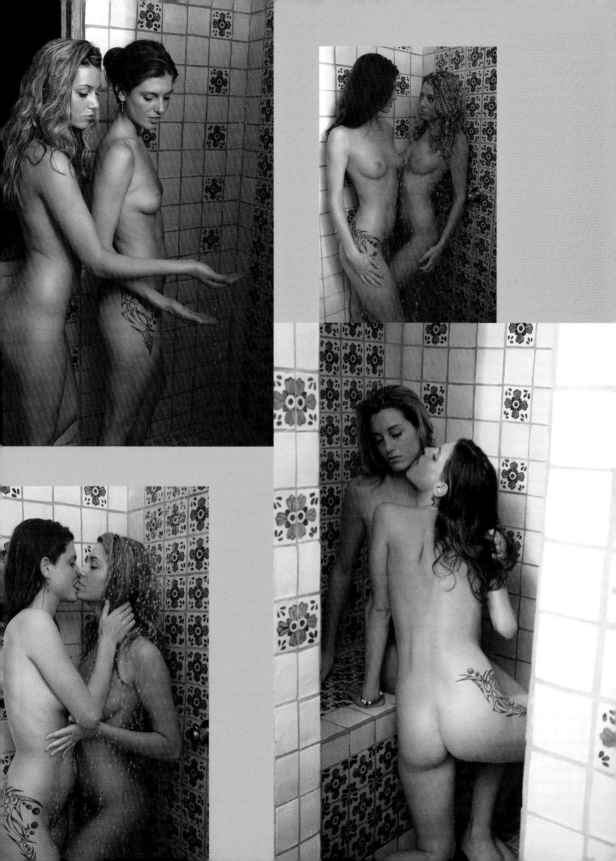

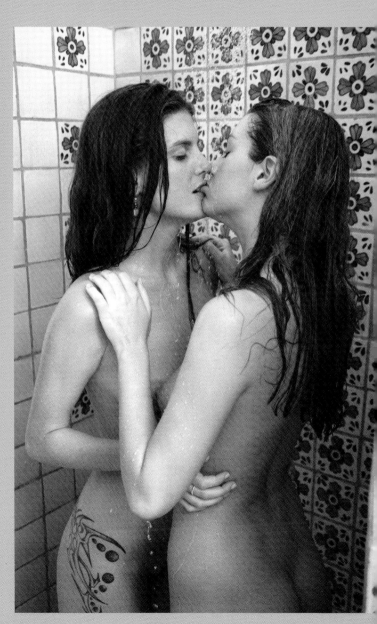

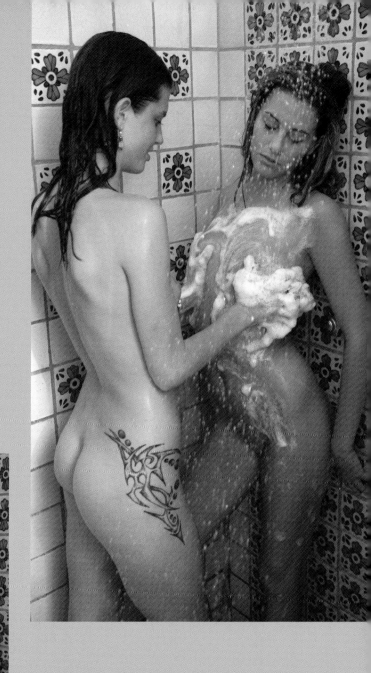

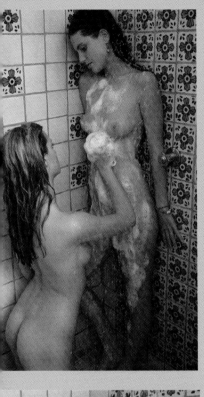
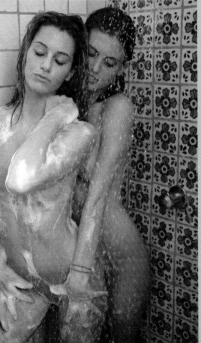
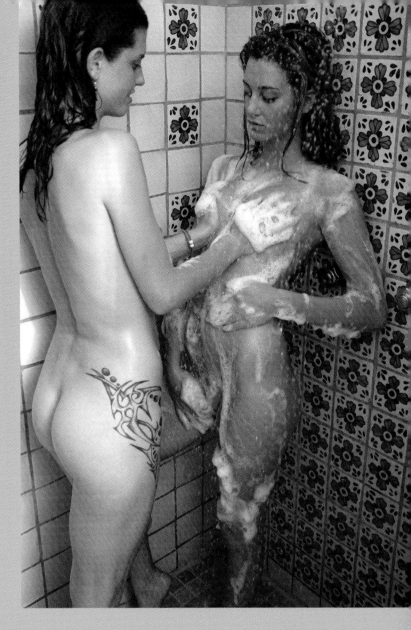

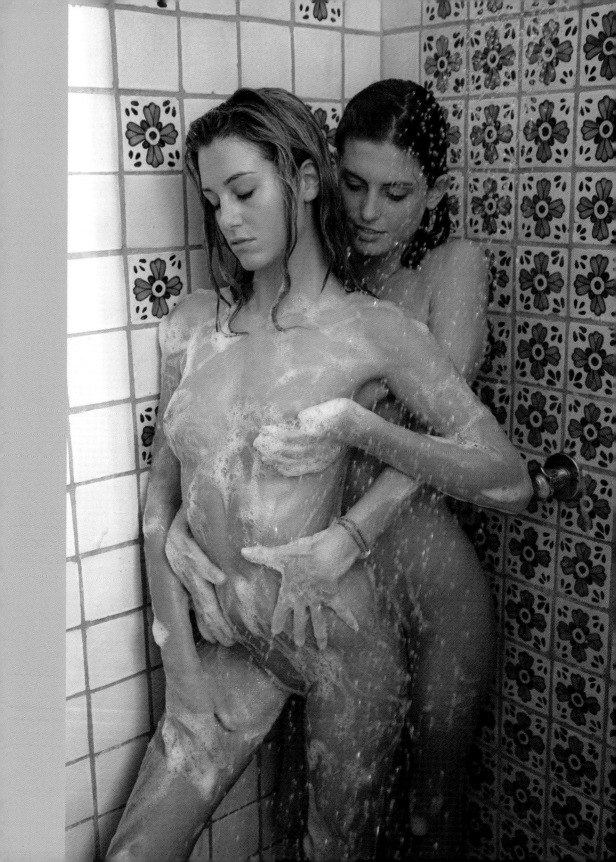

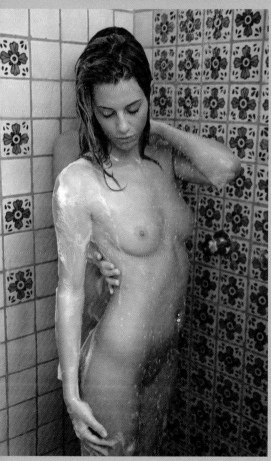

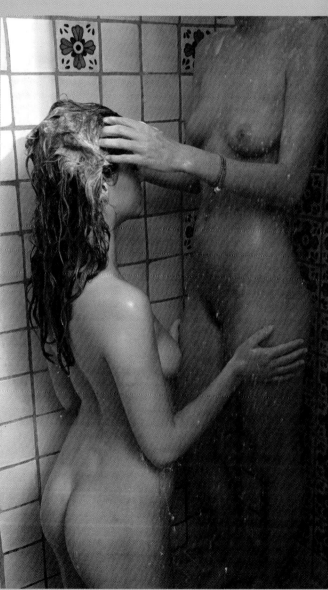

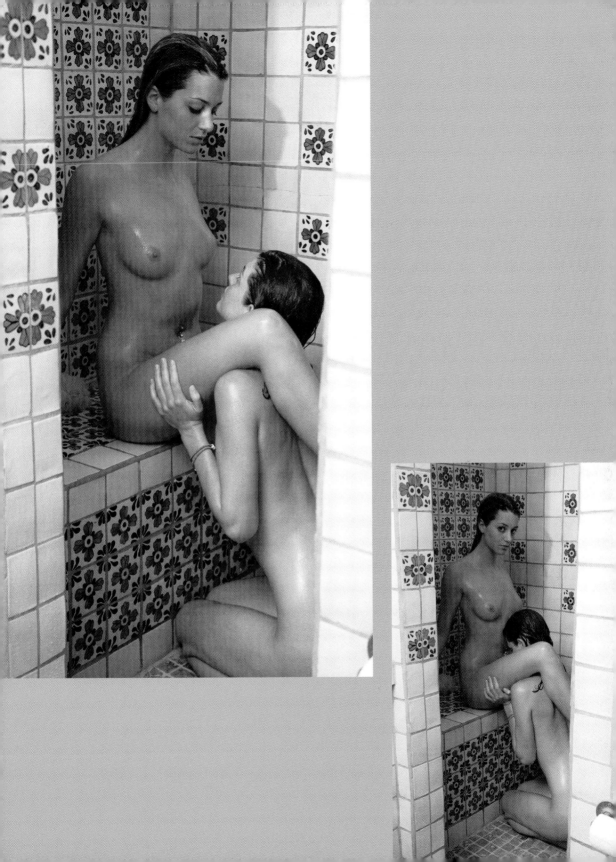

Out of Sexile:
You're Not Bitter, You're Better

by **SHONA**
IVY LEAGUE UNIVERSITY

I COULD SEE THE SCREAMING, NEON beacon the moment I turned the corner after stepping out of the elevator. My room was still a ways down the corridor, but Day-Glo pink isn't exactly a subtle color, and in this case it certainly was not meant to be. I made my way quietly down the hall hoping that it was something else: A shopping list...directions to a crazy party...hell, even a note asking me to clean the bathroom would have been within reason (our bathroom was gross...occasional vomiting and too much hair dyeing tends to have that effect, but that's another lesson for another time). With my final steps before bringing myself within range of the door handle I took my last, deep breath of hope, and exhaled slowly...

Alas, my optimism was short-lived. There, taped securely to the door handle just in case the pre-applied glue meant to keep it in place were to fail, was the headache-inducing, obnoxiously bright pink Post-It note with an all too familiar phrase scrawled across it: "DON'T COME IN!!!"

Thus began yet another night of sexile, and I turned myself around to head back down the hallway.

Sexile is a phenomenon that I defined one evening (while unhappily situated at a Starbucks toiling over my own sexless misery) as: The act of being forcibly removed from one's own living space by a horny roommate so that said roommate can do it. That's the edited, more professional version of the definition. The original was scratched into a napkin, included several

expletives, and had an "I hate you" border (which was accented with squiggly lines and spirals for a little extra oomph).

Whether or not sexile is something you have experienced, chances are it will happen to most who are living in a college residence hall at some point or another. Thus, everyone should at the very least have a plan of action just in case a time should come when he or she is suddenly in need of something to kill a few hours (while the act itself may not last this long, chances are the copulating couple will probably want a little cuddle time afterwards, or at the very least a nap).

One of my favorite things to do when faced with sexile was head for my best friend's room a few floors down. Since his roommate was generally the one sticking it to mine, I felt that keeping him company in his cold, lonely room was the decent thing for me to do. My presence was regularly welcomed with open arms and a rather large bottle of vodka he kept hidden under his desk. I learned very quickly that drinking away your sorrows = simple fix for any blues you may be experiencing knowing that while your roommate is having lots of sex in your room, you have been in a rut for the last, you know, nineteen years.

If you decide to go the way of alcoholism (the severity of which will obviously depend on how often your roommate gets laid) there are a few rules you may want to follow as best you can:

1. Under no circumstances should you do anything of an intimate nature with your drinking buddy. All that will follow is awkwardness and the possible loss of your supplier, neither of which do anything to help your original problem.

2. Whatever room the boozing starts in, stay there until it's time to return to your own abode. Remember, you have a low alcohol tolerance (well, if you're me), and the RAs roaming the halls will not hesitate to be-

rate your state. Even if you have a higher than normal threshold, it's probably best not to venture far from your place of origin. If there's booze on you breath, moochers probably won't be far, and alcohol is an expensive thing to have to share, and you need it to last.

3. By all means, have some fun at the expense of your roommates. Drunkenly insulting those who are the cause of your misfortune and are out of earshot can be enjoyable as well as therapeutic. We generally focused on my roommate's appearance and general mental instability, but don't be afraid to be creative.

For those unwillingly sexiled individuals in search of an activity that may leave them in a more conscious state of existence, there are plenty of options available that don't involve tempting an alcohol violation from that pesky RA. One popular, cheap, and healthy approach to passing the time while your roommate is "passing the time" is, quite simply, taking a walk. Now, the appeal of this may vary from person to lonely person depending on location. Personal experience allows me to speak highly of the walking option, but I live in Boston. There are parks, and brick buildings, and entertaining drunkards spilling out of bars, all fantastic distractions for a mind full of disturbing images of a roommate in various states of...well, you get the point.

Taking a brisk walk is also probably the healthiest time consuming option for the sexiled. The simple fact that it doesn't slowly rot away your liver is certainly a plus, but there are plenty of other healthy turns your body will be taking during your lap around campus. Studies have shown that walking for roughly 2 to 3.5 hours per week (or roughly 12 miles) can significantly decrease a person's risk of cardiovascular disease. This can also be an easy way to burn some of those nasty excess calories. With the threat of the dreaded "Freshman 15"

(don't let the name fool you, those pounds can pack themselves on just as easily sophomore through senior year as well) hovering not so far in the distance, and a general rule of thumb for walking being reported as 1 mile = 100 calories, not getting any action could actually be the key to a healthier, sexier you. Besides, recent data

Since his roommate was generally the one sticking it to mine, I felt that keeping him company in his cold, lonely room was the decent thing for me to do.

shows that your roommate is probably only staving off somewhere between ten and twenty calories per rendezvous, so you can give yourself a silent pat on the back when they're the one worrying about how they look naked. A little schadenfreude never hurt anyone.

Let us not forget that this is college, and on occasion there are more scholastic activities that need be tended to. I know how tough it can be to get myself motivated to knuckle down and finish that paper that's due at 8 o'clock in the morning before 3 a.m. the night before. Sitting in a dorm

No matter how good-looking your roommate's partner may be, seeing them in the buff will probably cause some awkward silences in the future...not that barging in on them fucking won't be awkward, but there's really no need to heighten the embarrassment.

room provides far too many distractions, whether from a blaring television, to roommates chattering, to the search for new music to (let's not kid ourselves now) illegally download, to those six seasons of *The West Wing* we have on DVD just begging to be watched over and over and over again.

The key here is to always, always have some sort of writing utensils with you when you leave your room. You never know when you're going to show up at your door desperately needing to start that 15-page final draft that's due in the morning, only to find yourself locked out without warning. Armed with a legal pad and your favorite pen (you'd be surprised how easy it is to get attached), you can march yourself to any number of places you may find suitable. A local coffee shop, your college library. Depending on the time of day and the weather you can always grab a sunny spot in the great outdoors, any of these will do as long as you are comfortable. Before you know it, you'll be on the Dean's list and calling your parents to tell them about those straight A's you earned yourself.

Sexiled individuals should not be afraid to be lucrative in their use of time banished from home base. Do not be afraid to use sexile as a chance to branch out and expand your social horizons. College comes fully equipped with clubs to join, plays to see, poetry slams to take part in. Venture into the world provided for you, make new friends, have those experiences you'll want to tell everyone about when you head home for Winter Break. If anything, sexile will prevent you from becoming that boring

kid that sits in their room all day and nobody really likes. Who knows, maybe you'll even meet someone who will one day help you give your roommate a taste of their own, bitter medicine.

Should all else fail, or should it be absolutely, unavoidably necessary that you get into your room during your roommate's one-on-one time with his or her significant other, then for God's sake just interrupt them. This may take some brief preparation on your part, but nothing too strenuous. Begin by taking a deep, calming breath. Quietly but assertively remind yourself that, hey, this is your room too! What right do they have to lock you out at a moment's notice with nowhere to go and nothing to do? That's right, none. Following your affirmation, you should first resort to a simple phone call. This is as polite as you can be when interrupting the sexual escapades of someone who sleeps a few feet from you. Hopefully your roommate will answer, allowing you to explain your situation, and giving the dynamic duo some time to clothe

themselves before they have to face you. Should your call be ignored, do not be discouraged. Bang on the door a few times to let them know that it's about time for them to stop banging.

Now, some of the more obnoxious roommates will still neglect to take the hint. It is at times such as this that, well, they get what they damn well deserve. You're probably going to want to shield your gaze from what you are about to be exposed to. No matter how good-looking your roommate's partner may be, seeing them in the buff will probably cause some awkward silences in the future...not that barging in on them fucking won't be awkward, but there's really no need to heighten the embarrassment. Get a steady grasp on the fact that the room is partially yours...remember that key they gave you when you moved in? Use it. In one swift motion, unlock and throw open the door to your room. Pay no attention to the screeches of protest you may be met with. Fuck them. They should have thought of these consequences before completely ignoring your phone call, your knocks, your needs. Depending on your level of frustration and how often you find yourself sexiled by said roommate, I suggest letting the door stay open while you rummage around for an unnecessarily long time searching for whatever it is you want to

take with you. Inform them that they have ten minutes to get their shit together before you return, and you won't be warning them this time. Punctuate this as you leave the room with a brief, barely audible expletive. Motherfuckers.

Remember however, forcing yourself upon your roommate while they are in the act should be used only as an absolute last resort. Keep in mind that the day may come when you are the one who finds it necessary to force sexile upon someone, and karma happens to be quite the bitch. When that time does arrive, remember how it felt to be deprived of a living space for hours at a time. Clear it with your roommate(s). Give them a chance to fully prepare themselves for a long, long night. Perhaps you can even pass along the advice of your own experiences. Remember the inconvenience you had to put up with, and the little thanks you got on those lonely, lonely nights that you so graciously made yourself scarce. Once in a while, remember to thank said roomie. Perhaps buy them a cup of coffee...or lunch...or get them laid. And if you are lucky they may return the favor some day.

AFTERWORD

Revolutionary:

The Explosion of Sexual Expression and Experimentation in the College Press

by **DANIEL**
STATE UNIVERSITY

UNIVERSITY OF SOUTHERN MISSISSIPPI President Shelby Thames is up in arms about sex. In late September 2006, Thames sent an open letter of disgust to the school's campus newspaper, *The Student Printz*, outlining his anger at the paper's decision to publish "Pillow Talk," a regular sex column written by a student.

"I vigorously oppose the printing of the Pillow Talk...and characterize the content as offensive to the quality and respectability of our student body and institution," he wrote in a letter to the editor run on the paper's opinion page. "This article was not, in any way, representative of the high caliber of our student body or our institution overall."

What is the content causing such a fuss? In its short run so far, the column begun at the start of that fall semester has addressed issues involving foreplay, safe sex, the need for awareness about the spread of STDs, and the eternal question "Do love and sex belong together?"

Thames's vigorous opposition to students' public pillow talk is the latest in a long line of administrative, legislative, parental, school donor, and alumni distaste over the modern-day student penchant for examining sex in print. In November 2002, administrators at New York's Wagner College removed all copies of the student newspaper, *The Wagnerian*, and threatened to fire the newspaper adviser after a sex column was published titled "Orgasms: do you fake it?" In 2005, the Arizona state legislature added and approved a footnote to the annual budget withdrawing state funding for

Current and former student writers and editors at school newspapers nationwide describe many other instances of intimidation and censorship coming from the university professoriate and administration, often carried out in private via "Not for Publication" e-mails and phone calls or through related staff or adviser hiring and firing.

university student newspapers, partly as a response to a sex column published in 2004 in *The Lumberjack*, Northern Arizona University's student newspaper that began, "On Valentine's Day, nothing says 'I love you' like oral sex." Around the same time, administrators at North Carolina's Craven Community College mounted an ultimately unsuccessful takeover of the independent student newspaper, *The Campus Communicator*, in response to a short-lived sex column titled "Between the Sheets." Current and former student writers and editors at school newspapers nationwide describe many other instances of intimidation and censorship coming from the university professoriate and administration, often carried out in private via "Not for Publication" e-mails and phone calls or through related staff or adviser hiring and firing.

On a national level, criticism has focused on the potentially harmful ramifications of college-age students with little or no related professional training or academic experience offering advice and insight on matters of sex and health. Political and religious concerns also have been expressed, especially at schools with religious affiliations such as Boston College and Georgetown University, mostly from conservative groups, decrying the lack of pro-marriage and abstinence issues addressed and denouncing the tolerance shown for sexual experimentation and homosexual, bisexual, and transgender individuals and lifestyles.

The threats and official action related to the funding, freedom, and distribution of the student publications printing sexually explicit fare show

how far removed the older generation and educational heads have become from the students in their stead. The powers-that-be may believe they are simply challenging the rampant sexualization of the college media, but they are truly fighting a larger, losing battle against the boundary-pushing mode of expression that the campus press have always aspired to be.

The student media at the college level have long been bastions of forward-thinking rebellious avenues for testing the waters and discovering both oneself and the outside world. A spirit of pure protest has also always defined the campus press, with student writers and editors of times past battling McCarthyism and the Vietnam War and debating women's voting rights, birth control, abortion, and parity in collegiate sports with an intellectual vigor and a righteous, blind passion that only a late-teen or early-twentysomething could muster.

In modern times, in the wake of the AIDS epidemic, the Clinton-Lewinsky scandal, and even HBO's *Sex and the City*, the activism has transformed from mainly political to wholly sexual. Truly, the explosion of sexual expression in the college student media over the past decade, epitomized most publicly and controversially by the college newspaper sex column and campus sex magazine, hints at the power of the campus press to continue enabling students to challenge the status quo, define new limits of good taste, and attempt to understand and experience the incidents and issues that in the sexualized America of today can and should no longer be ignored. As the lead-in of the first *Student Printz* column, published in early September 2006, aptly pointed out, "Experimentation is a common part of the college experience."

The administrators such as Thames who aspire to shut down this experimentation are going against every value the modern college campus should embrace: freedom of speech, soul-searching, identity-definition, and knowledge aquisition. They are also preventing information to spread about an

area of students' lives in which ignorance can be harmful and even deadly.

In this sense, along with encouraging experimentation, the columns are filling a gap in the nonexistent or abstinence-only sexual education endured by a majority of students reaching the college level today. Students and health experts cite an overwhelming need for sex and health information of any kind to be made available for student perusal, pointing to studies and personal experiences in which current collegians have been shown to exhibit dangerous levels of ignorance related to safe sexual activity. And while criticism has focused on the potentially harmful ramifica-

tions of college-age students with little or no related professional training offering guidance on matters of sex and health, a majority supports safe-sex practices and an increasing number cite outside sources such as the campus health coordinator when passing along advice.

Even in instances when the columns' focuses appear to cross the taste threshold, with many columnists citing pieces on anal sex as causing the most public backlash, health professionals see the benefit of simply having the topic introduced into the campus consciousness and causing debate at the student level, instead of the perception that it is being pushed down students' throats by an outsider. In this respect, in terms of social distance and the private nature of most things sex-related, students are viewed as being more likely to turn to advice offered by a peer instead of an elder expert and to seek such advice through the anonymous avenue of newspaper readership rather than face-to-face interpersonal communication.

And as evidence of their success, even in the wake of administrative decrees about their non-representativeness of the campus community at large, students are turning to the columns in student papers in droves. Since beginning in a single student publication in 1997, through a Q&A feature called "Sex on Tuesday" still running as the most popular part of *The Daily Californian* at the University of California-Berkeley, sex and health columns have expanded to more than 200 campus newspapers and magazines nationwide, according to the Associated Collegiate Press. Campus sex magazines also are now beginning to grow in number, more than seven years after a publication titled *Squirm* debuted at Vassar College, a liberal arts school in Poughkeepsie, New York.

The columns specifically in many instances have become the most well-read and debated portions of the publications in which they appear, registering the highest number of Web site hits and letters to the editor. In certain cases, the columns have single-handedly, and dramatically, upped certain newspapers' circulation numbers and Web site traffic. For example, a column titled "Sex and the (Elm) City," written by former Yale University student and *Yale Daily News* staffer Natalie Krinsky, received between 200,000 and 500,000 hits each week, at one point existing as the tenth most-Googled page on the Internet and registering more than ten times the normal Web traffic for all other *Daily News* content. A similar must-read status has characterized past and current columns run in a variety of other student newspapers, from *The Stanford Daily* and *The Daily Kansan* to *The Columbia Spectator* and *The Muhlenberg Weekly.*

From a more personal angle, the popularity of the columns and magazines has subsequently, and unequivocally, changed the lives of many involved in their creation, including leading some current and former students to receive national press attention, make television appearances, and receive cold calls from literary agents. For example, in 2002 former

> I...characterize the content as offensive to the quality and respectability of our student body and institution.
>
> —SMU President
> Shelby Thames

Daily Kansan columnist Meghan Bainum was invited to pose for a special spread in *Playboy Magazine*, while in 2003 former *Tufts Daily News* columnist Amber Madison was selected by MTV to appear in the feature film *The Real Cancun* due to her sex column work. And Krinsky, Madison, former *Washington Square News* sex columnist Yvonne Fulbright (New York University), and *boink magazine's* own Alecia Oleyourryk have built upon the experience and celebrity generated by their columns or magazine work and published or signed book deals with U.S. publishers.

boink 259

In addition, apart from the sexual subject matter specifically, some consider the student writers' and editors' refusals to bow to outside pressure and to continue running the content to be akin to a modern-day protest march and an important reminder and lesson about the value of free speech and the First Amendment on campus and within the news media. "By their very nature, campus publications are more laboratories of journalistic and artistic expression than they are representative journals of the official college viewpoint," an October 2006 *Hattiesburg American* editorial noted, in response to the open letter penned by Thames. "But they are an integral and essential element in both the academic and social component of university life. And they are perfect examples of free speech and the value and strength of the First Amendment."

Even more, with a majority of the student columnists and editors involved in the creation of the sexually related content being female, gender politics also have influenced the creation and direction of the columns and magazines in the contemporary campus media. Supporters point to the columns, mostly written by female undergraduates, as beacons of female empowerment, in enabling women a public forum to discuss their sexual selves in an open and frank manner that has traditionally been frowned upon or seen in purely male terms. Issues

The threats and official action related to the funding, freedom, and distribution of the student publications printing sexually-explicit fare show how far removed the older generation and educational heads have become from the students.

related to feminine strength and sexual openness, often linked by the female student writers and editors with third-wave feminism, are embedded directly and contextually in many of their related writings and publications, owing to past incidents as varied as the Title IX rules granting women equal rights with men in higher education athletics, the rising divorce rate, and increasing female enrollment in colleges and universities nationwide.

Meanwhile, simply from a journalistic perspective, the printing of sexually related content is seen, if nothing else, as a way to better acquaint student publications today with the true passions and thought processes of their core audience. "So much stuff that's published in a

college paper is super dull," said Michael Coleman, the former editor in chief of *The Daily Californian* who approved the first "Sex on Tuesday" column. "You know, the story of what goes into a city council meeting or how the water polo team did last night. So, I liked the idea that a sex column would be a little provocative on purpose, to really get at the heart of what students actually talked about and cared about."

As Coleman and other student journalists have pointed out, whether administrators like it or not, sex is at the heart of student thought and action. It has been a reality of higher education since the first public university admitted women in 1855 and most certainly since the first co-educational dormitory in the U.S. was constructed in 1969. The columns are right to recognize sex's place of significance in the current collegiate landscape and should be applauded for providing education, reflection, debate, and just-plain

entertaining insight into its possible positive and negative consequences.

In the end, the passionate tenor of Thames's response illustrates the columns' value, as no other single entity in the post-millennial college journalism universe continues to stir so much simultaneous interest and admonishment, fame and notoriety, fear and fervent support. They are provoking thought, emotional responses, drawn-out debate, and internal examination. In these respects, sex and the columns that discuss it don't exemplify what's wrong with college today—they embody what college is all about.

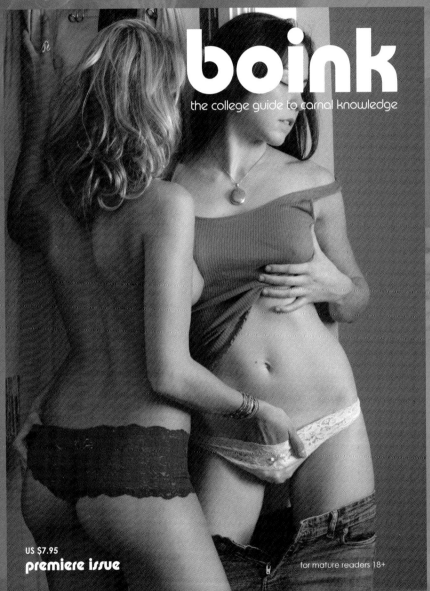